ANGELS & FAIRIES

Author: Iain Zaczek Foreword: George P. Landow

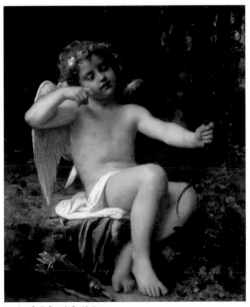

Leon Jean Basile Perrault, *Cupid's Arrows*

STAR FIRE

John Anster Fitzgerald, *Fairy Twilight*

Contents

Constantin Makowsky, *The Toilet of Venus*, John Atkinson Grimshaw, *Iris* , Richard Doyle, *The Fairy Queen's Carriage*

John Duncan McKirdy, *Yorinda and Yoringel in the Witch's Wood*, Robert Huskisson, *Titania's Elves Robbing the Squirrel's Nest*, A.C. Lalli, after Dante Gabriel Rossetti, *Dante's Dream at the Time of the Death of Beatrice*

Literary Influences

 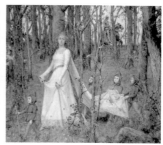

Arthur Rackham, *The Meeting of Oberon and Titania* , Gustave Doré, *The Fairies: A Scene Drawn from Shakespeare*, Henry Meynell Rheam, *The Fairy Wood*

Other Influences

 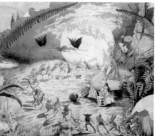

John George Naish, *Elves and Fairies, A Midsummer Night's Dream*, Amelia Jane Murray, (Lady Oswald), *A Fairy Resting Among Flowers*, George Cruikshank, A Fairy Gathering

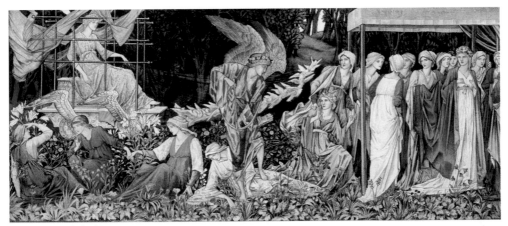

John Henry Dearle, *The Passing of Venus*

How To Use This Book

The reader is encouraged to use this book in a variety of ways, each of which caters for a range of interests, knowledge and uses.

- The book is organized into four sections: **Movement Overview**, **Society**, **Literary Influences** and **Other Influences**. The text in all these sections provides the reader with a brief background to the work, and gives greater insight into how and why it was created.
- **Movement Overview** is an introduction to the artists, styles and subjects that are featured throughout the rest of the book.
- **Society** shows how the wider world in which the artists of the period lived had a bearing on their work, and explores their different interpretations of it.
- **Literary Influences** looks at the literary sources that influenced the artists, including Shakespeare, Classical mythology and tales of romance and chivalry. It also includes pictures inspired by biblical themes.
- **Other Influences** reveals what other sources of inspiration artists drew upon to create their works, including light, the natural world, children's literature and picture books, and their own imaginations.

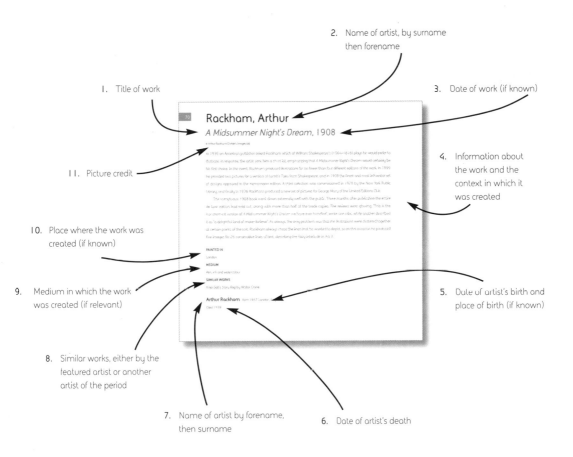

2. Name of artist, by surname then forename

1. Title of work

3. Date of work (if known)

4. Information about the work and the context in which it was created

11. Picture credit

Rackham, Arthur

A Midsummer Night's Dream, 1908

10. Place where the work was created (if known)

9. Medium in which the work was created (if relevant)

5. Date of artist's birth and place of birth (if known)

8. Similar works, either by the featured artist or another artist of the period

7. Name of artist by forename, then surname

6. Date of artist's death

Foreword

Pictures of angels, cupids, and fairies appear at first fundamentally opposed to an age of increasing industrial and urban development. In fact, they constitute an important, if unexpected, strain in the complex period that begins the modern age. The years of Victoria's reign had so many opposing strands that the term 'Victorian' often raises more questions than it provides answers. We do know that these years embraced a series of oppositions. After the early days of Romanticism, which emphasized the personal, even idiosyncratic expressions of the individual artist-poet, nineteenth-century painters and writers confronted opposing tensions. Wanting to combine the Renaissance and Neoclassical artist's public role with a romantic emphasis on deeply felt private experience, they sought ways to make an acceptable public use for private thoughts and feelings. In doing so they had to bridge personal and public, private and political, poetry and science, emotion and fact – the wonder of science and the wonder of angels and fairies. At their most successful – in the works, say, of Dickens, Tennyson, and Millais – artists and writers of the nineteenth century managed to produce great art that appealed to both the cultural elite and to the masses. The Victorian age, – the second English Renaissance – was the last able to achieve this feat.

Paintings of angels, cupids, and fairies represent two sides of the Romantic moment. Wordsworth and Coleridge's lyrical ballads asserted that the new kind of supposedly truer poetry it contained took two different forms: those whose diction and subject exemplified realism, and those that took the form of fantasy, as in Coleridge's *The Ancient Mariner*. These apparently oppositional modes also appear in paintings. On one side we have fairy painting, and on the other Millais's *Ophelia* and Holman Hunt's *The Hireling Shepherd*. Like Ruskin's drawings of rocks and mountains, these works embody his influential belief that artists, particularly novice artists, had to convey what he termed nature's infinite variety with lavishly detailed pictures.

Realism as a painterly style brought with it great difficulties. Ruskin and his followers believed that one could only create great art by abandoning conventional generalized views of the visible world, and instead carefully observing the minutest details of shape, tone and colour. They also feared that such an artistic approach inevitably led to a dead, anti-spiritual, anti-emotional realism. Painters therefore tried a range of devices to "elevate materialism", as one Victorian reviewer put it. Artists such as Frederick Goodall, J. R. Herbert, Holman Hunt, J. F. Lewis and David Roberts all believed that the sacred history of the landscape in which biblical events had unfolded automatically infused detailed representations with powerful emotion, so

they journeyed to the Middle East. Other artists, such as Atkinson Grimshaw (who also painted fairy pictures) used city lights and urban fogs to reveal a magical side of capitalist industrial urban life. Still others, like members of the Pre-Raphaelite Brotherhood, followed Ruskin's example and used elaborate biblical symbolism that permitted one both to descend to the minutest details of visible reality, and yet create a work in which almost every detail had meaning. Fairy painting is another approach – a genre of British nineteenth-century art that both employs the realistic style of painting that for many implied a materialist conception of the world, yet uses its subject to create something supernatural, imaginative and anti-materialistic.

Examined in the context of history, fantasy exists in a dependent (perhaps parasitical) relationship to realism. Realism implies an entire attitude toward reality: it assumes that one discovers and communicates in the minute details of visible reality. This gives rise to the crucial importance of individual, even eccentric detail, historical accuracy, and sociological fact in literature and the arts. Only when Realism becomes so culturally widespread that it appears the natural way to depict people and the world of nature does fantasy arise as a separate, identifiable style or mode. Earlier work often had elements of what today might seem fantastic, but they were not included to offer the pleasures of fantasy as they were thought to embody a higher, non-visible reality. When Renaissance painters represented the Madonna and child Jesus sharing the same picture space with saints born 1,000 years after Gospel times, no viewer believed such a meeting took place in human physical reality. Similarly, medieval romances often had fantastic elements, such as the sword Excalibur and the Lady of the Lake.

Paintings of angels, cupids and fairies, like the prose fantasies of George MacDonald and William Morris, offered artist and audience a glimpse of worlds of wonder. Since they took form in an age of realism, they often included detailed depictions of the natural world – hyper real depictions of identifiable plants, such as those one encounters in both Millais's *Ferdinand Lured by Ariel* and Paton's many fairy works. At the same time that this characteristic nineteenth-century British artistic mode provided an escape, a brief respite from the Victorian worlds of labour, the office, factory and urban wasteland, it also provided respite from rigid middle-class morality because one could always put wings on naked women and call them fairies. Angels, cupids and fairies do not exist within the eccentric, outsider art of the nineteenth century. They play an important, if yet essential, role in the art and thought of the age.

George P. Landow, *2005*

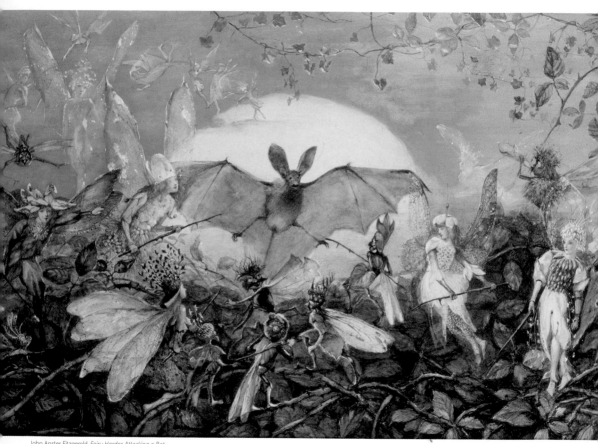

John Anster Fitzgerald, *Fairy Hordes Attacking a Bat*

Introduction

For the art-going public of the Victorian era, pictures of beautiful winged creatures were a familiar sight. Paintings of fairies, angels, cupids and cherubs filled the walls of exhibition galleries and museums. In theory, these pictures should have been very different, as they stemmed from fields that hardly seemed compatible – Christianity, pagan mythology and fantasy. In practice, though, the boundaries between these concepts had become rather blurred. It was just as acceptable to place a fairy on the top of a Christmas tree as it was to use an angel; in pantomimes, the fairy godmother had become the popular equivalent of a guardian angel; and one of the most famous statues of the day – Eros in Piccadilly – was given the nickname of a pagan god, even though it was meant to represent the Angel of Christian Charity.

In artistic terms, angels came from a far older tradition than fairies. They took their name from *angelos*, a Greek word for 'messenger', and derived some aspects of their appearance from the winged messenger-spirits of Assyrian sculpture. In the Old Testament they were usually described as male and wingless, and this is how they initially appeared in Christian art. Winged angels were derived partly from the Jewish antecedents of the cherubim (see page 232) and partly from the classical figures of Victory and Fame, both of whom were portrayed as winged women. At first, cherubs were shown as a head surrounded by three pairs of wings based on the descriptions in Ezekiel and Isaiah, but artists soon preferred to depict them as winged infants. The latter stemmed from classical images of *erotes* or *genii* – guardian spirits that accompanied a person throughout their life.

During the Renaissance, the links between Christian and Classical art became more entangled. Cupid, the god of love, was portrayed as a youth in certain themes, most notably his affair with Psyche. When he was shown with Venus, however, he was usually depicted as a child. In addition, both of these deities were occasionally accompanied by winged infants, who acted as their attendants. These infants are generally referred to as *putti* (literally 'little men') or *amoretti* ('little loves'). In purely visual terms, they are often indistinguishable from the cherubs that were featured in many religious paintings.

Classical themes remained popular in the nineteenth century, largely because they were promoted by the academies. These institutions based their education around the study of the nude human figure, encouraging their pupils to include it in suitably uplifting subjects – namely allegories and scenes from mythology, history or the Bible.

The distancing effect of these themes gave the nude an aura of respectability that was denied to more modern subjects. At the Paris Salon (France's official art exhibition) of 1863, for example, Alexandre Cabanel's *Birth of Venus* (see page 234) proved a resounding success. Yet, just two years later, Edouard Manet's *Olympia* – another reclining nude – caused an outrage at the same exhibition. The key distinction was that Manet's picture had no mythological trappings. The nude was set in a modern context and, as such, was deemed little better than pornography.

In Britain, some fairy painters benefited from a similar set of double standards. The nudes of John Simmons and his followers would have been far less acceptable without the fairy subject-matter. As it was, their mildly erotic content made the pictures highly saleable. One hint of this can be discerned from the fate of Millais' *Ferdinand Lured by Ariel* (see page 176). Prior to its completion, the artist had agreed to sell this picture to the dealer, William Wethered. The latter withdrew his offer, however, because the fairy elements were not sufficiently 'sylph-like' – in other words, not sufficiently erotic.

Throughout the nineteenth century, academic painting, with its Classical emphasis, was the art of the establishment. Increasingly, though, its position was challenged by newer and more adventurous movements. The most influential of these was Romanticism. The Romantics rebelled against reason and order, the values that had defined the Enlightenment. In their place, they extolled the virtues of emotion and individualism. They still looked to the past, but they preferred the evocative tales of Arthurian legend and medieval romance to the myths of the Classical world. In addition, they developed a taste for subjects that were wild, exotic or mysterious. The genre of fairy painting fell into this category.

In Britain, the Romantic era gave rise to a revival of interest in some of the neglected areas of the nation's cultural heritage, amongst them the druids, the Celts and the fairies. The latter had attracted the interest of a number of writers, but had made no appreciable impact on the visual arts. This changed quite suddenly, due to the enterprising spirit of John Boydell. During the eighteenth century, a number of artists, led by William Hogarth, had bemoaned the lack of a national school of painting. In particular, they resented the way that the most lucrative commissions were automatically granted to foreigners. Boydell decided to address this situation. He was rich, having made a fortune through his printselling business, and also had political clout (he became Lord Mayor of London in 1790). Using these dual assets, he commissioned the major artists of the day to produce paintings of Shakespeare's plays, displaying the results in a purpose-built gallery. Among the artists who contributed to this series were Henry Fuseli (see page 22) and Sir Joshua Reynolds, who produced fairy subjects drawn from *A Midsummer Night's Dream*.

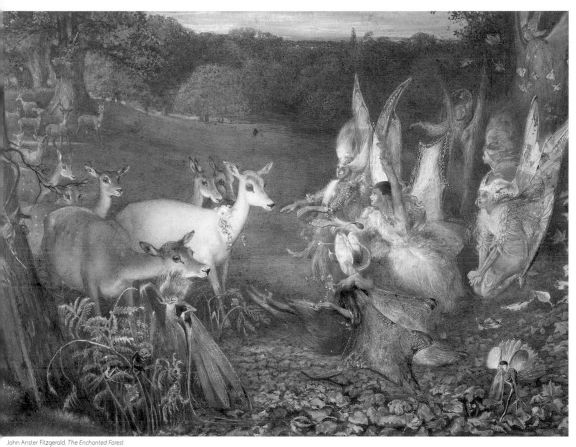

John Anster Fitzgerald, *The Enchanted Forest*

Fuseli was fascinated by folklore and the occult and, in his paintings, he explored the darker side of the fairy tradition. His interests were shared, to a greater or lesser degree by William Blake, Joseph Paton and David Scott. Similarly, the mental instability of Richard Dadd and Charles Doyle enabled them to bring fresh insights into a subject that was, after all, governed by fantasy and the irrational.

Despite all this, it was the theatrical associations of the subject that actually led to the biggest upsurge in fairy art. The spectacular effects in William Macready's staging of *The Tempest* (1838) and Lucia Vestris's version of *A Midsummer Night's Dream* (1840), coupled with the rise of fairy subjects in the ballet, left their mark on a generation of fairy painters. Daniel Maclise, Robert Huskisson and, prior to his illness, Richard Dadd, all produced paintings that resembled miniature stage sets. In particular, they reflected the latest advances in stage lighting. Gas-lighting was introduced in 1817, swiftly superseding the use of candles in most London theatres. Limelight was also developed at this time. Its brilliant flare could create a realistic impression of moonlight and, when used as a spotlight, it could bathe the principal characters in a radiant glow.

In John Fitzgerald, the fairy genre found its greatest innovator. His paintings owe little to literature, the theatre, or even folklore. Instead, he took the bold step of entering the tiny creatures' world and portraying them just as other fairies might

see them. More than any artist since Fuseli, he created his own fantasy world. His fairies are an alien species; sometimes sentimental, though they can also be cruel. Some of them look sweet, while others resemble insect-like demons. Fitzgerald stopped painting fairy scenes after the 1860s, perhaps because the market for this type of picture had dried up. From this time on, certainly, fairy subjects were increasingly confined to book illustrations. Richard Doyle's humorous illustrations started the trend, but it was the extravagant productions of

Arthur Rackham and Edmund Dulac that brought it to a splendid climax. As *The Times'* critic said of Rackham's *Peter Pan*: "the appeal again seems to be addressed to the drawing room, rather than the nursery... It will remain, we may be sure, 'downstairs', where, in fact, illustrations and text will both be best appreciated".

Even when the taste for fairy pictures declined, the tiny creatures remained obstinately in the public eye. In *Iolanthe* (1882), Gilbert and Sullivan used the framework of a fairy opera to poke fun at the House of Lords, as well as Queen Victoria's friendship with John Brown. *Peter Pan* (1904) proved a huge success on the London stage, while the controversy over the Cottingley fairies rumbled on for years. In 1917, two young girls claimed to have seen fairies near their Yorkshire home, producing photographs as evidence. Experts of every kind descended on Cottingley and the girls' claims were supported by no less a figure than Arthur Conan Doyle in *The Coming of the Fairies* (1922). The photos were eventually confirmed as fakes in the 1980s.

Like Tinker Bell herself, the fairy phenomenon has never quite disappeared. There are proprietary brands of soap and washing-up liquid named after a fairy – a reminder that good fairies liked to lend a hand with the

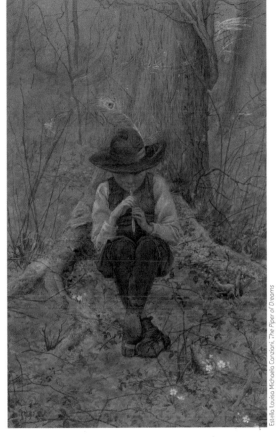

Estella Louisa Michaela Canziani, *The Piper of Dreams*

housework. Similarly, the Brownies (the junior branch of the Girl Guides) share their name with a helpful, Scottish fairy. More recently, the Dark Lords of Sith in the *Star Wars* films were inspired by a Celtic fairy (a *sith*), while the statue of *The Angel of the North* outside Newcastle is the latest manifestation of a guardian angel. Fairies and angels continue to fascinate people of all ages, and this book looks at some of the reasons for their enduring appeal.

John Atkinson Grimshaw, *Autumn – Dame Autumn Hath a Mournful Face*

Angels & Fairies

Movement
Overview

Fuseli, Henry

Titania and Bottom, c. 1790

In 1786 Fuseli was invited to a dinner, with a group of other artists, by John Boydell (1719–1804), the future Lord Mayor of London. There Boydell proposed the foundation of a Shakespeare Gallery, with contributions from the leading painters of the day. This picture was one of a number on Shakespearean themes that Fuseli created specifically for the project.

Titania and Bottom was inspired by the characters from *A Midsummer Night's Dream*, but does not illustrate any particular scene from it. Instead Fuseli used the subject as a launching pad for his own imagination, producing a far darker vision of fairyland than any devised by his Victorian successors. In the centre, in a pose borrowed from Leonardo's (1452–1519) Leda, Titania waves her wand aloft while her attendants lavish attention upon Bottom. Around them a macabre array of spirits loom out of the darkness. On the right, a woman holds a short old man on a leash, symbolizing the triumph of beauty over reason. Beside her a hooded night-hag displays a hideous changeling, which she will leave in the place of a stolen baby. On the left a group of monstrous children assemble, headed by a sinister little girl with butterfly wings for ears.

PAINTED IN

London

MEDIUM

Oil on canvas

SIMILAR WORKS

Oberon, Titania and Puck with Fairies Dancing by William Blake, c. 1785

King Lear in the Storm by Alexander Runciman, 1767

Henry Fuseli *Born* 1741 Switzerland

Died 1825

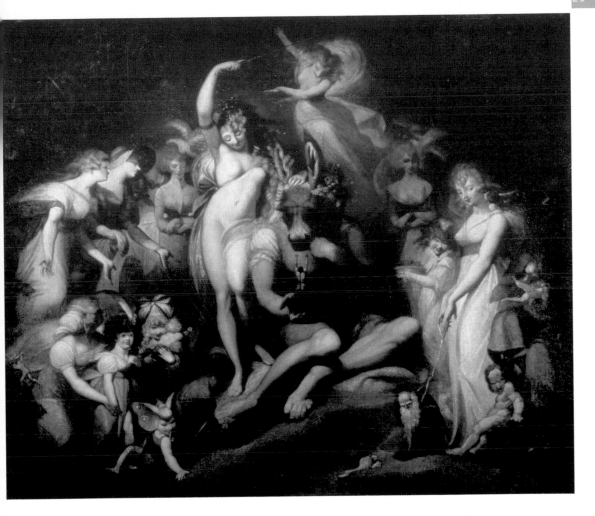

Maclise, Daniel

The Faun and the Fairies, c. 1834

Maclise produced this remarkable painting for the novelist, Edward Bulwer Lytton (1803–73), calling it *Pan and the Dancing Fairies*. The latter had it engraved and used it as an illustration in one of his works, *The Pilgrims of the Rhine* (1834), a curious book combining German folklore, travel writing and romance. More specifically he used it for a story entitled *The Complaint of the Last Faun*, which included a scene based on the painting. This described how the sylvan figure was persuaded to play his pipes, so that the fairies could begin their swirling dance. In the centre meanwhile, three hideous goblins loiter inside a cave. After the publication of the book the name of the picture was changed.

Although he forged his reputation as a history painter, Maclise also made a significant contribution to the development of the fairy picture. He exerted a powerful influence on several of the leading figures in this field, most notably Richard Dadd (1817–86) and Sir Joseph Paton (1821–1901). His work also found favour at the highest level. In 1844 Queen Victoria purchased *Undine*, Maclise's finest fairy painting, as a birthday present for Prince Albert.

PAINTED IN

London

MEDIUM

Oil on board

SIMILAR WORKS

The Visit at Moonlight by Edmund Thomas Parris, 1832

Fairy Lovers by Theodore von Holst, *c.* 1840

Daniel Maclise *Born* 1806 Cork, Ireland

Died 1870

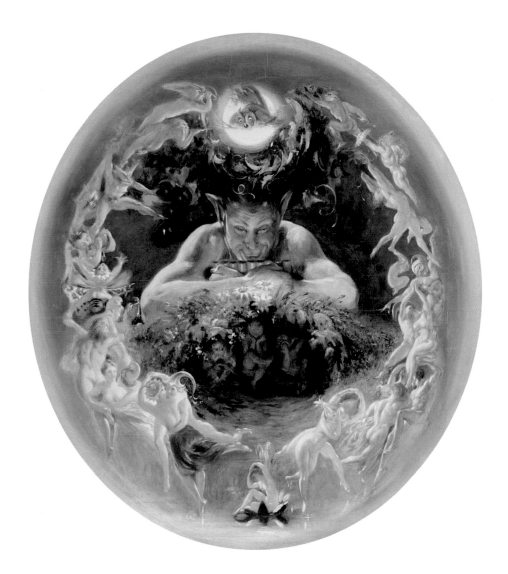

Rossetti, Dante Gabriel
The Annunciation, 1855

During the early days of the Pre-Raphaelite Brotherhood, Rossetti produced a series of paintings on the youthful Virgin Mary, which transformed the imagery of traditional religious painting. The conventional approach, typified by Fellowes-Prynne's version of the subject (see page 218), is combined here with the theme of the 'Girlhood of the Virgin'. Instead of depicting Mary as a sacred, otherworldly figure, Rossetti portrays her as a young girl going about her everyday business when she is surprised by the arrival of the angel Gabriel. Rossetti's treatment of the latter is not as revolutionary as in his *Ecce Ancilla Domini*, where the angel is shown without wings and with flames around his feet, but it is still unusual. Instead of proffering a lily to the virgin, Gabriel holds his arms outstretched, prefiguring the Crucifixion. The act of washing and the extensive use of white are both meant to emphasize the purity of the virgin. The profusion of flowers is symbolic of the fact that the Church calendar places the Annunciation in the spring, the birth of Jesus taking place nine months later in December. The picture's wooden mount features a number of biblical quotations, most notably, 'My Beloved is mine and I am his: he feedeth among the lilies' and 'Hail, thou are highly favoured: blessed art thou among women'.

PAINTED IN

London

MEDIUM

Watercolour

SIMILAR WORKS

Christ in the House of his Parents by Sir John Everett Millais, 1849

Dante Gabriel Rosetti *Born* 1828 London, England

Died 1882

Paton, Sir Joseph Noël

The Reconciliation of Oberon and Titania, 1847

© National Gallery of Scotland, Edinburgh, Scotland/www.bridgeman.co.uk

This *tour de force* was Paton's first major fairy painting. It illustrates a scene from Act IV of A *Midsummer Night's Dream*. Oberon has reversed the effect of the magic flower, ending his wife's infatuation with Bottom. Meanwhile Puck, the grinning youth with large ears pictured to the left of the tree, has just removed his ass's head. Oberon also places a charm on the sleeping Athenians, so that they are not awoken by the fairies' celebrations. These revelries are very varied, but will shortly come to an end. To the left, dawn is breaking and the fairies must depart.

Paton's picture is remarkable for the sheer wealth of detail, as fairies of all shapes and sizes swarm over the sleeping figures. He also made a significant innovation by adding a statue of Pan in the background. Pan was not only the Greek god of woods and fields, but also a personification of lust. This explains the many amorous figures in the scene, while also suggesting that Paton may have drawn some inspiration from earlier depictions of bacchanals. These wild scenes of celebration had been a favourite theme for artists such as Nicolas Poussin (1594–1665) and Titian (c. 1485–1576).

PAINTED IN

Edinburgh

MEDIUM

Oil on canvas

SIMILAR WORKS

Contradiction: Oberon and Titania by Richard Dadd, 1854–58

Sir Joseph Noël Paton *Born* 1821 Dunfermline, Scotland

Died 1901

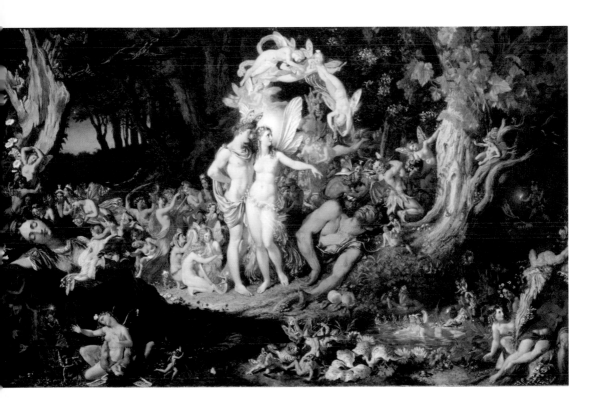

Dadd, Richard

The Fairy Feller's Master-Stroke, 1855–64

By common assent, this is the most complex and original of all fairy paintings. The spectator peers through a web of grasses, to witness the secret activities of a distinguished group of fairy folk. In the centre a fairy woodsman (the 'feller') raises his axe, to see whether he can split a hazelnut with one blow (a 'master-stroke'). He waits for the word from the white-bearded magician, who is running the show ("Except I tell you when, strike if you dare"). The other spectators include Oberon and Titania (above the magician), Queen Mab in her coach (on the brim of his hat), and figures from a nursery rhyme: soldier, sailor, tinker, tailor, ploughboy, apothecary, thief.

Dadd invented the subject himself, explaining the characters in a lengthy poem. He did not attempt to compose the scene, but "gazed at the canvas and thought of nothing, until pure fancy began to give form to the cloudy paint". There is no horizon, no logical sense of space and the fairies are painted in many different shapes and sizes. As a result, the picture seems airless and disorientating. The painting was not exhibited publicly until the 1930s. It was owned for a time by the poet Siegfried Sassoon (1886–1967), who donated it to the Tate Gallery in memory of three of Dadd's great-nephews, who had served with him in the trenches.

PAINTED IN

Bethlem Hospital, London

MEDIUM

Oil on canvas

SIMILAR WORKS

Work by Ford Madox Brown, 1852–63

Richard Dadd *Born* 1817 Kent, England

Died 1886

Doyle, Richard
The Fairy Queen's Carriage, 1870

This delightful scene comes from *In Fairyland: A Series of Pictures from the Elf World* by William Allingham (1824–89) and Andrew Lang (1844–1912), and is Doyle's most ambitious contribution to the field of fairy painting. Published in 1870, the book featured 36 coloured plates by the artist, accompanying William Allingham's verse text. Allingham probably had the harder job as, contrary to normal practice, the illustrations were completed first and he had the unenviable task of producing a series of poems that could match up to Doyle's flights of fancy.

Quite apart from the fairy elements, this picture is notable for the detailed landscape in the background. In common with many illustrators, Doyle yearned to gain acceptance in the upper echelons of the art world. Away from his work on books and magazines he tried his hand at landscape painting. Doyle based his style on that of the Idyllic school, a group of artists centred around Fred Walker (1840–75). In their paintings of rural life they abandoned the meticulous realism of Pre-Raphaelite landscapes, aiming for a more poetic effect. Doyle sent several of his landscapes to the Royal Academy, but the public and critical response to this facet of his work was disappointing.

PAINTED IN

London

MEDIUM

Colour-printed wood engravings

SIMILAR WORKS

The Fairy Balloon by Walter Crane

Richard Doyle *Born* 1824 London, England

Died 1883

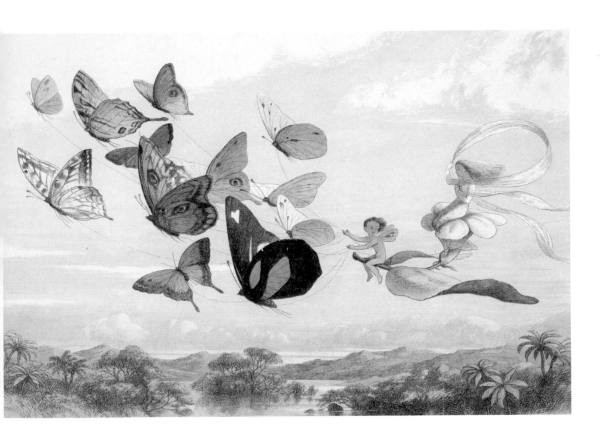

Dadd, Richard

The Haunt of the Fairies, c. 1841

Dadd painted two versions of this subject. The second picture, *Evening*, was roughly half the size of this one, but otherwise virtually identical. They are the least complicated of all Dadd's fairy paintings. As the sun begins to set a female fairy gathers flowers, which she weaves into a garland for her hair.

In the early 1840s Dadd produced a series of exquisitely painted, if fairly conventional, fairy pictures that established him as a leading figure in the field. His promising career was dramatically cut short, however, by the onset of mental illness. In 1843 Dadd embarked on a painting tour of the Middle East. There he worked in a frenzy, reducing himself to a state of nervous exhaustion. On his return he began suffering from delusions, believing that he was a servant of the god Osiris, charged with the task of exterminating demons. On 28 August 1843 he killed his father and fled to France. There he was arrested after trying to stab a second man and was sent back to England. Dadd spent the remainder of his life in mental institutions, initially at Bethlem Hospital in London and later at Broadmoor. He was allowed to continue painting, however, producing his greatest masterpieces during his confinement (see page 30).

PAINTED IN

London

MEDIUM

Oil on canvas

SIMILAR WORKS

Under the Sea I by Sir Joseph Noël Paton

Richard Dadd *Born* 1817 Kent, England

Died 1886

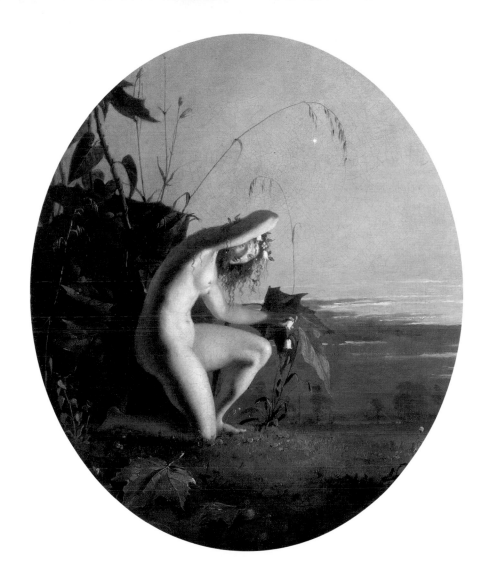

Huskisson, Robert

The Midsummer Night's Fairies, 1847

© Christie's Images Ltd

Huskisson exhibited this picture with an unwieldy title, which included a misquotation from *A Midsummer Night's Dream*: 'There sleeps Titania sometime of the night, / Lull'd in these flowers with trances (instead of 'dances') and delight...' The picture was shown at the Royal Academy in 1847 where it was warmly received. One critic even remarked that the painter was "destined to play a premier role in British art". This optimism must have seemed well founded when the picture was bought by Samuel Carter Hall, a highly influential figure in the art world.

In creating this picture Huskisson was undoubtedly influenced by Richard Dadd, who had exhibited his own version of the theme six years earlier (see page 150). As in that picture the spotlight is on Titania, who reclines in her bower in a pose borrowed from Giulio Romano's (*c.* 1499–1546) *Sleeping Psyche*. Behind her, the gigantic figure of Oberon lurks in the shadows, while Puck flies towards the fairy queen ready to anoint her eyes with the magic juice. In the foreground, tiny elves protect Titania by doing battle with a snail and a spider. The most original feature is the painted arch, which features the figures of Bottom and the Athenian lovers who lie sleeping, perhaps even dreaming the action that is taking place behind them.

PAINTED IN

London

MEDIUM

Oil on panel

SIMILAR WORKS

Titania Sleeping by Richard Dadd, 1841

Musidora by William Etty, 1846

Robert Huskisson *Born* 1819 England

Died 1861

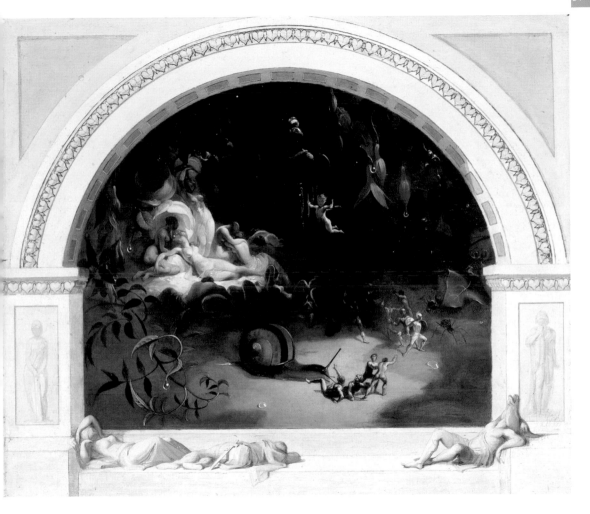

Grimshaw, John Atkinson
Iris, 1876

Grimshaw painted several nearly identical versions of this picture in the 1870s and 1880s (see pages 270 and 274). Here the subject is Iris, the goddess of the rainbow. According to Greek mythology she was the daughter of Pontus (the Sea) and Oceanus (the Ocean) and was therefore closely associated with water. Her main function, however, was as a messenger of the gods, taking orders primarily from Hera. In fulfilling these duties she used the rainbow as a bridge between the heavens and earth.

There is also a separate legend that links the creation of the rainbow to an act of disobedience. At the start of one autumn, Iris was sent down to wither the plants to mark the change of season. As she was carrying out this task, however, she stopped to admire a fine array of water lilies and forgot her instructions. As a punishment for this she herself was transformed into a rainbow. Grimshaw probably had this tale in mind when he produced his various depictions of the goddess. The vegetation in the foreground usually looks singed and withered (see page 270), indicating that she had at least begun her task, while Iris herself glows mysteriously, as if in the grip of a transformation. In addition, the entire scene is bathed in autumnal shades of brown and gold.

PAINTED IN

Knostrop Old Hall, near Leeds

MEDIUM

Oil on canvas

SIMILAR WORKS

The Marsh Flower by Odilon Redon, *c.* 1885

John Atkinson Grimshaw *Born* 1836 Leeds, England

Died 1893

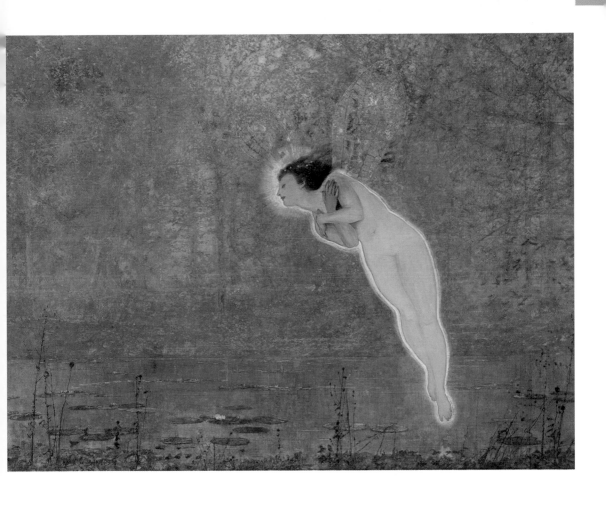

Burne-Jones, Sir Edward Coley
Rainbow Fairy, c. 1890

This tiny watercolour comes from the *Flower Book*, a private project that absorbed the artist in his later years. The book contains 38 circular paintings each representing a single flower. The individual blooms do not appear in these pictures; instead they are evoked through mysterious allegories. In some cases these take the form of elaborate puns, similar to Meteyard's *Love in Idleness* (see page 78). Burne-Jones began the series in 1882 when he created *Love-in-a-Mist* (the fennel flower), depicting the figure of Love in a misty landscape. Most of the titles have similarly evocative names, such as *Love in a Tangle, Black Archangel* and *Most Bitter Moonseed*. Here the rainbow is probably a reference to the iris, since this took its name from the goddess of the rainbow (see page 38).

Burne-Jones produced the *Flower Book* primarily for his own amusement, giving full rein to his imagination. As a result the pictures have a strong Symbolist flavour, with more emphasis placed on poetic mood than meaning. The painter eventually gave the book to his wife, Georgiana, who described it as "the most soothing piece of work that he ever did". The format was to prove influential, giving rise to other flower books such as those by Cicely Mary Barker (1895–1973).

PAINTED IN

Rottingdean or London

MEDIUM

Watercolour

SIMILAR WORKS

Autumn by Frances MacDonald

Sir Edward Coley Burne-Jones *Born* 1833 Birmingham, England

Died 1898

Zuber-Buhler, Fritz
The Spirit of the Morning

© Sotheby's Picture Library

The vogue for fairy paintings did not extend far beyond the shores of Britain and Ireland. When Continental artists tackled the subject they did not usually relate it to local folk traditions; instead they tended to use the fairy trappings as decorative, fantasy elements. Fritz Zuber-Buhler was a Swiss painter born in Le Locle, who spent much of his career in France. He trained at the Ecole des Beaux-Arts and the Berlin Academy before living for a brief spell in Rome from 1848–49. He went on to become a regular exhibitor at the Salon, showing his work there between 1850 and 1877. Zuber-Buhler painted in a fresh, naturalistic style, tinged with sentimentality. In common with Sophie Anderson (see page 52), many of his pictures are of young women, often in regional dress. He also depicted prettified rural scenes and images of mothers with their children.

PAINTED IN

Paris

MEDIUM

Oil on canvas

SIMILAR WORKS

Three Women in Church by Wilhelm Leibl, 1878–81

Fritz Zuber-Buhler *Born* 1822 Le Locle, Switzerland

Died 1896

Paton, Sir Joseph Noël

How an Angel Rowed Sir Galahad Across Dern Mere

Paton painted at least three pictures on the subject of Sir Galahad, the others being *Sir Galahad and his Angel* and *Sir Galahad's Vision of the Sangreal*. The theme had a particularly strong appeal for him, as it combined his passionate interest in romantic medievalism with his personal commitment to the Christian faith. Paton's fascination with the Middle Ages came partly from his father, who had worked as a fabric designer but became engrossed in antiquarian matters, and partly from the novels of Sir Walter Scott (1771–1832). The most tangible evidence of this fascination could be found at Paton's home, where he amassed a most remarkable collection of arms and armour. He had inherited a few pieces from his father, but as soon as his career took off he began buying in earnest. The collection was so impressive that it was eventually acquired by the National Museum of Scotland. Inevitably Paton was keen to introduce aspects of his hobby into his work. In addition to his Arthurian subjects, armour appears in a number of religious, allegorical and genre pictures. In *The Choice* an armoured knight is torn between the attractions of an angel and a seductive sorceress, while *I Wonder Who Lived in There is* a charming depiction of the artist's son, staring into an empty helmet.

PAINTED IN

Edinburgh

MEDIUM

Oil on canvas

SIMILAR WORKS

The Achievement of the Grail Quest (tapestry) by Sir Edward Coley Burne-Jones, 1892–95

Sir Joseph Noël Paton *Born* 1821 Dunfermline, Scotland

Died 1901

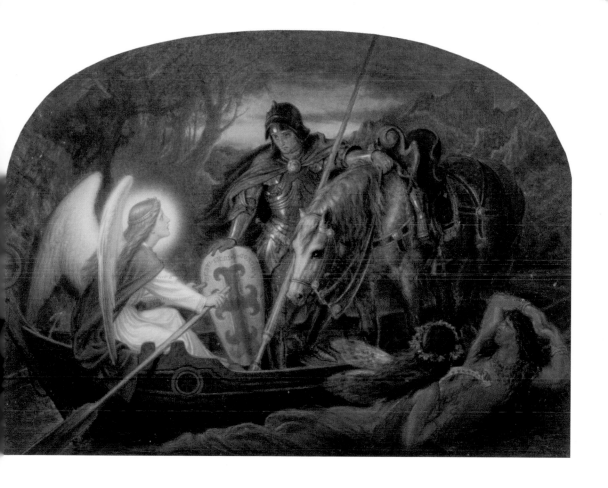

Simmons, John

Flying Fairy

A native of Bristol, Simmons was trained as a miniaturist and earned his living primarily as a portraitist. During the 1860s, however, he found a profitable niche market producing fairy pictures. Most of these followed a set pattern: a moonlit scene with a mildly erotic female nude, posing amidst an array of giant flowers. Simmons often gave these pictures Shakespearean titles, although any links with the plays are purely nominal. His work has sometimes been described as pornographic, although tellingly this criticism has largely come from modern critics, rather than Simmons' contemporaries.

Nude paintings could be controversial in the Victorian era. Some commentators felt that displays of this kind were alien to the Anglo-Saxon temperament. In 1867, for example, a critic in the *Art Journal* proclaimed that, "The French do not even pretend to delicacy. Our notions, fortunately for the morals of our people, and certainly for the good manners of society, happen to be different, and so English pictures are for the most part decently draped." Despite this it is worth remembering that Lord Frederic Leighton (1830–96), Sir Edward Poynter (1836–1919) and Sir Lawrence Alma-Tadema (1836–1912), three of the leading figures of the English art establishment, were all renowned for their portrayal of the nude.

PAINTED IN

Bristol

MEDIUM

Watercolour and gouache on paper

SIMILAR WORKS

Tepidarium by Sir Lawrence Alma-Tadema, 1881

John Simmons *Born* 1823 Bristol, England

Died 1876

Munier, Emile
Le Sauvetage ('The Rescue'), 1894

© NYC Christie's Images Ltd

Sentimental pictures of young children were extremely popular in the late nineteenth century, whether in a domestic setting or in the guise of figures from the past. Here, two youngsters are portrayed as mischievous cupids. They have been larking about near the river and a quiver of arrows has fallen in the water. A second quiver is visible at the left-hand side of the picture.

Munier's father was an upholsterer and at the start of his career he followed a similar path, working at the Gobelins, a famous tapestry factory. He switched to painting after becoming interested in the work of François Boucher (1703–70), a Rococo artist who had produced designs for the Gobelins. He was also inspired by the example of William Adolphe Bouguereau (1825–1905) (see page 50), who became his friend and mentor. The latter nicknamed him '*sage* Munier' ('Munier the wise'). He adopted the same highly polished style as Bouguereau, although his subject matter was quite different – by the 1880s he was specializing in paintings of children and animals. Munier's two children, Henri and Marie-Louise, served as models for many of these pictures. His most successful work in this vein was *Three Friends*, featuring a child, a kitten and a dog, which became famous after Pears Soap used it in one of their advertising campaigns.

PAINTED IN

Paris

MEDIUM

Oil on canvas

SIMILAR WORKS

A Summer's Day by William Stott

Emile Munier *Born* 1840 Paris, France

Died 1895

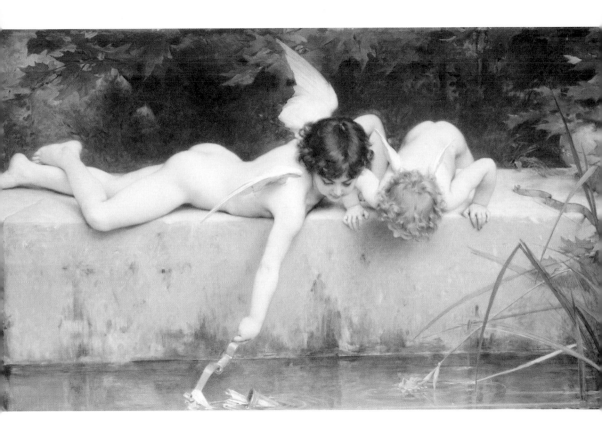

Bouguereau, William Adolphe
L'Innocence, 1890

Towards the end of the nineteenth century there was a vogue for portraying allegorical pictures of young women. In most cases artists preferred to depict the most extreme forms of behaviour. Either the women were paragons of virtue, as in this case, or they were manifestations of evil, represented by a *femme fatale*. Here, the subject is Innocence. Her purity is symbolized by her white dress. She also resists temptation by ignoring the two cherubs, who are trying to whisper thoughts of love into her ears.

In many ways, Bouguereau was the archetypal establishment figure in the French art world. He won the *Prix de Rome* in 1850, the award most coveted by young academic artists, and for almost 30 years (1876–1905) he was on the governing body of the Académie des Beaux-Arts. This institution had enormous influence, organizing the exhibitions at the Salon, supervising education and advising on state commissions. By reputation it was fiercely conservative, opposing the Impressionists and most other avant-garde trends. Paul Cézanne (1839–1906), for example, expressed his regret at being barred from the 'Salon of Monsieur Bouguereau'. As a bastion of authority, Bouguereau's reputation plummeted after his death, although critics have acknowledged his technical skill.

PAINTED IN

Paris

MEDIUM

Oil on canvas

SIMILAR WORKS

The Kiss by Carolus-Duran (pseudonym of Charles-Emile-Auguste Durand), 1868

William Adolphe Bouguereau *Born* 1825 La Rochelle, France

Died 1905

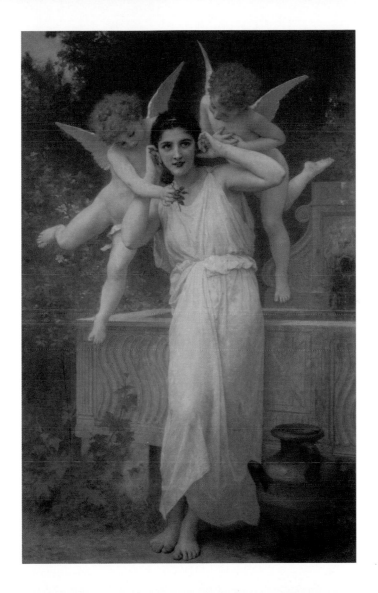

Anderson, Sophie

Thus Your Fairy's Made of Most Beautiful Things

The title of this work refers to a verse by Charles Ede:

> Take the fair face of woman, / and gently suspending./ With butterflies, flowers and / jewels attending,
>
> Thus your fairy is made of / most beautiful things.

By the mid-Victorian period, fairy painting was so much in vogue that it had become something of a bandwagon. Artists from other fields added a few fairy trappings to their work to give it a topical flavour. Anderson specialized in paintings of children, with a particular preference for young girls. A few of these have fairy accessories, although it is unclear whether they were meant to represent fairies or were simply girls in fairy costume. In some of Anderson's other pictures, for example, there are girls wearing butterfly hair pins, who are definitely human. Either way this is certainly the finest of her fairy pictures. It was exhibited at the Royal Society of British Artists in 1869.

Anderson was born in France, the daughter of a French architect and an English mother. After the 1848 Revolution the family fled to the United States, residing mainly in Pittsburgh and Cincinnati. While there she forged a successful career as a portraitist, which she cemented after moving to England in 1854. She married an English artist, Walter Anderson.

PAINTED IN

London

MEDIUM

Oil on canvas

SIMILAR WORKS

Anna and Agnes Young by Emma Sandys, 1870

Sophie Anderson *Born* 1823 Paris, France

Died 1903

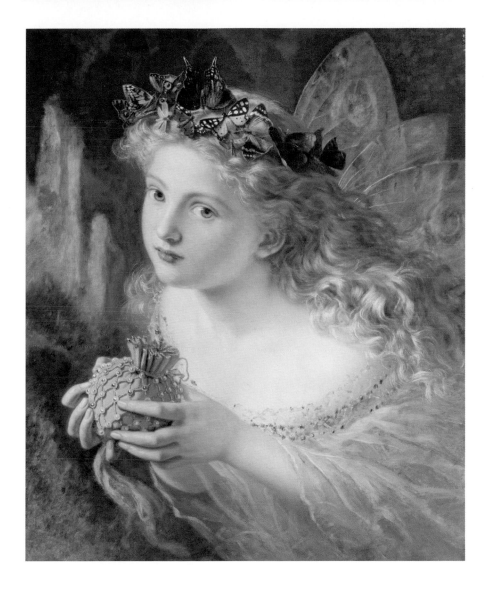

Bouguereau, William Adolphe
The Annunciation, 1888

The Annunciation is one of the central images in the Christian faith, wherein the archangel Gabriel appears before Mary and informs her that she will bear a son and that she is to name him Jesus. The event is principally related in the Gospel of St Luke, although artists often borrowed further details from the Apocrypha or the *Golden Legend*, a medieval anthology of Christian material. The Feast of the Annunciation, also known as Lady Day, is celebrated on 25 March.

Usually Mary and Gabriel are shown facing each other, with the virgin often displaying some surprise at the sudden appearance of the angel. This natural human reaction is notably absent from Bouguereau's austere version of the subject. The figures face the spectator, but their gaze is downcast. Both are absorbed in the spiritual significance of the event and pay no heed to their material surroundings. The traditional symbols of the Annunciation are lined up in the foreground, instead of being integrated into the scene. The spinning wheel and the basket of wool allude to the virgin's upbringing in the Temple of Jerusalem, where tradition has it that she was given the task of making vestments for the priests. The flowering shrub emphasizes that the Annunciation took place in the springtime.

PAINTED IN

Paris

MEDIUM

Oil on canvas

SIMILAR WORKS

The Vow of Louis XIII by Jean-Auguste-Dominique Ingres, 1820

William Adolphe Bouguereau *Born* 1825 La Rochelle, France

Died 1905

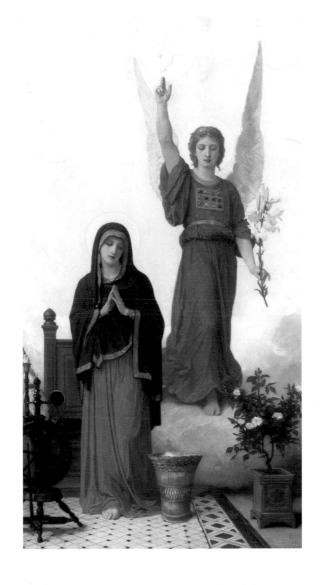

Fitzgerald, John Anster

Fairy Twilight

Fitzgerald ushered in a new phase in fairy painting. He removed the theatrical overtones of the subject, which had been predominant in the 1840s, opting instead to show the fairies in a rustic setting, co-existing with other woodland creatures. Often these animals appear very static, suggesting perhaps that the artist was influenced by the Victorian taste for stuffed animals. There was a particular vogue for arranging these into imaginary tableaux, but the trend also extended into other media. Some landscape photographers, for example, used stuffed animals to overcome the limitations of their equipment, which was too slow to capture animals in motion. One of the pioneers in this field was John Dillwyn Llewelyn (1810–82). His wife wrote to a friend that he was "very busy making pictures of stuffed animals and birds with an artificial landscape, in real trees, shrubs, flowers and rocks… ". Llewelyn had close links with the art world, as he was a member of the Royal Society of Arts and won a medal at the Paris Exposition Universelle of 1855, his pictures influencing a number of painters. It is quite feasible that Fitzgerald knew of his landscapes with stuffed rabbits, which were produced in the early to mid-1850s.

PAINTED IN

London

MEDIUM

Watercolour

SIMILAR WORKS

Rabbit (photograph) by John Dillwyn Llewelyn, 1850s

After Sunset by William J. Webbe

John Anster Fitzgerald *Born* 1832 London, England

Died 1906

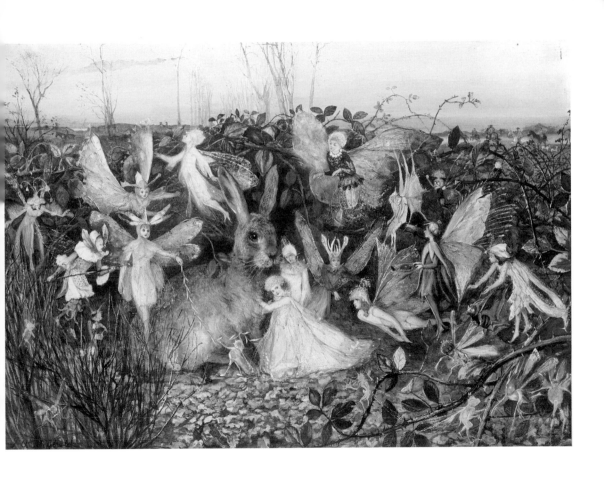

Perrault, Léon Jean Basile

Cupid's Arrows, 1882

© Sotheby's Picture Library

From an early stage, Cupid was traditionally depicted with a bow and a quiver of arrows. The latter had long been used to represent any unseen phenomenon that struck out of the blue. In particular, arrows were linked with sickness and the plague. Cupid's weapons also denoted strength. Artists sometimes showed the young deity carving his bow out of one of Hercules' clubs. This was meant to emphasize the overwhelming power of love.

Cupid's bow and arrow were first mentioned by Euripides (*c.* 485–406 BC), and later Ovid (43 BC–AD 17) specified in his *Metamorphoses* that the god employed two different types of arrow. The better-known variety, which kindled love, was made out of gold, but on rare occasions he also made use of lead arrows, which produced the opposite effect. These featured in the myth of Daphne and Apollo. Foolishly, the latter once teased Cupid for playing with weapons that were better suited to a grown warrior. The youngster took his revenge by shooting a golden arrow into Apollo and a lead one into the object of his affections, a nymph called Daphne. She was so repulsed by the deity that she begged to be turned into a tree, rather than submit to Apollo's embraces.

PAINTED IN

Paris

MEDIUM

Oil on canvas

SIMILAR WORKS

Bubbles by Sir John Everett Millais, 1886

Le Petit Nemrod by James Tissot

Léon Jean Basile Perrault *Born* 1832 Poitiers, France

Died 1908

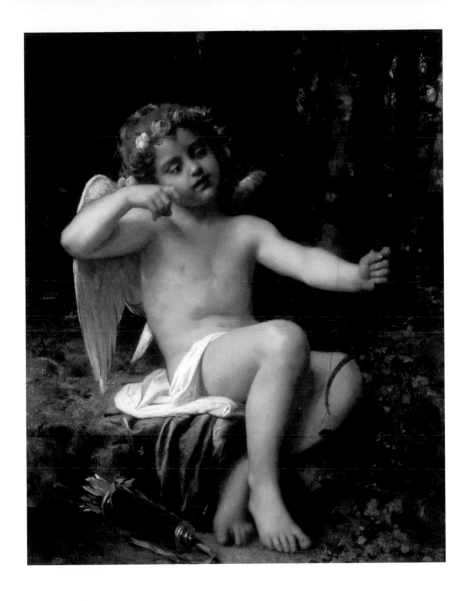

Fitzgerald, John Anster
Cock Robin Defending his Nest

Robins appear frequently in Fitzgerald's paintings, usually as the victims of fairy malice. Occasionally these pictures refer to the children's nursery rhyme about Cock Robin (see page 126), but most of the subjects came from the artist's own imagination. These showed the robin under attack, defending his nest or even as a prisoner of the fairies. The choice of bird would have seemed particularly shocking to Fitzgerald's contemporaries. The robin redbreast was very popular with the British public, often appearing on Christmas cards after these were invented in 1843. The bird was thought to be well disposed towards humans. According to an old tradition, robins would cover a corpse with moss and flowers if they found one lying in a forest. There was also a Christian connection, in that the bird is said to have gained its red markings when, during the Crucifixion, it plucked one of the barbs from the crown of thorns, spilling a drop of Christ's blood on its breast. Significantly, in Fitzgerald's picture, the fairies are attacking the robin with thorns. It was deemed unlucky to kill a robin or steal its eggs, and if a farmer did so his cows would yield blood in their milk. Otherwise the usual penalties were a broken limb or uncontrollable trembling.

PAINTED IN

London

MEDIUM

Oil on canvas

SIMILAR WORKS

Fairies Among Mushrooms by Thomas Heatherley

John Anster Fitzgerald *Born* 1832 London, England

Died 1906

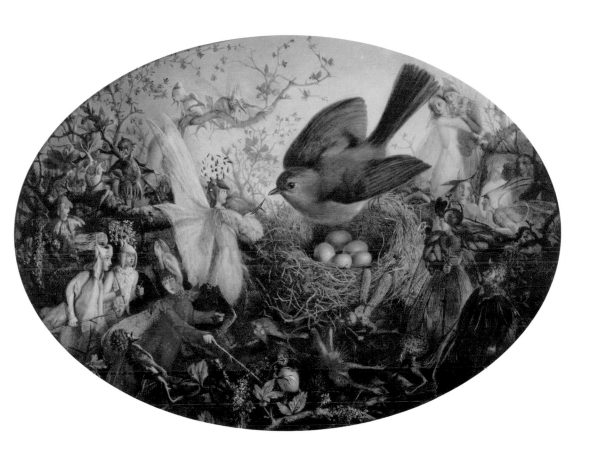

Makowsky, Constantin
The Toilet of Venus

This subject had been in circulation since the Renaissance, becoming particularly popular in Venice. It survived into the nineteenth century largely because the subject matter was so vague. It was not attached to any specific story from mythology, so artists tended to use it as a pretext for producing a decorative picture of a female nude. Traditionally in a Toilet of Venus, the nude was shown reclining, but in Makowsky's version the goddess is enthroned, a pose normally reserved for a Triumph of Venus.

The goddess is accompanied by several of her attributes. The most common of these is the mirror, a conventional symbol for vanity or lust. In Renaissance allegories Venus was often portrayed as a personification of lust, although later artists preferred to link her with *voluptas* or 'pleasure'. As usual she is surrounded by *amoretti* (the diminutive form of *amor* or 'love'), and these chubby figures act as playful reminders of the identity of the goddess. Amidst the profusion of flowers there are many roses, a plant that was sacred to Venus. The inclusion of a peacock in such a prominent position is a surprise, since the bird was traditionally associated with the goddess Juno. Here it may represent Pride.

MEDIUM

Oil on canvas

SIMILAR WORKS

The Slave Merchant by Victor-Julien Giraud

Constantin Makowsky *Born* 1839 Russia

Died 1915

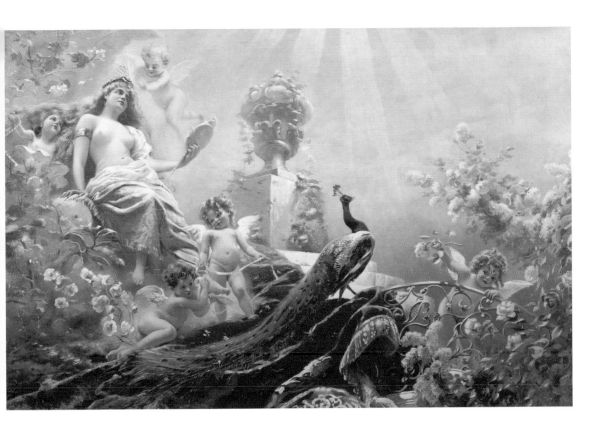

Crane, Walter

Costumes for Elves and Fairy Painters, 1899

By the later stages of the nineteenth century, fairies were so much in vogue that they were used to satirize the major institutions of the day. Even Queen Victoria was affectionately known as 'the Faery' by her prime minister. These costumes were designed by Crane for *The Snowman*, a type of pantomime that was staged at the Lyceum Theatre in December 1899. Several members of the Art Workers' Guild were involved in the show, in which they poked fun at the current art scene. The figure on the left, holding the palette and the sketching board, is one of the fairy painters. On the right his model represents Aestheticism, a literary and artistic movement that was epitomized by the dandyish figures of Oscar Wilde (1854–1900) and James McNeill Whistler (1834–1903). The lily in her left hand and the peacock motif on her dress were the favourite emblems of the group, while the mirror in her right hand echoed the general public's belief that the Aesthetes were highly narcissistic. The Art Workers' Guild had been formed in 1884 as a means of bringing about closer co-operation between the various branches of the decorative arts. This was parodied in the finale of *The Snowman*, when fairy architects jostled with fairy potters, weavers and carpenters.

PAINTED IN

London

MEDIUM

Watercolour on paper

SIMILAR WORKS

The Victory (embroidery) by Phoebe Traquair, 1893–1902

The Awakening of Cuchullin by John Duncan

Walter Crane *Born* 1845 Liverpool, England

Died 1915

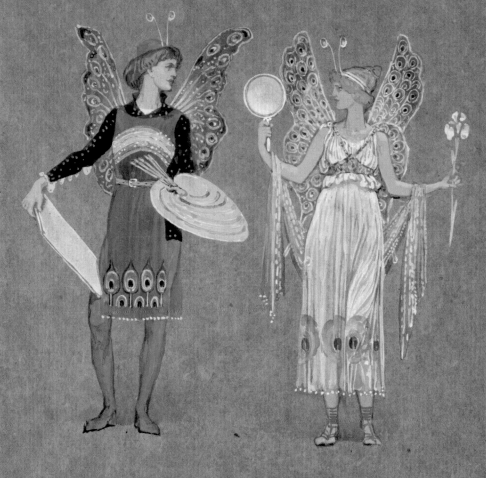

 ELVES: FAIRY-PAINTERS

Seignac, Guillaume

L'Amour Désarmé ('Cupid Disarmed')

This light-hearted scene illustrates the way that mythological subjects were popularized for the general market. Cupid is shown in the guise of a naughty infant, who has been causing trouble with his bow and arrow. As a result, Venus has decided to confiscate the weapons and attempts to conceal them behind her back. Seignac's picture is in a conventional academic style, although the frivolous mood is more reminiscent of the Rococo period a century earlier.

As a theme, the punishment of Cupid has a long pedigree. Over the years many of the Classical gods were featured in the scene, although Venus, as Cupid's mother, was usually the figure of authority. Sometimes she pulls the weapons away from the boy, while elsewhere she threatens to chastise him with a bunch of roses. Cupid's amorous escapades also aroused the anger of Diana, the chaste goddess of the hunt. On some occasions her nymphs were pictured in the act of breaking or burning the arrows while the child lay sleeping. Mars, the god of war, was also depicted in a similar vein, often trying to clip the infant's wings. His attempts at discipline were sometimes thwarted, however, as artists tried to combine the punishment with the equally popular theme of love overcoming strife.

PAINTED IN

Paris

MEDIUM

Oil on canvas

SIMILAR WORKS

The Old Soldier by George Adolphus Storey

Guillaume Seignac Born 1870 France

Died 1924

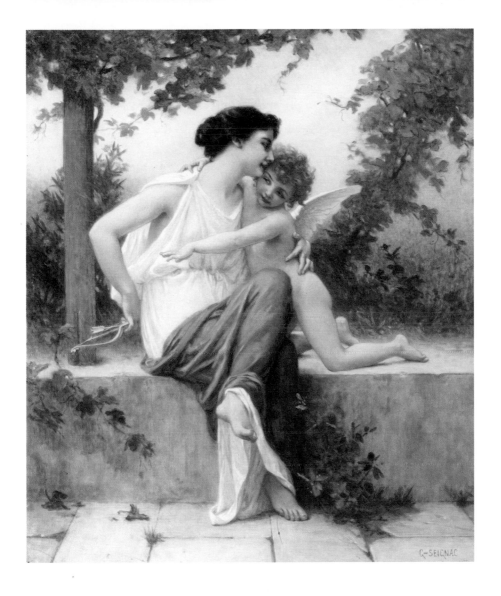

Cole, Herbert
Father Time, 1906

This illustration was produced by Herbert Cole for *Fairy-Gold: A Book of Classic English Fairy Tales* (1906) by Ernest Rhys (1859–1946). Cole was a prolific illustrator of magazines and children's books. He is probably best remembered for his work on the 1900 edition of *Gulliver's Travels* and the 1903 version of *The Ingoldsby Legends*. Ernest Rhys was a distinguished writer, who was born in London but brought up in Carmarthen. He worked for a time in the coal industry before turning to literature. In 1885 he moved to London, where he became a founder member of the Rhymers' Club, a group of poets who met in the Cheshire Cheese in Fleet Street. His most lasting achievement was as the founding editor of the Everyman's Library series of affordable classics.

Folk beliefs about the fairies' attitude to time and death are very varied. Some sources argued that fairies could not fear death, since they themselves were actually the spirits of the dead who had not been baptized. Others believed that they did not actually die, but gradually dwindled away, shrinking a little every time they used their shape-shifting skills.

PAINTED IN

London

SIMILAR WORKS

Democracy Enthroned by Edmund J. Sullivan

Herbert Cole *Born* 1867 London, England
Died 1930

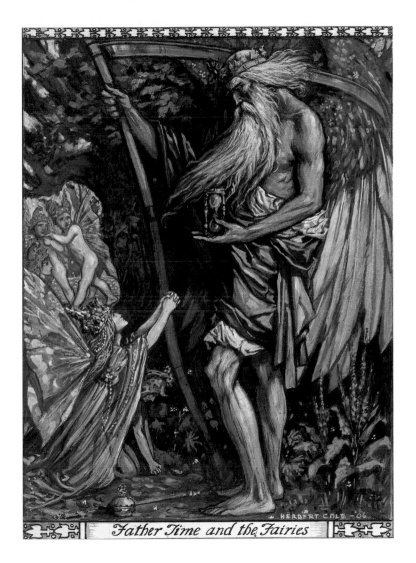

Father Time and the Fairies

Rackham, Arthur

A Midsummer Night's Dream, 1908

In 1936 an American publisher asked Rackham which of William Shakespeare's (1564–1616) plays he would prefer to illustrate. In response, the artist sent him a short list, emphasizing that *A Midsummer Night's Dream* would certainly be his first choice. In the event, Rackham produced illustrations for no fewer than four different editions of the work. In 1899 he provided two pictures for a version of *Lamb's Tales* from Shakespeare, and in 1908 the finest and most influential set of designs appeared in the Heinemann edition. A third collection was commissioned in 1928 by the New York Public Library, and finally in 1936 Rackham produced a new set of pictures for George Macy of the Limited Editions Club.

The sumptuous 1908 book went down extremely well with the public. Three months after publication the entire de luxe edition had sold out, along with more than half of the trade copies. The reviews were glowing. "This is the handsomest version of *A Midsummer Night's Dream* we have ever handled", wrote one critic, while another described it as "a delightful land of make-believe". As always, the only problem was that the illustrations were clustered together at certain points of the text. Rackham always chose the lines that he wanted to depict, so on this occasion he produced five images for 26 consecutive lines of text, describing the fairy interlude in Act II.

PAINTED IN

London

MEDIUM

Pen, ink and watercolour

SIMILAR WORKS

King Gab's Story Bag by Walter Crane

Arthur Rackham *Born* 1867 London, England

Died 1939

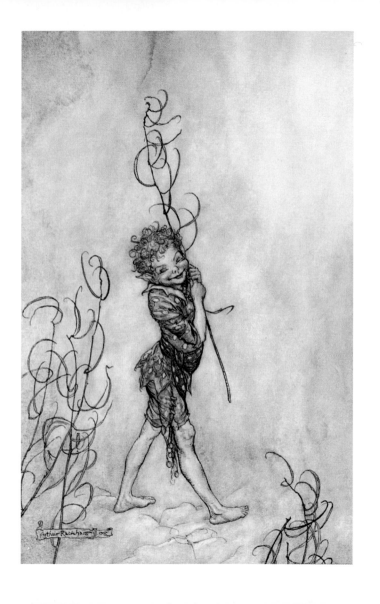

Robinson, Charles

Cherub on a Branch in the Rain, 1911

© Charles Robinson/Sotheby's Picture Library

This is one of a series of pictures that Robinson produced as illustrations for *The Sensitive Plant* (1820), a poem by Percy Bysshe Shelley (1792–1822). In it, Shelley traced the progress of a mimosa or 'sensitive plant' throughout the course of a year, from its vernal freshness to its autumnal decay. Shelley used these changes as a metaphor for his own melancholy reflections on love. The sensitive plant gained its nickname because it seemed to droop and wither when touched, but opened up again when left alone.

Charles Robinson was one of the leading illustrators of his time, even though he has since been overshadowed by his younger brother, William Heath Robinson (1872–1944), famed for his humorous drawings of eccentric machinery. Charles established his reputation with a series of illustrations for the 1896 edition of Robert Louis Stevenson's (1850–94) *A Child's Garden of Verses*. After this he was commissioned to illustrate a range of children's books by such authors as A. A. Milne (1882–1956), Lewis Carroll (1832–98) and Hans Christian Andersen (1805–75). Robinson's style was highly versatile. His pen and ink drawings recalled the work of Aubrey Beardsley (1872–98), while his watercolours were both rich and subtle. He also benefited enormously from belonging to the first generation of artists whose work could be reproduced by photo-mechanical means.

PAINTED IN

London

MEDIUM

Watercolour

SIMILAR WORKS

Uncle Lubin by William Heath Robinson, 1902

Charles Robinson *Born* 1870 London, England

Died 1937

Murray, Amelia Jane (Lady Oswald)

A Fairy Standing on a Moth While Being Chased by a Butterfly

© Christie's Images Ltd

Amelia Murray was one of the first artists to ignore the more threatening elements of fairy folklore, portraying the creatures as dainty and diminutive. She developed an interest in the subject at an early age, largely because of her background. She was born on the Isle of Man, in an area steeped in ancient, Celtic traditions (her birthplace was said to mean 'fairy music' in Gaelic). From childhood these tales were a source of endless fascination to her, inspiring her to begin painting fairies from the 1820s.

From her precisely drawn studies of flowers and insects, it is clear that Murray also took an interest in contemporary books and periodicals on natural history. These were not as far removed from fairy matters as might be imagined. In a bid to popularize their subject, authors would sometimes introduce fantasy elements. In *Fairy Frisket, Or Peeps at the Insect Folk*, a children's guide to the insect world, the narrators are two fairies. Similarly in *Episodes of Insect Life* (1849–51), a more adult book on the same subject, there are detailed illustrations of spiders and beetles, accompanied by whimsical little fairies dressed in tiny suits of armour.

PAINTED IN

Isle of Man

MEDIUM

Watercolour and pencil

SIMILAR WORKS

Frontispiece to *The Population of an Old Pear Tree* by Ernest Van Bruyssel, 1871

Amelia Jane Murray, Lady Oswald *Born* 1800 Port-e-Chee, Isle of Man

Died 1896

Brickdale, Eleanor Fortescue
Angel at the Door, 1930

Brickdale painted both fairies and angels, frequently placing them in a medieval context or using them to illustrate a romantic tale. Here, an angel comes to the door of a rich household begging for alms. The occupant is so suspicious, however, that she only opens the door a little way. As a result she fails to notice the angel's wings, along with the crown in his hand.

During the nineteenth century and beyond, there was a ready market for paintings of children dressed up as beggars. The Victorians did not invent this kind of picture – Thomas Gainsborough (1727–88) and Sir Joshua Reynolds (1723–92) both produced pictures featuring similar ragamuffins, but it was the Victorians who embraced the subject with enthusiasm. Their street urchins were, in a sense, the urban equivalent of the eighteenth-century taste for dressing up as shepherds and shepherdesses. So when Lewis Carroll came to photograph Alice Liddell (the model for his Alice in Wonderland), he dressed her up as a beggar girl even though she came from a prosperous family. The idea of viewing poverty as picturesque may seem strange to modern eyes, particularly given the scale of the problem. When the philanthropist Charles Booth produced his massive 17-volume study, *Life and Labour of the People in London* (1903), he discovered that over 30 per cent of the city's inhabitants were living below the poverty line.

PAINTED IN

London

MEDIUM

Watercolour with body colour

SIMILAR WORKS

Alice Liddell as a Beggar-girl (photograph) by Lewis Carroll

Eleanor Fortescue Brickdale *Born* 1871 London, England
Died 1945

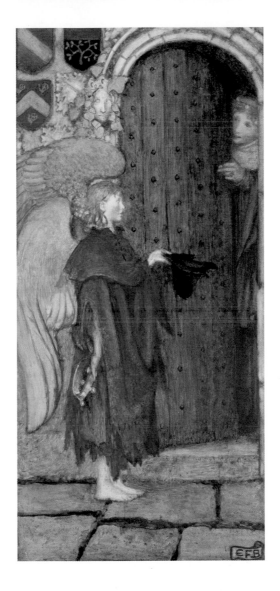

Meteyard, Sidney Harold

Love in Idleness

Meteyard's depiction of Cupid marks a significant departure from the Victorian norm. In place of the customary pretty infant he portrays the deity as a sulky teenager reclining lazily on a couch, with his bow and arrows deposited untidily on the floor. In fact, the painting is an elaborate pun, as love-in-idleness is also the popular name of a plant, also known as the pansy. This flower was closely associated with Cupid. In *A Midsummer Night's Dream*, Oberon instructed Puck to seek it out, because it had magical properties. When its juice was sprinkled on the eyelids of someone who was asleep, it would cause them to dote on the first person they saw after they awoke. The pansy had acquired this power after one of Cupid's arrows missed its target and struck it. As Oberon explained:

Yet marked I where the bolt of Cupid fell: / It fell upon a little western flower,

Before, milk-white; now purple with love's wound: / And maidens call it 'love-in-idleness'.

Fittingly, Cupid's wings are painted a sumptuous shade of purple. The pansy's amorous links are reflected in some of its other nicknames: 'heart's ease', 'kiss me quick' and 'a kiss behind the garden gate'.

PAINTED IN

Birmingham

MEDIUM

Oil on canvas

SIMILAR WORKS

The Enchanted Sea by Henry Arthur Payne

Ydelnesse by Keith Henderson

Sidney Harold Meteyard *Born* 1868 Stourbridge, England

Died 1947

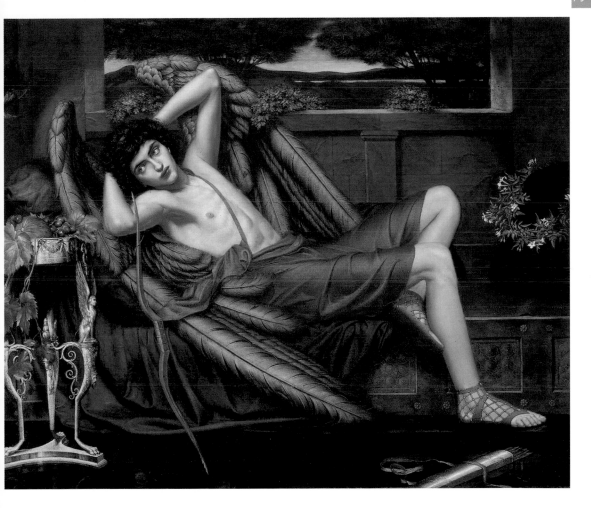

Allen, Daphne Constance

Flower Fairies: Autumn

© Sotheby's Picture Library

This is one of a group of four pictures showing fairies with flowers at different times of the year (see also pages 276, 288 and 308). Depictions of the four seasons had been common since antiquity and were frequently used in decorative schemes. Over the years, a set of symbols evolved to represent these, some of which were adopted by Allen. Spring was normally portrayed as a young girl with flowers; the depiction of summer included signs of harvesting, such as a sickle or a sheaf of corn; autumn featured grapes and vine leaves; while winter showed people wrapped up warmly against the cold.

The fairy with the cobweb may well have been inspired by one of Titania's attendants in *A Midsummer Night's Dream*. Some of the latter were associated with plants, although more importantly they were also linked with healing, another fairy skill. Mustard seed was one of the ingredients used in poultices for stiff muscles; boiled moths were employed in a number of plasters and potions; the pea plant (as in Peaseblossom) was said to relieve the melancholy effects of lost love; while cobwebs were often placed on cuts, to help staunch any bleeding.

PAINTED IN

London

SIMILAR WORKS

Foxgloves and Brambles by Christiana Jane Herringham

Daphne Constance Allen *Born* 1899 London, England

Died unknown

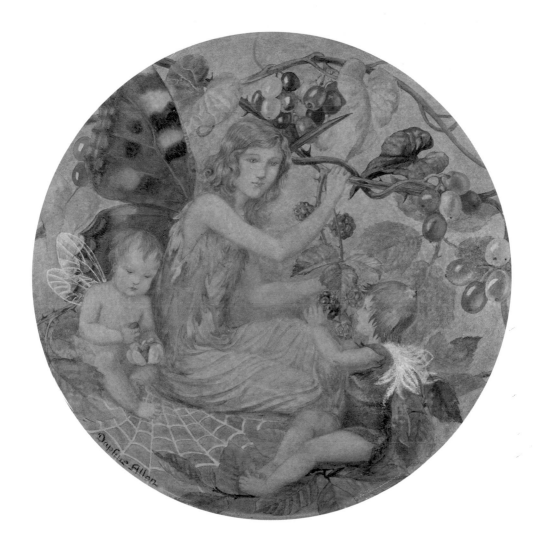

Angels & Fairies

Society

Burne-Jones, Sir Edward Coley

Hill Fairies, c. 1881

The painting now known as *Hill Fairies* was originally intended to be part of a triptych. Burne-Jones designed it as one of the side panels for his work *Arthur in Avalon*, a major project commissioned by the Earl of Carlisle. The huge, central panel, measuring more than 20 ft (6 m), was to show the sleeping warrior in his otherworldly resting place. According to legend he was destined to remain there until the nation needed him again, when a terrific noise would rouse him from his slumbers. The side panels, meanwhile, showed the 'fairies' waiting for this moment. Burne-Jones conceived these creatures as the spirits of the hills. More specifically they were the echoes that dwelt in the fissures between the rocks, ready to repeat the trumpet blare that would one day wake the king from his long sleep.

Significantly, this picture bears no resemblance to the standard type of Victorian fairy painting, which Burne-Jones regarded as a minor, specialist branch of the art scene. Instead, his inspiration stemmed from the Italian Renaissance, and his figures were closer to Classical nymphs than to the traditional idea of fairies. As such they did not blend easily with the Arthurian theme, so at an early stage Burne-Jones decided to dispense with the side panels. They were eventually sold off separately.

PAINTED IN

London

MEDIUM

Oil on canvas

SIMILAR WORKS

Ligeia Sirens by Dante Gabriel Rossetti, 1873

Sir Edward Coley Burne-Jones *Born* 1833 Birmingham, England

Died 1898

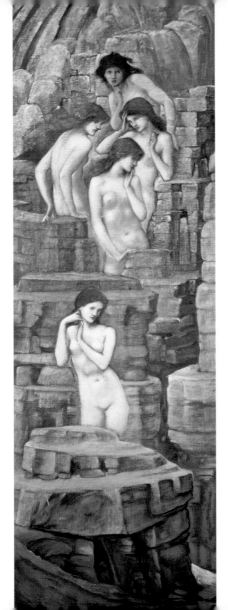

Simmons, John
Titania

When the fashion for fairy paintings was at its peak, there was a tendency for artists to cram their canvases full of colourful, anecdotal details of the little people. Simmons cut against this trend. Instead, he usually focused on a single, female fairy, depicting her in a variety of semi-erotic poses. As a result, his paintings are sometimes now described as Victorian pin-ups. Simmons' use of nudity was rarely censured at the time, although there were critics who opposed the general increase in subjects of this kind. The most vocal of these was John Horsley, the Treasurer of the Royal Academy, who believed that nudes should be banned from public exhibition on the grounds of morality. He became closely involved in the so-called 'British Matron' controversy of 1885, when a letter to *The Times*, signed anonymously by a British Matron (although many believed that it was actually Horsley), sparked off a national debate on the topic. Ultimately, however, Horsley was swimming against the tide. The most respectable art of the day, Classical paintings produced by the leading academicians, relied heavily on the nude. In addition, it had the royal seal of approval. Queen Victoria purchased several paintings of nudes as birthday presents for Prince Albert and went out of her way to praise Landseer's depiction of Lady Godiva.

PAINTED IN

Bristol

MEDIUM

Watercolour heightened with body colour

SIMILAR WORKS

Lady Godiva's Prayer by Sir Edwin Landseer *c.* 1865

John Simmons *Born* 1823 Bristol, England

Died 1876

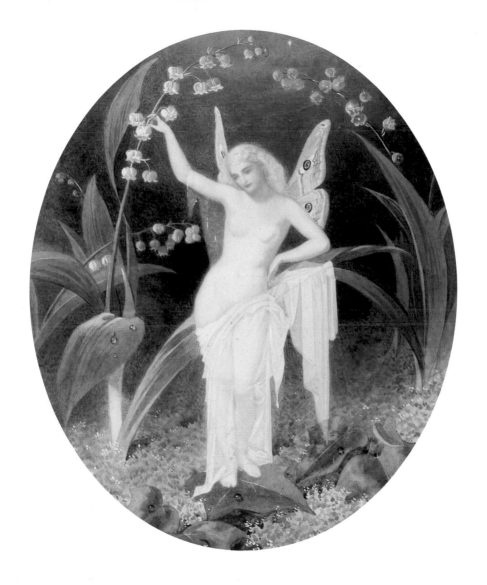

Paton, Sir Joseph Noël
A Midsummer Night's Dream, 1884

© Sotheby's Picture Library

Paton's picture depicts a key episode from Act II of *A Midsummer Night's Dream*. Puck has returned from his search and hands the magic flower to Oberon. He will anoint Titania's eyes with its juice, and when she awakes she will fall in love with the first creature she sees. Although this is far less complex than Paton's principal treatments of the theme (see pages 28 and 166), it still has some unusual features. Puck, for example, is portrayed with bat wings, rather than those of a butterfly. He also wears a curious red hat, resembling the winged cap of Mercury, the messenger of the gods.

Prominent nude figures rapidly became a staple feature of this subject. Depictions of the nude were generally on the increase in nineteenth-century British art, but they were only deemed respectable in certain contexts. Links with nudes from Classical or Renaissance art were particularly desirable. These associations were not restricted to the subject matter, but also included the pose. Many artists chose to show Titania sleeping, for example, because this offered them an opportunity to echo the pose of a reclining Venus. This was one of the favourite themes of the Venetian artist Titian (*c.* 1485–1576), whose reputation soared in Britain after his *Diana and Actaeon* and *Diana and Callisto* were exhibited publicly at the start of the nineteenth century.

PAINTED IN

Edinburgh

MEDIUM

Oil on canvas

SIMILAR WORKS

Scene from A Midsummer Night's Dream by Francis Danby, 1832

Sir Joseph Noël Paton *Born* 1821 Dunfermline, Scotland

Died 1901

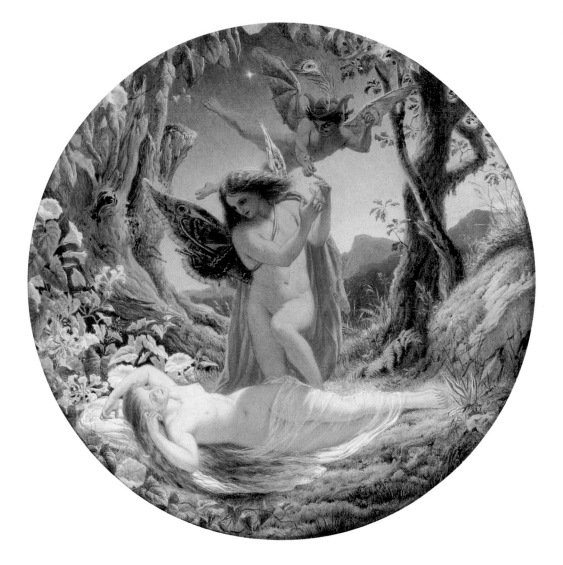

Seignac, Guillaume
The Awakening of Psyche, c. 1904

© Christie's Images Ltd

The story of Cupid and Psyche is not so much a myth as an ancient fairy tale (see page 210). It dates back to the second century, when it appeared in the *Golden Ass* by Apuleius (*c.* AD 155). The popularity of the story made it a favourite theme for painters, particularly during the Renaissance. Towards the end of the nineteenth century it gained a new lease of life after featuring in Walter Pater's (1839–94) philosophical romance, *Marius the Epicurean in 1885*.

Guillaume Seignac was a successful academic painter, who specialized in pictures of the female nude. This particular example was exhibited at the Salon, the most important venue for French art, in 1904. In keeping with his normal practice, Seignac used the Classical theme as a pretext for the depiction of thinly veiled eroticism. There is no reference to a specific incident in the story – instead, the rumpled bed linen and the curtained-off boudoir hint at a night of lovemaking. This is further underlined by the scattered red roses and the pearls, both of which were traditional attributes of Venus, the goddess of love. Psyche is shown with wings, referring to her role as the personification of the soul, even though this is clearly irrelevant here.

PAINTED IN

Paris

MEDIUM

Oil on canvas

SIMILAR WORKS

The Bath of Psyche by Frederic Leighton *c.* 1890

Lilith by John Collier, 1887

Guillaume Seignac *Born* 1870 France

Died 1924

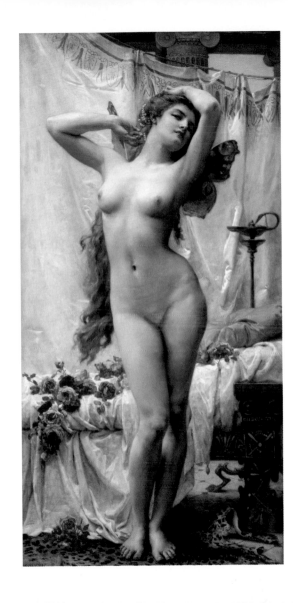

Huskisson, Robert

Come Unto These Yellow Sands, 1847

Huskisson painted this scene in the same year and in the same format as his *Midsummer Night's Fairies* (see page 36). Both pictures were purchased by Samuel Carter Hall, who may perhaps have commissioned this painting as a pendant to the first. The subject is taken from Ariel's song in Act I of *The Tempest*, although Huskisson's immediate source is more likely to have been Richard Dadd's treatment of the theme (see page 78), which was exhibited at the Royal Academy in 1842. The two pictures are very alike, although Huskisson's lyrical colouring is quite distinctive. Once again he framed the scene in a remarkable *trompe l'oeil* arch.

Aside from Dadd, Huskisson also drew inspiration from the work of William Etty (1787–1849) and William Edward Frost (1810–77). Both artists specialized in voluptuous depictions of the female nude, an element that was to feature strongly in early Victorian fairy paintings. In this instance, there are clear borrowings from Frost's *Sabrina* (1845), which in common with Huskisson's pictures was bought and engraved by the *Art Union* publication. These engravings could then be purchased by subscribers. Quite evidently there was a ready and profitable market for the mild eroticism of pictures such as these.

PAINTED IN

London

MEDIUM

Oil on panel

SIMILAR WORKS

Come unto these yellow sands by Richard Dadd, 1842

Sabrina by William Edward Frost, 1845

Robert Huskisson *Born* 1819 England

Died 1861

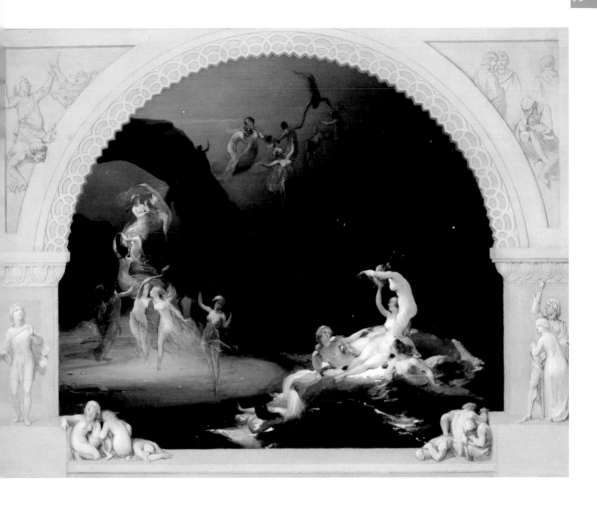

Grimshaw, John Atkinson

Autumn – Dame Autumn Hath a Mournful Face, 1871

During the 1870s and 1880s, Grimshaw produced a series of fairy pictures, all ostensibly drawn from literary or Classical sources. Here the title comes from an old ballad, although the artist was probably more interested in creating a wistful personification of the season itself. He saw it as a time for melancholy reflection, epitomized by such pictures as *Autumn Regrets* and *Meditation*.

Nudes are rare in Grimshaw's work, and are confined almost exclusively to his fairy pictures. Depictions of the nude could be controversial in Victorian England, but Grimshaw's paintings escaped this type of censure. This was partly due to the fairy subject matter, but also to the lyrical colouring. Problems normally only arose when a nude was painted too naturalistically, or if it was too readily identifiable with real, contemporary women. Significantly, the most famous scandal centred around John Gibson's (1790–1866) *Tinted Venus*. Gibson was the most celebrated sculptor of his day, but he aroused considerable controversy when he exhibited this polychrome statue at the International Exposition of 1862. The ancient Greeks had also coloured their sculptures, but this did not appease contemporary critics. As one pointed out, "The absence of colour in a statue is... one of the peculiarities that remove it from common Nature, that the most vulgarly constituted mind may contemplate it without its causing any feeling of a sensuous kind."

PAINTED IN

Knostrop Old Hall, near Leeds

MEDIUM

Oil on canvas

SIMILAR WORKS

Tinted Venus (sculpture) by John Gibson, *c.* 1851–56

John Atkinson Grimshaw *Born* 1836 Leeds, England

Died 1893

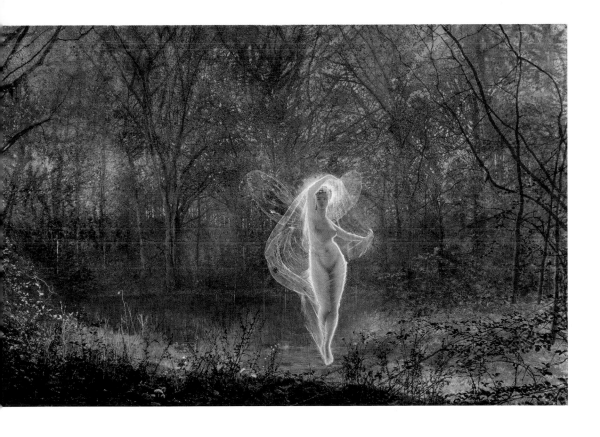

Simmons, John (circle of)
The Sleep of Titania

This nocturnal scene is based very loosely on *A Midsummer Night's Dream*. Queen Titania lies sleeping in the woods, and when she awakens she will fall in love with Bottom. The theme of sleeping and dreams was highly popular during the Romantic era, and not just with fairy painters. Artists increasingly regarded dreams as the gateway to the imagination. Henry Fuseli (1741–1825) is said to have consumed a plate of raw beef just before retiring in the hope that it would bring him more impressive dreams.

The nude also became a more common subject in nineteenth-century Britain. To some extent this was a patriotic move designed to give the country a greater standing within the international art world. Britain had been slow to develop a national school or tradition, although William Hogarth (1697–1764) had begun the campaign to establish one, complaining at the way that major commissions were automatically given to foreign artists. The depiction of the nude formed an important part of this process. Ever since the Renaissance, the study of the human figure had been the cornerstone of academic training. The absence of a British tradition in this field was a cause for concern. French critics, in particular, used it to deride the standard of art in England.

PAINTED IN

Bristol

MEDIUM

Oil on canvas

SIMILAR WORKS

Puck and the Fairy by Sir Joseph Noël Paton

John Simmons *Born* 1823 Bristol, England

Died 1876

Perrault, Léon Jean Basile
The Sleeping Angel, 1897

Perrault found a ready market for his sentimental paintings of chubby infants. The Victorians and their French counterparts adored pictures of children, whether playing, in the home or in images of bereavement as here. Throughout the century the subject of childbirth produced mixed emotions. There was joy of course, but also fear. The procedure could be lethal, both for the mother and the child. In 1901, for example, the official statistic for deaths in childbirth was 4,400 in England and Wales, which was almost certainly an underestimate of the real figure. For mothers the average mortality rate was an appalling 4.8 per thousand live births. This rate did not actually drop below one per thousand until as late as 1944. And even if the difficulties of childbirth were successfully negotiated, the first few years of life remained perilous. In 1899 the mortality rate for infants under the age of one was 163 per thousand. The problems stemmed from a number of factors, most notably poor living conditions, the absence of organized antenatal care and the very variable standards of medical expertise in doctors and midwives. For obvious reasons, these problems were most keenly felt by the poor, but no family was safe from the threat of infant mortality.

PAINTED IN

Paris

MEDIUM

Oil on canvas

SIMILAR WORKS

Dream of Love by Willem Martens

Léon Jean Basile Perrault *Born* 1832 Poitiers, France

Died 1908

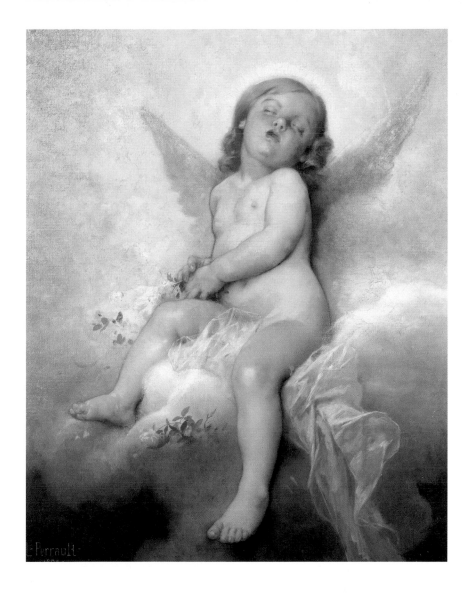

Doyle, Richard
Baby's Dream

Sleep and dreams are common motifs in fairy paintings. This was a natural association since people, who never saw fairies under normal circumstances, were thought sometimes to sense them in their dreams. In addition there was the link with Queen Mab, the bringer of dreams (see page 130), who often put humans to sleep for sinister reasons. Ben Jonson (1572–1637), among others, noted her reputation for stealing infants:

This is Mab, the mistris Faerie...

This is shee, that empties cradles,

Takes out children, puts in ladles...

Although he is probably best remembered now for his fairy pictures, Doyle was first and foremost a humorous illustrator. In his youth he worked for several years on the satirical magazine *Punch*, designing its original cover. He also illustrated a series of books, highlighting the foibles of British society. These included *The Manners and Customs of Ye Englyshe* (1849), the *Bird's-eye View of Modern Society* (1864) and *The Foreign Tour of Messrs Brown, Jones and Robinson* (1854).

PAINTED IN

London

MEDIUM

Watercolour on paper

SIMILAR WORKS

Punch's Essence of Parliament by Edward Linley Sambourne

Richard Doyle *Born 1824 London, England*

Died 1883

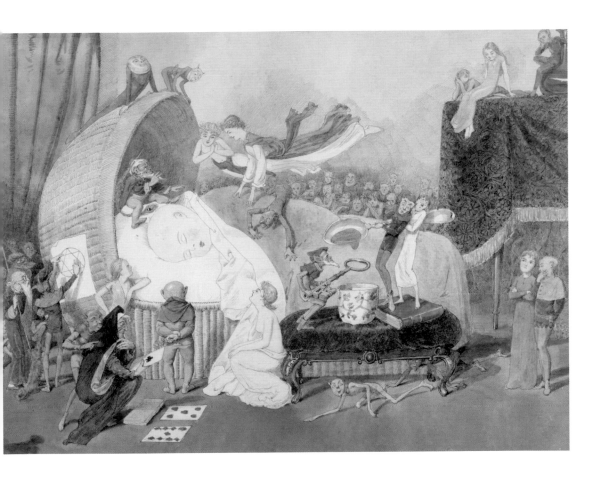

Paton, Sir Joseph Noël

A Dream of Latmos, 1878–79

© Sotheby's Picture Library

In Greek legend Endymion was a beautiful youth, the son of Zeus and the nymph Calyce. While on Mount Latmus he fell into a deep sleep, from which he would never awaken, although he would always remain young and handsome. Some said that Endymion begged his father for this fate so that he would never have to grow old; others believed that Zeus placed him in that state as a punishment for having an affair with Hera. Paton opted for a third version in which a moon goddess fell in love with the youth. Usually this deity was Selene, but here the bow and arrows identify her as Artemis. She was the goddess of chastity as well as the moon, and she sent Endymion into his endless sleep so that she could visit him each night while also ensuring that their love remained chaste.

The theme of sleep and dreaming was very popular with the Romantics. In most cases they preferred to depict nightmares, but Paton's picture is closer to a holy vision. The goddess's head is deliberately silhouetted against the moon so that it resembles a halo. Paton also produced several religious pictures with similar themes, most notably *Satan watching the Sleep of Christ*.

PAINTED IN

Edinburgh

MEDIUM

Oil on canvas

SIMILAR WORKS

A Golden Dream by Thomas Cooper Gotch, 1893

Sir Joseph Noël Paton *Born* 1821 Dunfermline, Scotland

Died 1901

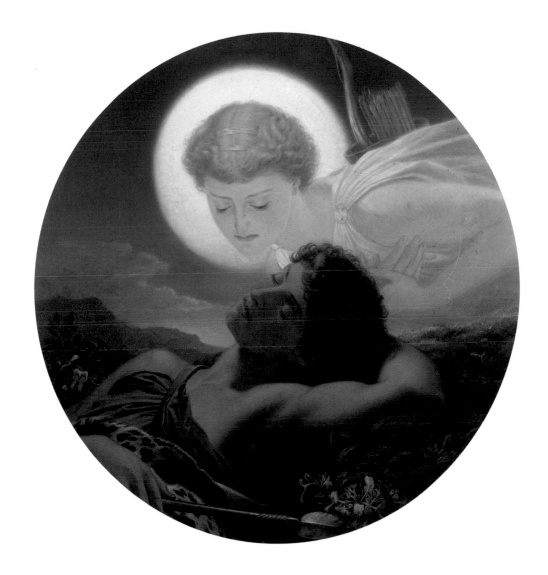

Fitzgerald, John Anster

The Stuff That Dreams Are Made Of, 1858

In the 1850s, Fitzgerald painted a series of 'dream' pictures that are his most complex and controversial works. Here, a young woman lies fast asleep on her bed. In her dream she sees herself with a young man, standing underneath a bunch of mistletoe that is dangled over them by a grinning wraith. To the right of this romantic episode the woman can be seen again, fleeing from a goblin. In a third scene, by the window, she appears to be in the grip of the creatures, although she gazes back wistfully at her former, happy state. Meanwhile, all around the girl's bed a grotesque fairy band create a fearful din. It was well known, of course, that fairies could play a magical form of music that would not disturb the sleep of any mortal (see page 154).

Fitzgerald's painting is full of ambiguities. It is clear that this is no ordinary sleep. The girl is fully clothed, wearing the same exotic attire as in her dream. There are suggestions that the dream may have been induced by narcotics. In earlier versions of the picture a goblin carries a tray of foaming drinks (still barely visible on the left) and there are medicine bottles on the table. Equally it is possible that the girl is under an enchantment, administered by the creatures in her vision.

PAINTED IN

London

MEDIUM

Oil on canvas

SIMILAR WORKS

The Entomologist's Dream by Edmund Dulac

John Anster Fitzgerald *Born* 1832 London, England

Died 1906

Canziani, Estella Louisa Michaela
The Piper of Dreams, 1914

© Estella Louisa Michaela Canziani/Sotheby's Picture Library

This is one of the last great fairy paintings. A boy leans against a tree wearing a peacock feather in his hat, a traditional symbol of immortality. He is playing a magical strain of fairy music, which draws the woodland creatures to his side. A robin perches on his shoe, a squirrel approaches on the right, while around his head diaphanous fairies swoop and swirl.

Canziani painted this memorable scene when she was staying with the classical scholar, Gilbert Murray. His son was the model for the piper, while the woods behind their cottage provided the setting. The picture was exhibited at the Royal Academy in 1915 where it was sold on Private View Day. The reproduction rights were acquired by the Medici Society and the picture became an international bestseller. More than a quarter of a million prints of it were sold within a year. In many cases these were hung in the nursery, but thousands were also sent to soldiers in the trenches. Many of them wrote to the artist expressing their appreciation. For them the tranquil, fairyland scene was a nostalgic reminder of the world they had left behind, a world that they feared might not survive.

PAINTED IN

London

MEDIUM

Watercolour heightened with body colour

SIMILAR WORKS

Bother the Gnat by A. Duncan Carse

Estella Louisa Michaela Canziani *Born 1887 Italy*

Died 1964

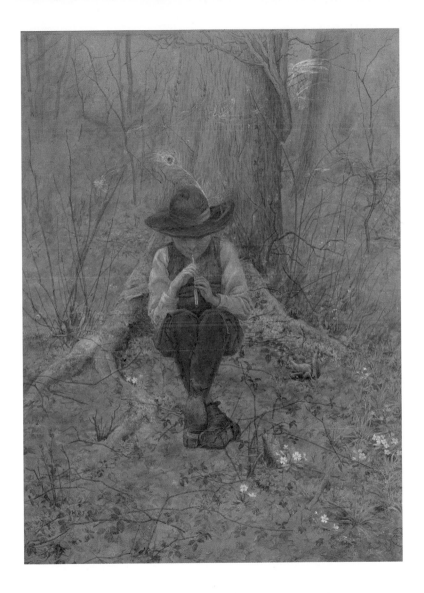

Fitzgerald, John Anster
The Painter's Dream, 1857

This compelling work dates from the late 1850s, when Fitzgerald produced a series of paintings on the subject of sleep and dreams. Here the artist has fallen asleep in his chair. In his dream he sees himself painting a beautiful fairy. This same portrait is shown on the right, covered by a drape, where a mischievous spirit attempts to make his own amendments to it. There are suggestions that the sleep may be drug-induced. One of the creatures offers a large glass to the artist, while the female fairy sits under a purple convolvulus, which was known for its narcotic properties. The same flower was also featured prominently in *The Fairies' Banquet* (see page 338). It is unclear whether these grotesque fairies were meant to be figments of the artist's imagination, appearing to him in his dream, or whether they were meant to be genuinely threatening him in his studio. Either way the picture makes an interesting comparison with a similar painting that Charles Doyle (1832–93), father of Richard Doyle, produced during his confinement in the Montrose asylum. *In Self-Portrait, A Meditation* Doyle pictured depicted himself in the company of a group of equally menacing figures. The difference was, however, that Doyle was wide awake and the demons seemed all too real.

PAINTED IN

London

MEDIUM

Oil on millboard

SIMILAR WORKS

Self-Portrait, A Meditation by Charles Altamont Doyle, c. 1885–93

John Anster Fitzgerald *Born* 1832 London, England

Died 1906

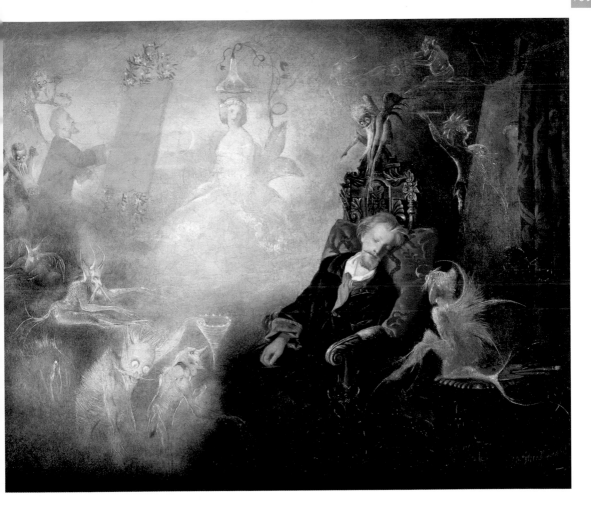

Fuseli, Henry
The Nightmare, 1781

This compelling image is one of the key works of the Romantic movement, combining the themes of mystery, horror and tortured sexuality. A young woman lies unconscious with her head dangling uncomfortably over the edge of the bed. She is in the grip of a terrible nightmare, inflicted on her by an incubus that squats on the pit of her stomach. On the left, the head of a spectral horse peers round from behind a curtain. This is the 'night-mare', the terrible creature that transports the incubus on his nocturnal visitations.

In the Middle Ages the incubus was defined as a demon lover, who assumed human form and preyed on young women by night. The female equivalent was the succubus, who sought out male victims. The incubus could impregnate its partners. In some tales, Merlin is said to have been fathered by an incubus. Equally the parents of some illegitimate children, including a number of medieval nuns, ascribed their unexpected pregnancy to rape by an incubus. The 'night-mare' took its name from Mara or Mera, another demon. Fuseli painted several other, less potent, versions of the subject, usually showing the incubus galloping away from the bedroom of one of his victims.

PAINTED IN

London

MEDIUM

Oil on canvas

SIMILAR WORKS

Milton's Mysterious Dream by William Blake

Horse Being Attacked by a Lion by George Stubbs, 1770

Henry Fuseli *Born* 1741 Switzerland

Died 1825

Doyle, Richard

A Group of Fairies Tormenting a Polar Bear

The fairies in *A Midsummer Night's Dream* were able to cross the globe at will (see page 162), so it is no surprise to find them operating in the frozen, Arctic wastes. The ferocity of polar bears was a topical subject, following Sir John Franklin's (1786–1847) disastrous expedition to find a viable sea route across northern Canada. The ships never returned and the fate of the explorers remained uncertain until a second expedition of 1858–59 discovered their skeletons. From these it was evident that the bodies had been consumed by polar bears. Sir Edwin Landseer (1802–73) produced a gruesome painting recording this event called *Man Proposes, God Disposes*, which caused a stir at the Royal Academy in 1864.

In theory fairies might attack any animal, but given that they were largely seen as a rural phenomenon most of the legends relate to farm animals. Cattle blight, fowl pest and swine fever were all attributed to fairies. Similarly if a cow failed to produce milk it was assumed that the fairies had stolen it. A human could also be the target of fairy malice. It was sometimes said that they mixed their cakes with human blood, while blindness was a common punishment for those who spied on secret fairy acts.

PAINTED IN

London

MEDIUM

Pen and black ink

SIMILAR WORKS

Man Proposes, God Disposes by Sir Edwin Landseer, 1877

Richard Doyle *Born* 1824 London, England

Died 1883

Duncan, John McKirdy

Yorinda and Yoringel in the Witch's Wood, 1909

© John McKirdy Duncan/Christie's Images Ltd

The subject is taken from one of Grimm's fairy tales. The two lovers, Jorinda and Joringel, are wandering through a wood when they fall foul of an evil witch. She turns Jorinda into a nightingale and then imprisons her in her castle, where she has 7,000 other maidens trapped in the form of birds. Joringel is desperate to free his beloved and return her to her original state. He eventually achieves this, with the aid of a magic flower. Duncan's painting is a very loose adaptation of the start of the story. The two are so in love that they barely notice the circle of good fairies, who dance around them. These fairies bring light to the forest, but cannot protect the lovers from the forces of darkness that await them. A witch can take the form of a screeching owl or cat, but is represented here by the old woman, sitting cross-legged on the far left. The fire is for roasting the wild animals and birds, which are lured into the reaches of her power.

Grimm's fairy tales were first published in English as *German Popular Stories* in 1824. Duncan painted a number of fairy pictures, mostly with Celtic overtones. He entered into the spirit of his subject matter, claiming that he heard fairy music while he worked.

PAINTED IN

Edinburgh

MEDIUM

Oil on board

SIMILAR WORKS

The Brownie of Blednoch by Edward Atkinson Hornel

John McKirdy Duncan *Born* 1866 Scotland

Died 1945

Fitzgerald, John Anster

Fairy Hordes Attacking a Bat

© Sotheby's Picture Library

No artist was better at portraying the malevolent side of fairies than John Fitzgerald. Here, silhouetted against the Moon, a lone bat is ambushed by a swarm of tiny creatures wielding thorny sticks. Fitzgerald's treatment of the fairies is particularly effective. Several of the larger figures in the foreground resemble sweet-faced children, who seem too innocent to be involved in an act of such cruelty. Alongside them, however, their allies are grotesque, often more like insects than humanoids.

The hostility between fairies and bats was documented by William Shakespeare (1564–161). In Act II of *A Midsummer Night's Dream*, Titania sent her followers off to "war with reremice (bats) for their leathern wings/To make my small elves coats...". This was not the only use for the creatures' hides. In his *Nimphidia* (1627), Michael Drayton (1563–1631) described a miniature palace that was made out of the body-parts of the fairies' defeated foes:

> The Windows are the eyes of Cats, / As for the Roofe, instead of Slats,
>
> Is cover'd with the skinns of Batts, / With Moonshine that are guilded.

Bats probably seemed legitimate targets, because of their associations with witchcraft and the devil. Tradition held that bats' blood was used in the Black Mass, as well as in the enchanted balm that enabled witches to fly by night.

PAINTED IN

London

MEDIUM

Watercolour and body colour

SIMILAR WORKS

An Old Fairy Tale Told Anew by Richard Doyle, 1865

John Anster Fitzgerald *Born* 1832 London, England

Died 1906

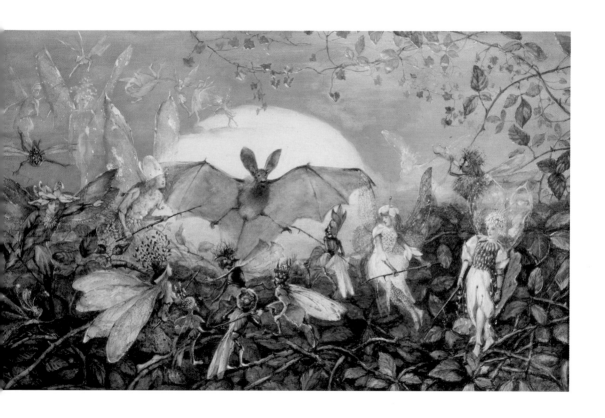

Huskisson, Robert

Titania's Elves Robbing the Squirrel's Nest, c. 1854

This may be the painting that Huskisson exhibited at the Royal Academy in 1854, his final appearance at this venue. The title alludes to *A Midsummer Night's Dream*, although this scene does not figure in Shakespeare's play. Indeed, the actions of these fairies are more hostile than the benign creatures who served Titania. Instead they are closer to the fairies of popular tradition, who often had a spiteful streak and were incorrigible thieves.

It remains a mystery why Huskisson failed to live up to his early potential, particularly when two of his early fairy paintings were purchased by Samuel Carter Hall. As the editor of *The Art Union* (later *The Art Journal)*, Hall was an important figure who certainly had the ability to make an artist's career. Huskisson was clearly in favour for a time as he was invited to produce the frontispiece for a book by Hall's wife in 1848. However, he stopped exhibiting in 1854 and in the following year Hall auctioned off his pictures. By the time of the artist's premature death, the pair had lost contact and Hall later wrote that he "slipped out of the world, no one knew when or how".

PAINTED IN

London

MEDIUM

Oil on panel

SIMILAR WORKS

The Fledgling by John Anster Fitzgerald

Robert Huskisson *Born* 1819 England

Died 1861

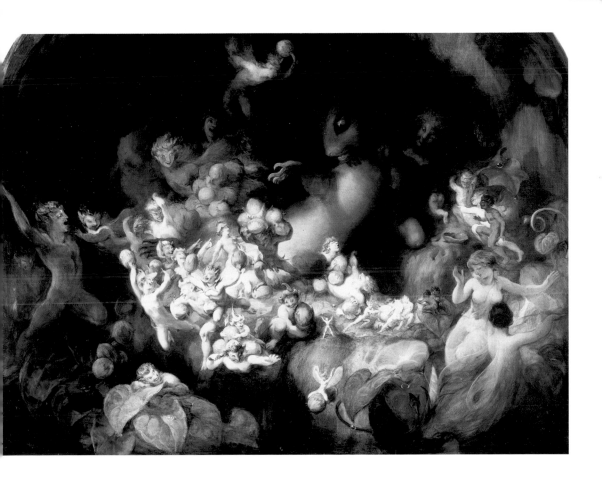

Sims, Charles

'...and the fairies ran away with their clothes'

There are many tales of fairies using their powers in order to steal from humans. The most serious cases involved babies. Reports of these date back to the Middle Ages, when they were recorded in the chronicles of Ralph of Coggeshall (c. 1210). The principal targets were unchristened infants, who lacked the protection of the Church. When the child was stolen a changeling was left in its place, usually an ancient, withered fairy. In the past children that were born with a handicap were sometimes deemed to be changelings.

On a lighter note, fairies were notorious for stealing food. Occasionally they would take the entire article, but more often they would extract the goodness from the food, its 'foison', and leave behind a stale husk. On a grander scale they sometimes lured cows away from the fold so that they could steal their milk. Clothes were a less obvious target, although the fairies would steal anything if a human had offended them in some way. By the same token, those who found favour with the little people were rewarded. When a hunchback called Lusmore pleased them with a song they took away his hump and gave him a brand new suit of clothes.

PAINTED IN

London

MEDIUM

Oil on canvas

SIMILAR WORKS

Once Upon a Time by Henry Meynell Rheam, 1859

Charles Sims *Born* 1873 London, England

Died 1928

Froud, Brian

Gwenhwyfar, 1993

Gwenhwyfar is one of the good fairies in Froud's bestselling book, *Good Faeries, Bad Faeries* (1998). In the text he defines her as the White Shadow, an ethereal spirit dancing under the moonlight to the tune of a fairy piper. In her wake she leaves a trail of glowing, star-shaped flowers, which grow from her footsteps. As she dances her eyes are closed and she dreams that she is far away, drifting in an unknown galaxy of stars. Froud also links Gwenhwyfar with the White Ladies, "luminous faery creatures who dance by the light of the moon". This term has been used to describe both ghosts and fairies. It has a particular relevance to Gwenhwyfar, as the literal meaning of her name is 'white phantom'. The White Ladies could be benevolent, although some were distinctly dangerous. The White Lady of Lough Gur, for example, claimed a human life every seven years.

Gwenhwyfar is a Welsh variant of Guinevere, a name that is inevitably associated with the adulterous wife of King Arthur. It has also been seen as the counterpart of the Irish name Finnabair, which is traditionally linked with the beautiful daughter of Maeve, the goddess of war.

PAINTED IN

Devon

SIMILAR WORKS

Ophelia by Annie Ovenden, 1979–80

Brian Froud *Born* 1947 Winchester, England

Dadd, Richard
The Attack of the Spider

Spiders were traditionally regarded as a natural enemy of most fairies. This is confirmed in the incantation that Titania's followers performed in *A Midsummer Night's Dream:* "Weaving spiders, come not here;/Hence, you long-legged spinners, hence!" Equally it is clear that the fairies found some gruesome uses for the creatures' body-parts. In his *Nimphidia*, Michael Drayton (1563–1631) described the construction of a fairy palace thus: "The walls of spiders' legs are made,/Well mortized and finely layd". The reason for this hostility is that in Tudor times it was erroneously believed that spiders were poisonous.

The fairies in *A Midsummer Night's Dream* rarely seemed capable of anything more than mischief, but some of their kind were far more dangerous. One of their activities has left its mark on the English language. The seizure known as a stroke was originally called a 'fairy-stroke', or 'elf-stroke', because it was thought to be caused by magical arrows fashioned by elves, which pierced the skin but left no mark. Various other disabilities were also ascribed to this, ranging from lameness to wasting diseases. Similarly, ailments such as rheumatism, which caused the body to become bent or deformed, were deemed to have been the result of fairy blows, delivered by invisible assailants.

PAINTED IN

London

MEDIUM

Oil on canvas

SIMILAR WORKS

Fairies and Fruit by James Elliott

Richard Dadd *Born* 1817 Kent, England

Died 1886

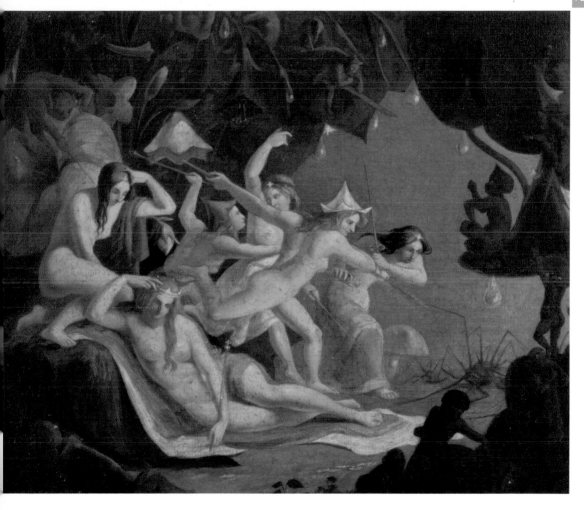

Fitzgerald, John Anster
Who Killed Cock Robin?

Fitzgerald was clearly fascinated by this subject, producing several different pictures on the theme. The series is unusual in a number of ways. Firstly it was rare for the artist to use material from a literary source (in this case, the title comes from a popular nursery rhyme). Admittedly he did produce a few Shakespearean pictures, but these were very much the exception to his rule. More surprising, though, is the unexpected tone of the series. Fitzgerald included robins in many of his paintings and invariably these showed the fairies acting aggressively towards the bird (see page 60). Yet in the scenes that portray the death of Cock Robin, there is an unmistakeable sense of grieving. Here, for example, the two main figures in the centre resemble a couple comforting each other by a graveside. This apparent inconsistency has prompted suggestions that Fitzgerald was inspired by a specific, visual source. In particular, a most convincing case has been put forward for Walter Potter's version of the theme. Potter specialized in arranging groups of stuffed animals into a tableau. His interpretation of *The Death and Burial of Cock Robin* gained widespread publicity when it was exhibited in 1861.

PAINTED IN

London

MEDIUM

Watercolour on paper

SIMILAR WORKS

The Death and Burial of Cock Robin (taxidermy group) by Walter Potter, 1861

John Anster Fitzgerald *Born* 1832 London, England

Died 1906

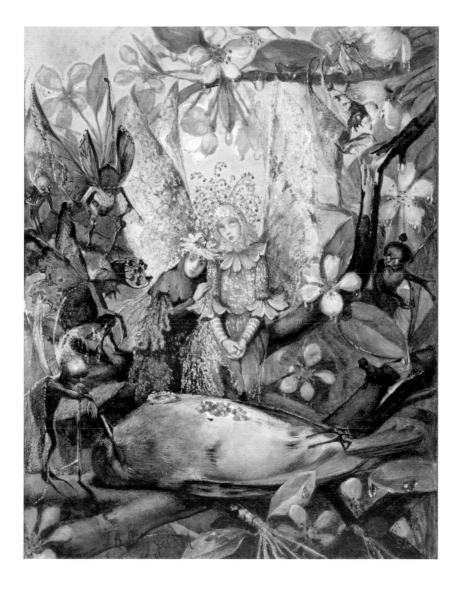

De Morgan, Evelyn

An Angel Piping to the Souls in Hell, c. 1916

This scene is reminiscent of some nineteenth-century depictions of Dante's *Inferno*, a source that was popular with some of the Pre-Raphaelites. Nevertheless, the picture was chiefly a response to the horrors of the First World War. De Morgan was appalled by the carnage in the trenches and did her best to raise money to alleviate the suffering. This culminated in the Red Cross Benefit Exhibition, which she helped to stage in 1916. De Morgan contributed 13 pictures to the show, including this one. In her will she also gave instructions for some of her paintings to be sold off, to raise funds for St Dunstan's, a charity for blind soldiers.

At this stage of her career de Morgan was producing complex allegorical pictures, very much in the manner of G. F. Watts (1817–1904). In this instance, the entry in the exhibition catalogue gave a clue to the picture's meaning: "Come from afar, the Angel bends over the abyss and pipes her angelic strains, that the flame-tossed souls in Hell may hear the distant music". In essence she was hoping that, like the angel, she and the charities she supported could bring some crumbs of comfort to the soldiers, who were going through their own personal hell.

PAINTED IN

London

MEDIUM

Oil on canvas

SIMILAR WORKS

Bacchus in India by Charles Ricketts, *c.* 1913

Evelyn de Morgan *Born* 1850 London, England

Died 1919

Cruikshank, George

Queen Mab

Cruikshank's painting is a very literal depiction of the fairy, as described by Shakespeare in *Romeo and Juliet*. In the play, Mercutio refers to Queen Mab as:

> In shape no bigger than an agate-stone / On the forefinger of an alderman,
>
> Drawn with a team of little atomies / Athwart men's noses as they lie asleep

In Tudor times, Mab was known as the bringer of dreams, hence why she drives her carriage across the heads of sleeping humans. However, Mercutio dismisses her as a piece of superstitious nonsense and, significantly, she does not figure in the play. Apart from anything else, this underlines the enormous impact that Shakespeare had on fairy traditions. Prior to *A Midsummer Night's Dream*, Mab had been regarded as the Queen of the Fairies, but, with her diminutive size, she was rapidly supplanted by Titania. The name remained in popular usage: she features in the writings of Michael Drayton (1563–1631) and Ben Jonson (1572–1637), but her powers were greatly diminished. She was largely reduced to turning milk sour and leading travellers astray. Yet she probably originated as a god. Many authorities have linked Mab with Medb or Maeve, the Celtic goddess of war, who dealt death and destruction to unwary humans.

PAINTED IN

London

MEDIUM

Oil on canvas

SIMILAR WORKS

More Nonsense by Dick by Richard Doyle, 1843

George Cruikshank *Born* 1792 London, England

Died 1878

Fitzgerald, John Anster
The Wake

This is an unusual subject for Fitzgerald, and one that reflected his Irish roots. The fairy traditions in Ireland were very different from those across the water, stretching far back in time to the island's ancient Celtic gods. The *Tuatha Dé Danaan* were said to have ruled Ireland for generations until their magical powers began to dwindle. At this point they cast a veil of invisibility over themselves and retired to the *sidhe,* their fairy mounds (actually prehistoric burial mounds). From there they continued to exert a telling influence over the affairs of mortals through their mystical powers. One of these spirits was the banshee (literally *bean sidhe* or 'woman of the *sidhe*'), who would utter a terrible howl to warn people of their impending doom. Sometimes when conditions were favourable, the barriers between the real and the spirit worlds fell away, enabling humans to see the fairies. The likeliest time was at *Samhain*, the festival of the dead, when the souls of the departed returned to warm themselves in the land of the living. *Samhain* was eventually adopted by Christians as All Saints' Day, and some of its traditions survived in the feast of Hallowe'en.

PAINTED IN

London

MEDIUM

Watercolour on paper

SIMILAR WORKS

Hallows' Eve by William Bell Scott

John Anster Fitzgerald *Born* 1832 London, England

Died 1906

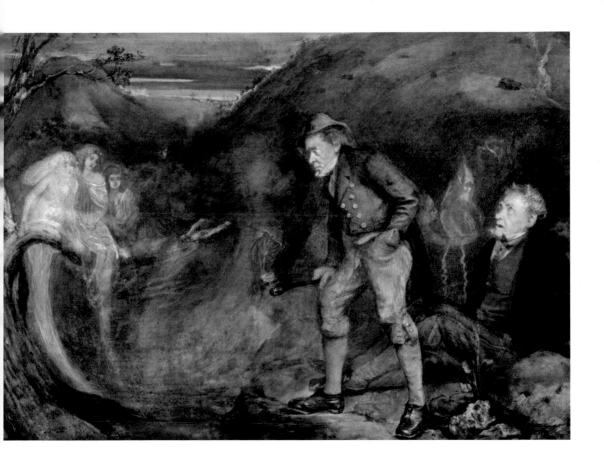

Paton, Sir Joseph Noël

Mors Janua Vitae, 1866

Away from his fairy paintings, Paton also produced a series of sombre, religious pictures. When he first exhibited *Mors Janua Vitae* ('Death is the Gateway to (everlasting) Life'), he included a lengthy extract from *The Good Fight* by A. Graves, which explained the allegory in detail. A Christian soldier is mortally wounded. Weary and in pain he follows a shadowy figure, who leads him through a dark and barren landscape to the gates of death. There he is rewarded for his faithful service: 'And the Shadow spake, and its voice was as the voice of an angel: "Thou hast been faithful unto death; the Lord will give thee a crown of Life." Then was the veil of the Darkness rent asunder and lo! the Shadow was clothed with light, as with a garment of rejoicing...'.

This type of approach was not unusual for the funerary art of the period. Both Harry Bates (1850–1914) and Sir Alfred Gilbert (1854–1934) produced sculptures entitled *Mors Janua Vitae* and there was a fashion for tomb effigies, which portrayed the deceased in the guise of a knight. The most celebrated was Edward Henry Corbourld's memorial portrait of Prince Albert (1819–61), which showed the subject in full armour and included the inscription, 'I have fought a good fight; I have finished the struggle; therefore the crown of the righteous is awaiting me'.

PAINTED IN

Edinburgh

MEDIUM

Oil on canvas

SIMILAR WORKS

The Happy Warrior by George Frederic Watts, 1884

Sir Joseph Noël Paton *Born* 1821 Dunfermline, Scotland

Died 1901

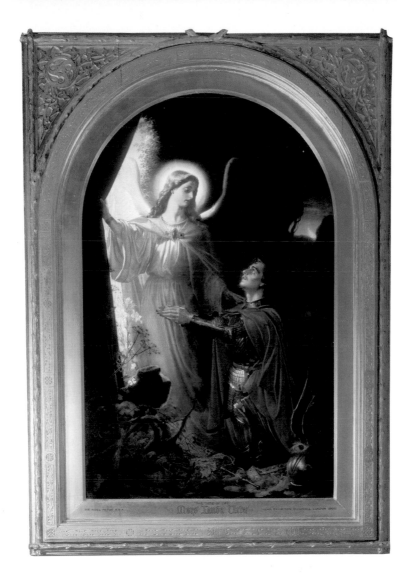

List, Wilhelm

Death of an Angel

List's chief claim to fame is that he was a founding member of the Vienna Secession. In common with several other members of this group he went through a Symbolist phase, during which he produced a series of powerful, mystical canvases. Here the prostrate angel is a blaze of light, contrasting sharply with the shadowy figure who supports her. The latter may represent sleep or night. Visually the scene is reminiscent of the levitation acts that were commonplace at the time. These were often performed by fake mediums, who would sometimes wear a turban to lend an exotic flavour to their act.

List trained at the Vienna Academy before undertaking further research in Munich and Paris. While in France he studied under William Adolphe Bouguereau (1825–1905), although he later rejected these academic influences. In 1897 he joined Gustav Klimt (1862–1918) and a number of other Austrian artists in founding the Vienna Secession. List exhibited with this avant-garde body and edited its influential periodical, *Ver Sacrum*.

PAINTED IN

Vienna

SIMILAR WORKS

A Song of Spring by Maximilian Lenz, 1913

Wilhelm List *Born* 1864 Austria

Died 1918

A. C. Lalli, after Dante Gabriel Rossetti

Dante's Dream at the Time of the Death of Beatrice, c. 1900

The composition of this painting is based on part of the Vita Nuova by Dante Aligheri (1265–1321):

> Then Love said, 'Now shall all things be made clear: / Come and behold our lady where she lies.' /
These 'wildering phantasies / Then carried me to see my lady dead. / Even as I there was led, / Her ladies with a veil
were covering her; / And with her was such very humbleness / That she appeared to say, 'I am at peace.'

Rossetti painted several versions of the subject, culminating in a huge canvas in 1871, the largest picture he ever produced. The red birds are messengers of death, while the figure of Love, also in red, leads the poet to the deathbed of his beloved. The floor is strewn with red poppies, which symbolize dreams.

Rossetti had close links with the poet. His father was a renowned Dante scholar and named his son after the writer. The artist shared his father's passion for Dante and painted numerous pictures based on his verses. Through him, Dante's work also proved a fruitful source of inspiration for other members of the Pre-Raphaelite circle.

PAINTED IN

London

MEDIUM

Oil on canvas

SIMILAR WORKS

Dante at Verona by Marie Spartali, 1888

Dante Gabriel Rossetti *Born* 1828 London, England

Died 1882

Fitzgerald, John Anster
The Fairy's Funeral, 1864

There are many reports of fairy funerals. The most famous of these came from the poet and artist, William Blake (1757–1827). In his garden he witnessed "a procession of creatures of the size and colour of green and grey grasshoppers, bearing a body laid out on a rose-leaf, which they buried with songs, and then disappeared". Blake cited his visions as a key source for his art. He claimed to have experienced his first one at the age of eight, when he saw "a tree filled with angels" on Peckham Rye. Even so, his account of the funeral was similar to a number of others gathered by folklorists. Most of these had some features in common: the human witness was drawn to the event by the sound of a muffled bell; the body was uncovered and resembled a tiny, wax doll; and the cortège passed through a sacred place, whether a pagan site, such as a stone circle, or a churchyard. Sometimes the episode came as a warning. When the human peered closely he noticed that the corpse bore a miniature version of his own face. The notion of fairy funerals did not sit easily with another popular folk belief — namely that fairies did not actually die, but gradually dwindled away.

PAINTED IN

London

MEDIUM

Oil on canvas

SIMILAR WORKS

Asleep in the Moonlight by Richard Doyle, 1870

John Anster Fitzgerald *Born* 1832 London, England

Died 1906

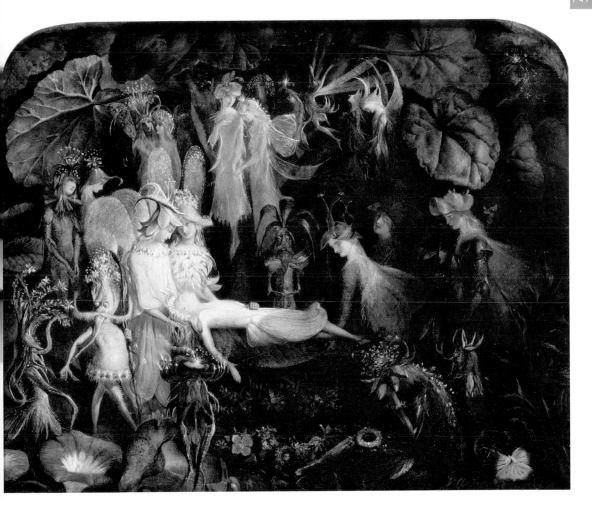

Angels & Fairies

Literary Influences

Doré, Gustave

A Midsummer Night's Dream, c. 1870

Doré's balletic picture serves as a reminder that for much of its history *A Midsummer Night's Dream* was performed as a spectacle of music and dance, rather than a traditional play. Generations of directors found it virtually impossible to stage and made savage cuts to the text. It was performed only once during the Restoration period, when Pepys praised the dancing but condemned the rest as "the most insipid ridiculous play that I ever saw in my life". In his version, David Garrick (1717–79) removed all but 600 lines of the original text, basing the performance around the antics of the fairies and the lovers.

A greater sense of balance was restored by Madame Lucia Vestris. In her 1840 production she restored most of Shakespeare's text, although opera and ballet still took precedence over drama. In particular, during the supernatural scenes, the stage was filled with crowds of female fairies wearing costumes made of white gauze. This became a feature of many productions throughout the nineteenth century and clearly provided the inspiration for Doré's picture. In her production Vestris actually took the part of Oberon herself. This started a trend for both the fairy rulers to be played by women. Traditionally Oberon was a contralto, while Titania was a soprano.

PAINTED IN

Paris

MEDIUM

Oil on canvas

SIMILAR WORKS

A Midsummer Night's Dream by Thomas Grieve, 1856

Gustave Doré *Born* 1832 Strasbourg, France

Died 1883

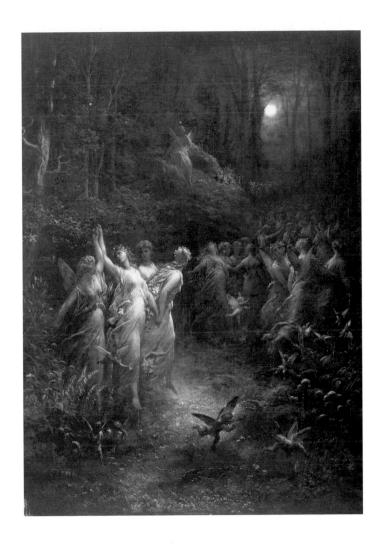

Simmons, John
There Sleeps Titania, 1872

© Private Collection/www.bridgeman.co.uk

Simmons' title refers to a line from Act II of *A Midsummer Night's Dream*: 'There sleeps Titania sometime of the night'. This episode proved particularly appealing to Victorian artists: Richard Dadd (1817–86) and Robert Huskisson (1819–61) both painted precisely the same scene (see pages 36 and 150). Simmons' version has more in common with the latter, most notably in the theatrical way that Titania is placed under a spotlight.

Simmons has emphasized the erotic charms of the fairy queen. This has raised a few modern critics' eyebrows, but the artist's contemporaries were less concerned. His career coincided with the passing of the Obscene Publications Act in 1857. This had little real impact on painters, although some shopkeepers were instructed to remove prints of nude pictures from their windows. From the outset, the Act was mainly directed against nude photographs. Here the usual defence was that they were art studies, designed for painters who were too poor to afford a live model. Simmons' work was exempt from any such problems – his nudes were acceptable partly because they were fairies, but even more so because they were illustrations of William Shakespeare (1564–1616). In their attempts to promote a national British school, the authorities did their utmost to encourage painters to tackle themes from British literature and history.

PAINTED IN

Bristol

MEDIUM

Oil on canvas

SIMILAR WORKS

The Fisherman and the Syren by Lord Frederic Leighton, c. 1856–58

John Simmons *Born* 1823 Bristol, England

Died 1876

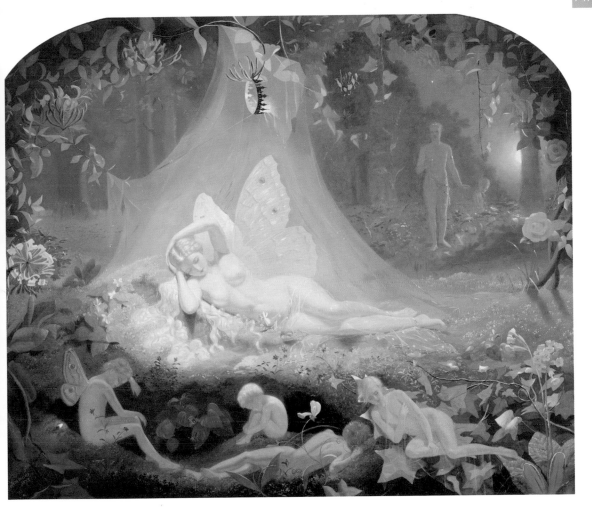

Scott, David

Oberon and Puck Listening to the Mermaid's Song, c. 1837

Scott's picture illustrates a moment from Act II of *A Midsummer Night's Dream* when Oberon recalls:

> Since once I sat upon a promontory, / And heard a mermaid on a dolphin's back
>
> Uttering such dulcet and harmonious breath / That the rude sea grew civil at her song

During this interlude, the fairy king notices one of Cupid's arrows going astray and striking a tiny flower, presumably the plant on the picture's left. Oberon would use this enchanted bloom to cast a spell over his wife. The image of the mermaid may have been suggested by the legend of Arion, a bard who escaped from pirates on a dolphin's back.

David Scott was the elder brother of William Bell Scott (1811–90), also an artist. David hoped to earn a reputation as a history painter, but his ambitions were never fulfilled. Instead he is best known for the bold colouring and imaginative vision of his Shakespearean fairy pictures. In *Puck Fleeing before the Dawn* (1837) he portrayed the creature hurtling through the air like a cannonball, while his monstrous depiction of Caliban has never been bettered.

PAINTED IN

Edinburgh

MEDIUM

Oil on canvas

SIMILAR WORKS

Oberon and Titania by Francis Danby, 1832

David Scott *Born* 1806 Scotland

Died 1849

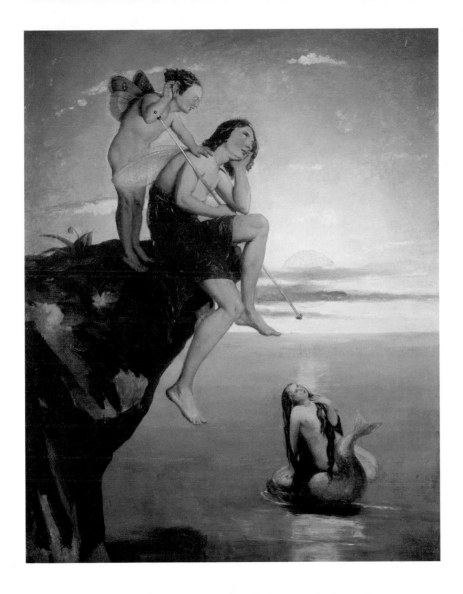

Dadd, Richard

Titania Sleeping, c. 1841

© Christie's Images Ltd

This is one of Dadd's best-loved Shakespearean paintings, illustrating an episode from Act II, Scene II of *A Midsummer Night's Dream*. It was exhibited at the Royal Academy in 1841. The catalogue entry included the relevant quotation from the play, 'There sleeps Titania sometime of the night/Lull'd in these flowers with dances and delight'. Behind the fairy queen the ominous figure of Oberon lurks in the shadows, waiting to cast his enchantment over her by squeezing juice from a magic flower into her eyes.

Dadd borrowed the compositional device of the fairy circle from *The Choice of Hercules* (*c.* 1830) by Daniel Maclise (1806–70). Other elements have been linked with older sources, in particular the kneeling fairy who is said to stem from Giorgione's (*c.* 1477–1510) *Adoration of the Shepherds* (*c.* 1504). In more general terms Titania's pose resembles the popular theme of a reclining Venus, while the central group appears to be based on a Nativity group. The most unusual feature is the eerie line of dancers, who skip off downhill, disappearing into the void. *Titania Sleeping* was well received by the critics and proved highly influential on other fairy painters, such as Huskisson and Fitzgerald. This influence is all the more significant given that so much of his later work was never seen by his contemporaries.

PAINTED IN

London

MEDIUM

Oil on canvas

SIMILAR WORKS

The Choice of Hercules by Daniel Maclise, *c.* 1830

Richard Dadd *Born* 1817 Kent, England

Died 1886

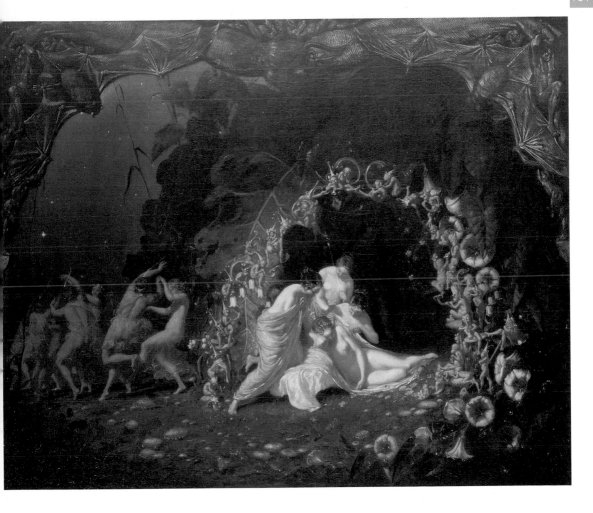

Paton, Sir Joseph Noël

Puck and Fairies, from *A Midsummer Night's Dream, c. 1850*

The character of Puck was not invented by Shakespeare, but he certainly modified it a great deal. Strictly speaking he should be described as a puck, since the word actually refers to his nature. A puck was not a fairy, but a type of hobgoblin. As such, there are links with the Irish *pooka*, the Cornish *bucca* and the Welsh *pwca*. Reports of their behaviour were very varied, but in general they were mischievous rather than malicious and on some occasions they could be willing helpers. Shakespeare's puck is identified in the text as Robin Goodfellow. The surname was a deliberate piece of flattery, designed to keep in the creature's good books. In the same way, country folk often used to leave out a bowl of milk for them to curry their favour.

In Victorian art, Puck was often shown sitting on a mushroom or toadstool. This betrayed the influence of the stage, for the character often made his first appearance in this guise. This is clearly evident in Dadd's version of the subject (see page 168). Here, a fairy mimics the usual pose while his companions serenade him and Puck looks on with apparent amusement.

PAINTED IN

Edinburgh

MEDIUM

Oil on millboard

SIMILAR WORKS

The Disenchantment of Bottom by Daniel Maclise, 1832

Sir Joseph Noël Paton *Born* 1821 Dunfermline, Scotland

Died 1901

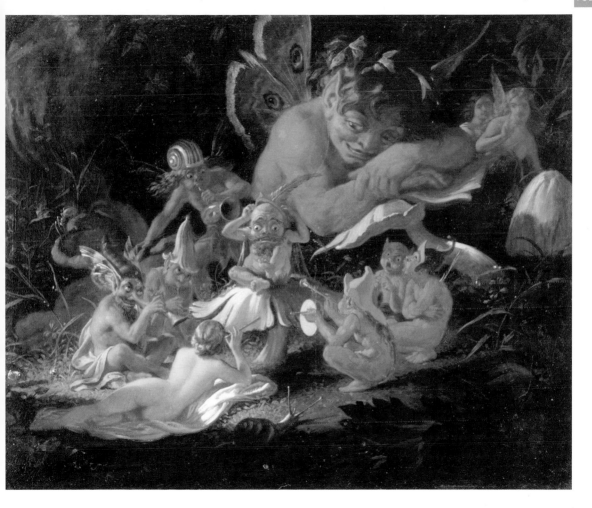

Sims, Charles
Titania's Awakening, 1896

When Queen Titania awoke, the spell was broken and she saw Bottom in his true colours. Then Oberon called for soft, magical music, which allowed the fairies to dance while the mortals remained asleep. The title inevitably conjures up this scene, but the painting itself was produced during Sims' Symbolist period, when the artist was more interested in evoking a poetic mood than any narrative event. The otherworldly musician wears the thick plumage of an angel, not the gossamer wings of a fairy. There are no celebrations here. The tone is elegiac and autumnal, as though her ethereal music is plucking the leaves from the trees.

Sims trained in Paris at the Académie Julian, but spent most of his career in England. His outstanding technique won him great critical acclaim, particularly at the Royal Academy where his breezy, outdoor subjects were especially popular. The latter part of his career, however, was clouded by tragedy. His son was killed in the trenches and he himself was traumatized by his experiences as a war artist. The strange, semi-abstract *Spirituals*, which Sims painted after the war, offered evidence of his emotional turmoil. He eventually took his own life in 1928.

PAINTED IN

London

MEDIUM

Oil on canvas

SIMILAR WORKS

The Death of the Grave-Digger by Carlos Schwabe, 1895–1900

Spirit of the Forest by Edgard Maxence

Charles Sims *Born* 1873 London, England

Died 1928

Rackham, Arthur

The Meeting of Oberon and Titania, 1905

Rackham produced this sparkling scene for the 1908 edition of *A Midsummer Night's Dream*, although in the end it was not used in the final version of the book. It depicts precisely the same episode that Paton had depicted in 1849 (see page 166), underlining the seismic changes that had taken place in the field of fairy painting during the intervening years. With their fine clothes and their regal airs, Rackham's royal couple are the stuff of pantomimes and fairy tales, quite unlike the nude, Classical figures of Paton. More significantly his fairies are well-mannered children, content to hold lanterns and carry their masters' trains, while Paton's creatures cavort lustily in the undergrowth.

Shakespeare derived his fairies from a number of different sources. Oberon stems from *Huon of Bordeaux*, a thirteenth-century romance that was first translated into English by Lord Berners (*c.* 1469–1533). In this, Huon performs a number of seemingly impossible tasks, with the magical assistance of the fairy king. Titania, meanwhile, came from a Classical source. Ovid (43 BC–AD 17) had used the name to describe a number of female woodland spirits who were descended from the Titans, an ancient race of Greek gods. Puck, or Robin Goodfellow, was well known from English folklore, but Shakespeare may have found additional information in Reginald Scot's (*c.* 1538–99) *Discoverie of Witchcraft* (1584).

PAINTED IN

London

MEDIUM

Pen, ink and watercolour

SIMILAR WORKS

Come Unto These Yellow Sands by Thomas Maybank

Arthur Rackham *Born* 1867 London, England

Died 1939

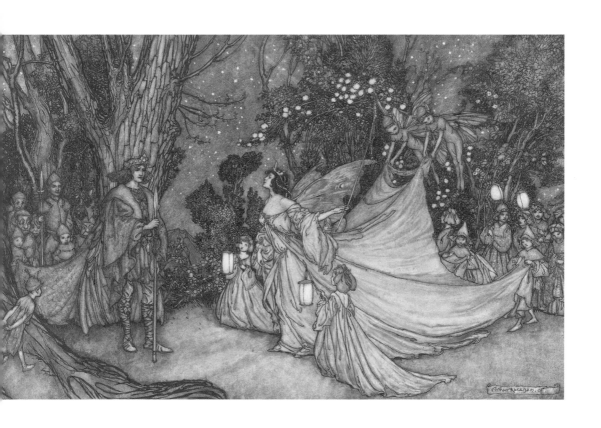

Von Herkomer, Sir Hubert

Bottom Asleep, 1891

Shakespeare is thought to have had two sources in mind when creating the character of Bottom. Firstly there was the famous legend of King Midas, who was given the ears of an ass after offending Apollo. In addition there was the tale of Apuleius in *The Golden Ass*, in which the narrator persuades his mistress to steal a jar of ointment from a witch in the hope that it will transform him into a bird. Instead, to his dismay, he finds himself turned into an ass. During this transformation period, however, a friendly maid offers to "finely combe thy maine" and "tye up thy rugged tayle", which may have given the playwright the idea for Titania's flirtation.

Herkomer became best known as a portraitist, although he worked successfully in several different fields. His most celebrated painting was *The Last Muster – Sunday at the Royal Hospital, Chelsea*, a patriotic celebration of British military pride. Throughout his life he was passionate about the stage, running his own private theatre at Bushey in Hertfordshire. He also set up an art school there in 1883, where William Nicholson (1872–1949) became one of his pupils.

PAINTED IN

Bushey, Hertfordshire

MEDIUM

Oil on canvas

SIMILAR WORKS

Scene from A Midsummer Night's Dream by Sir Edwin Henry Landseer, 1848

Titania and Bottom by Sir Edwin Henry Landseer, 1851

Sir Hubert von Herkomer *Born* 1849 Waal, Bavaria

Died 1914

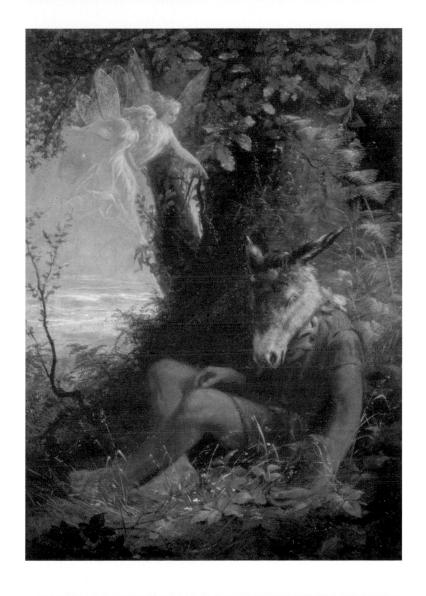

Simmons, John
Hermia and Lysander

Hermia and Lysander are the two young lovers who elope from Athens after their romance meets with parental disapproval. They spend the night in the woods, where life becomes more complicated after Puck places the magical juice in Lysander's eye, causing him to fall for Helena. Simmons' painting depicts the interlude before Puck's interference, when the couple are so blinded by love that they do not notice the swarms of tiny fairies who are busily engaged all around them.

It is no accident that most of the action of *A Midsummer Night's Dream* takes place in a wood. In Tudor times 'wood' was an everyday term for 'mad', and Shakespeare used this to punning effect throughout the course of the play. Thus Demetrius describes himself as 'wood (i.e. frantic) within this wood/Because I cannot meet my Hermia.' (Act II, Scene I, 192–3). The wooing of the lovers offered scope for further puns – Helena and Hermia are wooed within a wood. The irrational overtones of a wood made it a suitable environment for fairies. Moonlight, too, had similar associations. It was a symbol of change and inconstancy, while lunacy gained its name from the belief that madness was brought on by the Moon.

PAINTED IN

Bristol

MEDIUM

Watercolour and body colour

SIMILAR WORKS

Early Lovers by Frederick Smallfield

John Simmons *Born* 1823 Bristol, England

Died 1876

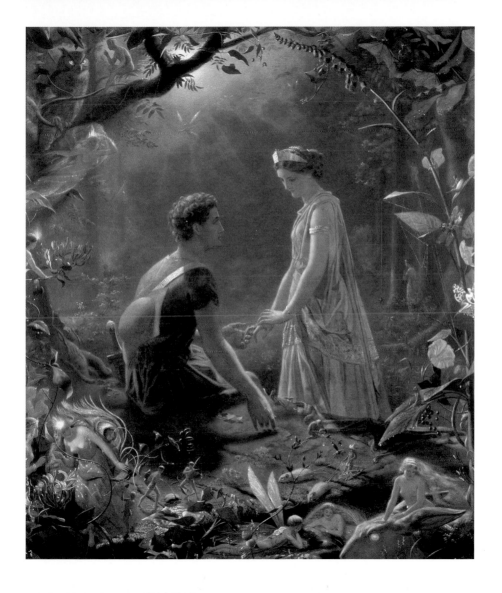

Paton, Sir Joseph Noël
Titania and the Indian Boy

In *A Midsummer Night's Dream*, a young Indian prince who has been kidnapped by the fairies is the cause of a bitter dispute between Titania and Oberon. The latter wishes to have the child as his page, but Titania refuses to part with him out of a sense of friendship. The boy's mother had been a worshipper of her cult before dying in childbirth, and she is determined to bring him up in her bower. Paton's picture illustrates this point, using a passage near the start of Act II where 'she perforce withholds the loved boy,/Crowns him with flowers, and makes him all her joy'.

Shakespeare probably got the idea of using an Indian boy from *Huon of Bordeaux*, his source for the character of Oberon. In the book, Huon crosses paths with the fairies while he is travelling east, on his way to meet up with the fairest maid in all of India. The precise location, however, was immaterial. The main idea was to underline the supernatural powers of the fairies by showing that they could fly to the other side of the globe with ease.

PAINTED IN

Edinburgh

SIMILAR WORKS

Fairy Lovers in a Bird's Nest by John Anster Fitzgerald, 1860

The Mother's Blessing by Robert Huskisson, c. 1848

Sir Joseph Noël Paton *Born* 1821 Dunfermline, Scotland

Died 1901

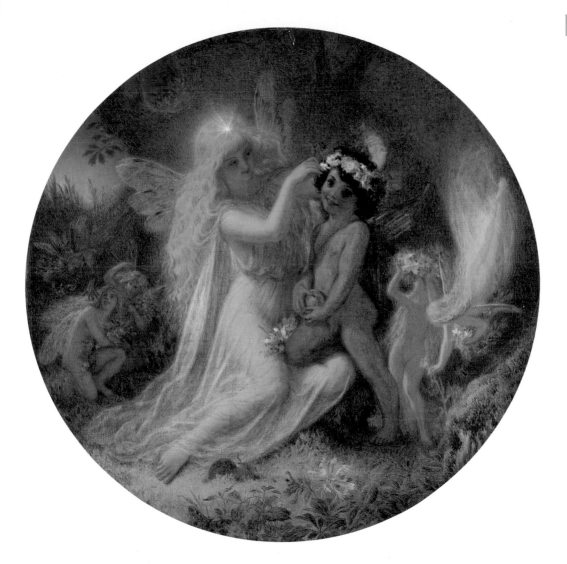

Wilhelm, Charles
The Bindweed Fairy, costume design

Wilhelm created this costume design for R. Courtneidge's production of *A Midsummer Night's Dream* at the Princes Theatre in Manchester. Bindweed is not a named member of Shakespeare's cast, but by the end of the nineteenth century the link between flowers and fairies had become so ingrained that it was natural for Wilhelm to use different plants as a linking theme for Titania's attendants. Wilhelm himself was one of the most prolific costume designers in the Edwardian era. He is remembered in particular for his work on pantomimes, and he also produced the costumes for one of the earliest stagings of *Peter Pan*.

Shakespeare made great play of the diminutive size of his fairies, so it is likely that he used child actors for these parts. Over the years directors have come up with some highly imaginative variations on this theme. During the Romantic era they were usually portrayed as ballet dancers dressed in white gauze, whether adult women or children. In Harley Granville-Barker's (1877–1946) revolutionary 1914 production, however, they were covered in gold paint, resembling Indian deities. In 1954 George Devine (1910–65) opted for feathered, bird-like costumes, while in Peter Brook's (b. 1925) startling version of 1970 the fairies were interpreted as adult, male circus performers.

PAINTED IN

London

MEDIUM

Pen, ink and watercolour

SIMILAR WORKS

A Fairy Scene, Rothkäppchen by Edward Henry Corbould

Charles Wilhelm *Born* 1858 England

Died 1925

Paton, Sir Joseph Noël
The Quarrel of Oberon and Titania, 1849

This depicts the first encounter between Titania and Oberon in *A Midsummer Night's Dream*. He chides her for failing in her wifely duties by keeping the Indian boy from him. Titania accuses Oberon of stealing away from fairyland to play on his pipes and seduce young women, a detail that may have inspired Paton to include the statue of Pan on the right.

Paton had produced a smaller version of this scene in 1846, but this is his definitive treatment of the subject. It forms an obvious companion piece to *The Reconciliation of Oberon and Titania* (see page 28). These two pictures did much to secure Paton's reputation. *The Reconciliation* won a £300 prize in the Westminster Hall Competition, while *The Quarrel* was received with great acclaim when it was exhibited at the Royal Scottish Academy in 1850. Critics were especially impressed by the amount of detail that he had managed to cram into the scene. Lewis Carroll (1832–98) reported excitedly that he counted 165 fairies when he saw the picture in 1857. Paton himself has often been described as the Scottish Pre-Raphaelite. He became a friend of John Millais (1829–96) when they trained together at the Royal Academy and, if he had not returned to Scotland in 1844, Paton would almost certainly have become a member of the Brotherhood.

PAINTED IN

Edinburgh

MEDIUM

Oil on canvas

SIMILAR WORKS

Isabella by Sir John Everett Millais, 1848–49

Sir Joseph Noël Paton *Born* 1821 Dunfermline, Scotland

Died 1901

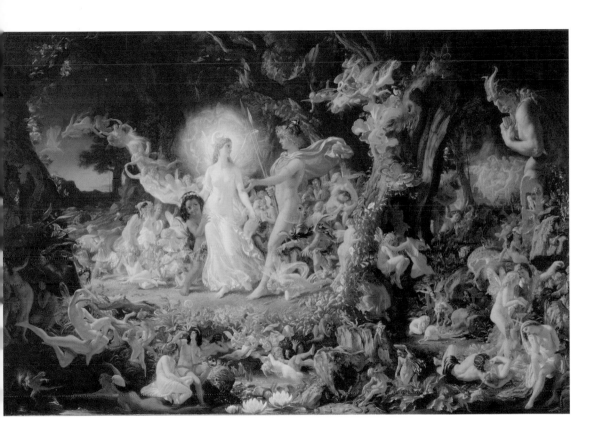

Dadd, Richard

Puck, 1841

Dadd began painting fairy pictures in the early 1840s, shortly after completing his studies at the Royal Academy. *Puck* was exhibited at the Society of British Artists in 1841, receiving considerable acclaim. In particular there was praise for the clever lighting, with the Moon behind the central figure throwing a spotlight on the action and creating a charming, dreamlike atmosphere. Together with the success of *Titania Sleeping* (see page 150) in the same year, it helped to establish Dadd as a rising star in this field. In some ways the two paintings can be seen as companion pieces, even though *Puck* does not illustrate a precise moment in Shakespeare's play.

Some writers equated Puck with the devil, but for Shakespeare he was 'a merry wanderer of the night', a mischievous hobgoblin who loved to lead innocent wayfarers astray. This sense of mischief is barely apparent in Dadd's painting, where the character is portrayed as an infant boy. His probable source of inspiration was Sir Joshua Reynold's (1723–92) version of the subject, which was commissioned in 1789 by Alderman Boydell, the founder of the Shakespeare Gallery. He had used as his model a small child, who turned up at the door of his studio in Leicester Fields.

PAINTED IN

London

MEDIUM

Oil on canvas

SIMILAR WORKS

Puck by William B. Essex, 1847

The Faun and the Fairies by Daniel Maclise, c. 1834

Richard Dadd *Born* 1817 Kent, England

Died 1886

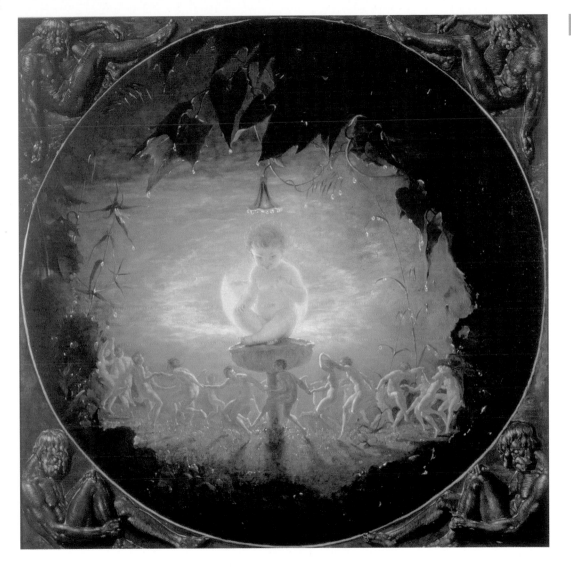

Fitzgerald, John Anster
The Fairy Barque, 1860

This is a variation of one of Fitzgerald's favourite themes, the fairy banquet. Here the fairy queen and her consort glide along in a giant water lily, while one of her attendants offers them sustenance. Meanwhile, the barque is gently propelled with bull-rushes by two other members of her retinue: one a sweet-faced fairy girl, the other a monstrous bird-like creature.

The real star of the show is the lily itself. The flower gleams brightly and appears to be the only light source in the picture. Almost certainly this was inspired by a contemporary event, as Joseph Paxton had recently succeeded in cultivating the *Victoria Regia* (a giant water lily) in England for the first time. The feat was widely recorded in the press, and in the *Illustrated London News* there was a picture of Paxton's daughter standing on one of the huge leaves. The topicality of the subject may have persuaded Fitzgerald to exhibit the painting. Accordingly, it appeared at the British Institution in 1860, with a price tag of £35. Although the artist frequently exhibited his more conventional work, he rarely showed his fairy pictures. For this reason, no doubt, *The Fairy Barque* displays no hint of the cruelty that is often present in his paintings.

PAINTED IN

London

MEDIUM

Oil on canvas

SIMILAR WORKS

Midsummer Fairies by Etheline E. Dell

Fairies among Mushrooms by Thomas Heatherley

John Anster Fitzgerald *Born* 1832 London, England

Died 1906

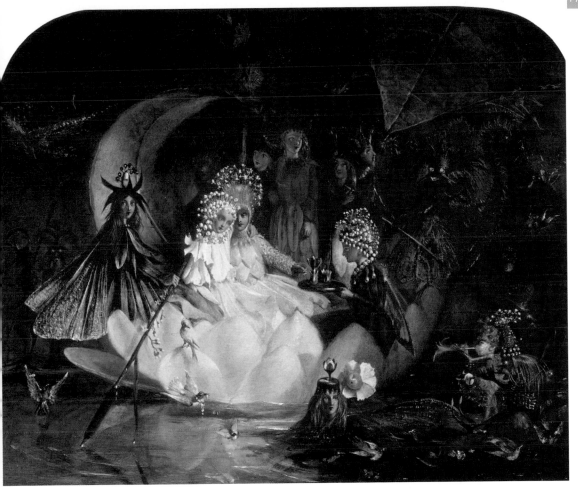

Doré, Gustave

The Fairies: A Scene Drawn from Shakespeare, 1873

Despite the title, Doré's picture is a very loose adaptation from *A Midsummer Night's Dream*. Oberon and Titania have been reconciled and now preside over the fairy revels. The tiny creatures flock to their leaders from all quarters and can even be seen silhouetted against the Moon. Oberon's somewhat effeminate appearance can be explained by the fact that the part was often played by a woman. The differences in scale are specified in Shakespeare's play. Titania is large enough to cradle Bottom's head in her lap, while her attendants are noted for their minute stature. They are tiny enough to crawl inside flowers or pick fights with bees.

Gustave Doré was a hugely versatile artist, who is probably better remembered now as a book illustrator rather than a painter. He had a gift for depicting the fantastic, as his illustrations for Dante's (1265–1321) *Inferno* (c. 1314) and Samuel Taylor Coleridge's (1772–1834) *Rime of the Ancient Mariner* (1798) confirm. However, when the occasion arose, he could also be grimly realistic. His scenes of London's slums, for example, were much admired by Van Gogh (1853–90). Indeed, his work was highly popular in England, and from 1868 to 1892 there was a Doré Gallery in New Bond Street, in London.

PAINTED IN

Paris

MEDIUM

Oil on canvas

SIMILAR WORKS

The Dragon Chariot by Charles Altamont Doyle

Gustave Doré *Born* 1832 Strasbourg, France

Died 1883

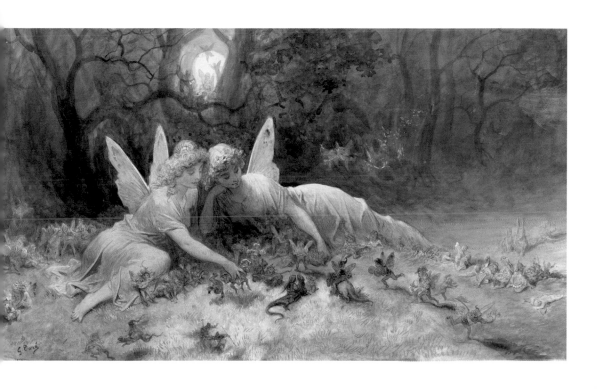

Fitzgerald, John Anster
Ariel, c. 1858–68

Fitzgerald rarely produced paintings that focused on a single figure, but he made an exception with *Ariel*. Shakespeare's 'airy' spirit reclines on the branch of a hawthorn tree, while exotic birds from Prospero's island flutter around him. The choice of tree was significant. According to a widely held superstition, it was unlucky to cut down hawthorns since fairies hid in them. Fitzgerald was clearly fascinated with the character as he produced another painting of Ariel, showing him trapped in the cloven pine, where he had been placed by the witch, Sycorax.

Ariel has always been a difficult character to define. Strictly speaking he is not a fairy, although his powers resemble theirs. He has been described as an elemental (it is he who conjures up the storm at the start of *The Tempest*) or a sylph (a spirit of the air). On stage he has been played by male and female actors. For Shakespearean audiences the name would also have prompted some literary associations. Uriel was the name of one of the seven principal archangels, as well as a magical spirit involved in John Dee's (1527–1608) controversial experiments. Ariel was also mentioned in the Old Testament, as a name for Jerusalem (*Isaiah XXIX*).

PAINTED IN

London

MEDIUM

Watercolour and gouache on paper

SIMILAR WORKS

Priscilla Horton as Ariel by Daniel Maclise, *c.* 1838

John Anster Fitzgerald *Born* 1832 London, England

Died 1906

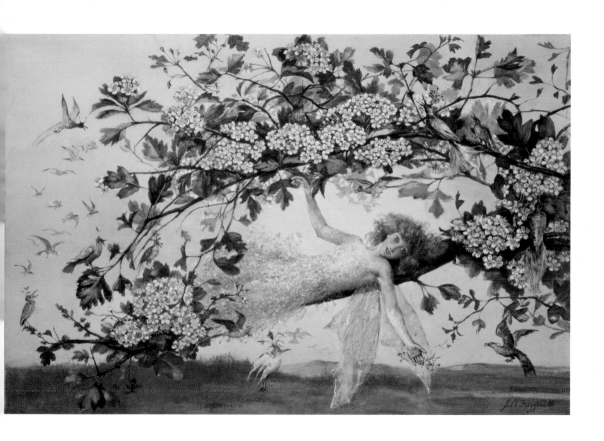

Millais, Sir John Everett
Ferdinand Lured by Ariel, 1849

The subject is drawn from Act I, Scene II of *The Tempest*, where Ferdinand has been shipwrecked on Prospero's island. Ariel, the latter's servant, lures the young man towards his master by whispering the false news that his father has perished in the storm:

Full fathom five thy father lies; / Of his bones are corals made;

Those are pearls that were his eyes...

Ferdinand is baffled by the invisible informant ('Where should this music be? i' the air or the earth?'), but consents to be taken to Prospero, carried by the strange bats that are pictured on the left.

Millais' picture was a bold invention, quite unlike the stagey depictions of Shakespearean fairy subjects that were popular at the time. He took great care to make the human elements appear as realistic as possible. Ferdinand's outfit was taken from Camille Bonnard's *Costumes Historiques,* and the background details were painted with immense precision, right down to the lizard in the corner. In spite of this, he experienced some difficulty in selling the picture. A dealer had reserved it in advance, but withdrew his offer when he saw the finished work. He was disappointed, it appears, with the fairy elements, which lacked the coy eroticism that had become the norm in Victorian fairy scenes.

PAINTED IN

London

MEDIUM

Oil on panel

SIMILAR WORKS

Puck (sculpture) by Thomas Woolner, 1845–47

Sir John Everett Millais *Born* 1829 Southampton, England

Died 1896

Dadd, Richard

Come unto these yellow sands, 1842

This is probably the finest of Dadd's early fairy pictures. It also has considerable poignancy, given that it was the last picture the artist completed before embarking on the fatal journey during which he lost his sanity.

The subject is taken from Act II of *The Tempest*. Ariel is wearing the sea-nymph costume, which renders him invisible to all but Prospero. In this guise he plays and sings the following tune:

Come unto these yellow sands, / And then take hands;

Curtsied when you have, and kissed / The wild waves whist...

Ariel's sprites dance obediently and as they do so, the storm begins to abate. Ferdinand hears their music, but sees nothing.

Dadd exhibited the picture at the Royal Academy and the Liverpool Academy, where it was shown under a different title (*Fairies holding their Revels on the Sea Shore at Night*). The critical response was highly favourable. The reviewer from the *Art Union* remarked that "it approaches more nearly to the essence of the poet than any other illustrations we have seen". The eerie lighting successfully conveys the stormy atmosphere, while the composition has a distinctly theatrical flavour. The sprites dance on their toes, resembling the ballet dancers in Marie Taglioni's London productions.

PAINTED IN

London

MEDIUM

Oil on canvas

SIMILAR WORKS

'Come unto these yellow sands' by Henry Stanier

Richard Dadd *Born* 1817 Kent, England

Died 1886

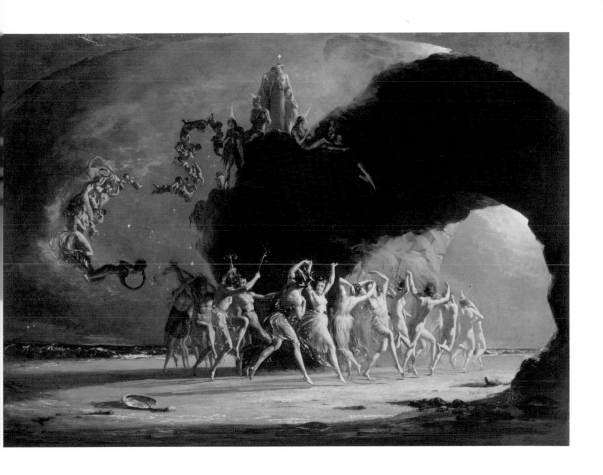

Scott, William Bell

Ariel and Caliban, 1865

Scott's picture illustrates a scene from *The Tempest*, where Ariel pours scorn on Caliban and his friends:

> At last I left them, / In the filthy mantled pool beyond your cell
>
> There dancing up to th' chins, that foul lake / O'erstunk their feet...

The theme had a particular interest for Scott, as it provided the subject for one of his brother's (David Scott) finest paintings. William noted that it was "the most truly poetic production of the painter" and proceeded to explain his interpretation of the characters, who represented "the two poles of human nature; the ascending and descending forces of mind and matter". William adopted this view in his own version of the theme, although his Caliban is far less grotesque than David's.

There has been much discussion about Shakespeare's source for Caliban. Some authorities have noted that the name is almost an anagram of 'cannibal', speculating that it may have been inspired by some of the more lurid travellers' tales about life in the New World. During the latter part of the nineteenth century, the character became associated with Charles Darwin's (1809–82) discoveries about evolution. In several productions Caliban was portrayed as 'the missing link', a creature that lay halfway between ape and man.

PAINTED IN

London

MEDIUM

Oil on canvas

SIMILAR WORKS

Ariel and Caliban by David Scott, 1837

William Bell Scott *Born* 1811 Edinburgh, Scotland

Died 1890

Rheam, Henry Meynell
The Fairy Wood, 1903

Rheam painted a series of paintings in a rich, Pre-Raphaelite vein, showing beautiful young women lost in the woods. Here, a high-born maiden is led away from the safety of the open country. Unwarily she is treading on a bluebell patch where fairy enchantments are at their strongest. Bluebell woods are also the haunts of the notorious oak men, with their red toadstool caps. Although most fairy painters looked to Shakespeare as a source, they also associated fairies with the Middle Ages. In particular they linked the period with Morgan le Fay, the fairy sister of King Arthur, who was known for her skills as a sorceress.

Rheam was born in Birkenhead, but pursued his studies in London and Paris. After his return he made his name as a watercolourist. He lived for a time in Polperro, but spent most of his life in Newlyn, a Cornish fishing port. This may seem surprising since his work could hardly have been more different from that of the Newlyn School, the local artists' colony. Its leader, Stanhope Forbes (1857–1947), insisted that Rheam was persuaded to join them in Newlyn because of his skill as a cricketer, so that he could play for their team against the rival colony at St Ives.

PAINTED IN

Newlyn, Cornwall

MEDIUM

Watercolour and body colour

SIMILAR WORKS

The Dead Knight by Robert Bateman

Henry Meynell Rheam *Born* 1859 Birkenhead, England

Died 1920

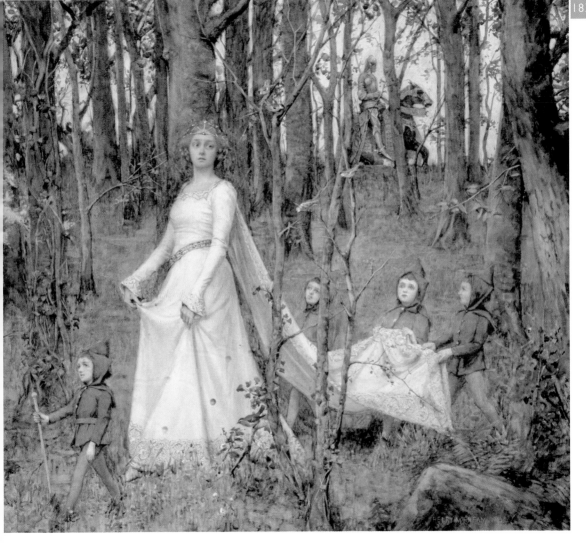

Doyle, Richard

The Attar Cup in Aagerup: The Moment of Departure

Doyle's painting illustrates a scene from a Danish legend, which was published in *The Fairy Mythology* (1828) by Thomas Keightley (1789–1872). In the story, a farmhand from the village of Aagerup spends a night in the woods cavorting with trolls. Here, as the night draws to a close, he mounts his horse and prepares to depart. As he does so one of the trolls hands him a stirrup cup. The picture is charming, although clearly Doyle had not been briefed on the nature of trolls. Originally they were conceived as malignant giants, but Scandinavians later saw them as mischievous dwarves. In his painting, however, Doyle depicted them as fairies. More specifically he portrayed them as the type of fairies that could be seen at the ballet.

In common with other art forms, ballet was affected by the craze for fairies. *Giselle, Ondine* and *La Sylphide* all had fairy themes. Ballet, in turn, had its own impact on the visual arts. Here, for example, Doyle depicts the new technique of dancing on pointes. Traditionally this innovation is ascribed to Amalia Brugnoli, but it was pioneered in England by Marie Taglioni. She made her London debut in 1830, appearing in Didelot's ballet *Flore et Zéphyr*.

PAINTED IN

London

MEDIUM

Watercolour on paper

SIMILAR WORKS

Marie Taglioni in La Sylphide by Alfred Edward Chalon, 1845

Fairy Seated on a Mushroom by Thomas Heatherley, c. 1860

Richard Doyle *Born* 1824 London, England

Died 1883

Froud, Brian
The Elfin Maid, 1976

Female fairies were often seen as great seductresses, captivating men with their beauty, but romances between mortals and fairies were perilous affairs, usually doomed to end in failure. Male elves were normally depicted as squat and ugly, but their female counterparts were very different. Under moonlight, in particular, elf maidens had a shimmering allure that most men found irresistible. They sang as sweetly as the sirens and their dances were full of grace and sensuality. They always faced their suitors, however, for elves have hollow backs. From behind they resemble trees struck by lightning. There are many stories of young men falling in love with elves. Sometimes they are lured away and never return; if they do, they are damaged in some way: crippled, speechless or befuddled. In their hearts they always remain under the spell of their elf maid.

Froud has reinvigorated the fairy genre, taking it out of the nursery and returning it to the adult world. His work has a particularly strong appeal for New Age enthusiasts, with their interest in Celtic myths, traditional folklore and alternative forms of spiritual belief. Some of his subjects have a medieval flavour, which harks back to the Victorian taste for Arthurian themes, but is also reminiscent of the contemporary movement by the Brotherhood of Ruralists.

PAINTED IN

Chagford, Devon

SIMILAR WORKS

His Helmet Now Shall Make a Hive for Bees by John Morley

Brian Froud *Born* 1947 Winchester, England

Burns, Robert
Sir Galahad, 1891

Sir Galahad was 'the spotless knight', the purest and most noble of King Arthur's followers. The son of Lancelot and Elaine, he was the last to take his seat at the Round Table, the seat known as the 'siege perilous', which was reserved for the greatest knight of all. Galahad merited this title not just because of his strength and valour, but also because of his flawless character. This enabled him to succeed in the quest for the Holy Grail. Here, three angels appear to the knight in a vision, together with the Grail itself – the chalice used by Christ at the Last Supper.

Arthurian subjects became extremely popular during the Victorian period. In part this stemmed from various artistic influences: the novels of Sir Walter Scott (1771–1832), the poems of Alfred, Lord Tennyson (1809–92), and the paintings of the Pre-Raphaelites. On another level, though, it echoed a revival of interest in the concept of chivalry. For many Victorians, Sir Galahad's blend of courage, honour and piety made him the ideal role model for the modern gentleman. As a result, knightly images were featured on a wide variety of objects, ranging from sporting trophies (such as the Queen's Cup, Ascot) to war memorials and school certificates.

PAINTED IN

Paris

SIMILAR WORKS

Chivalry by Francis Bernard Dicksee, 1885

Robert Burns *Born* 1869 Scotland

Died 1941

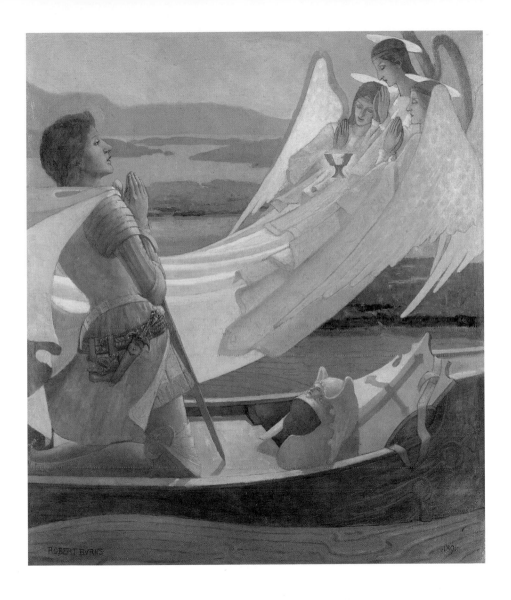

Paton, Sir Joseph Noël

Cymochles and Phaedria Crossing the Lake of Idleness in an Enchanted Boat

© Sotheby's Picture Library

The subject is taken from *The Faerie Queene* by Edmund Spenser (*c.* 1552–99). Cymochles is a knight seeking an adversary to fight a duel of honour. On the way he is deflected from his purpose by Phaedria, a sensuous damsel who offers to ferry him across the Lake of Idleness. She beguiles him with her charms, and he forgets his duty. Spenser's characters are allegorical. Cymochles is a waverer, fluctuating between action and indolence, while Phaedria symbolizes immodesty.

 The Faerie Queene appealed to Victorians for a variety of reasons. The work's central theme was Arthur's quest for a virtuous queen, Gloriana. Spenser had visualized the latter as Elizabeth I, but in the nineteenth century the term seemed equally applicable to Victoria. Arthurian subjects were a popular form of escapism because they evoked a vanished age of chivalry and romance, yet were also highly moral. This painting is about duty and honour, qualities very real to the Victorians. Phaedria is a cross between Venus and an enchantress. She bears many of the attributes of the goddess of love, but here her powers are sinful. Her cupid revels at the knight's downfall, while the serpent on her boat represents temptation.

PAINTED IN

Edinburgh

MEDIUM

Oil on canvas

SIMILAR WORKS

The Four Queens Find Lancelot Sleeping by Frank Cadogan Cowper, 1954

Sir Joseph Noël Paton *Born* 1821 Dunfermline, Scotland

Died 1901

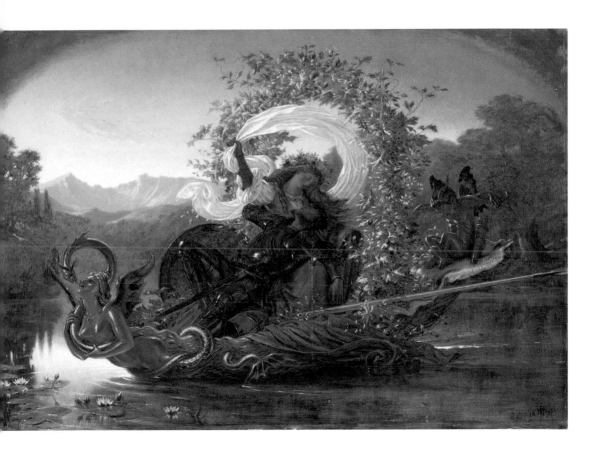

Solomon, Solomon Joseph
Laus Deo!

In this splendid painting, Solomon conjures up all the glamour and adventure of the Middle Ages, but reinterprets it in a very Victorian fashion. His knight is embarking on a noble quest. He is dressed for combat and the fearsome creature depicted on his saddle evokes the image of the dragon-slaying heroes of medieval romance. There is love on his mind, symbolized by the cherub who garlands him with flowers, but uppermost in his thoughts is his duty to God. The lady at his shoulder wears a halo and behind her a church is visible in the distance. As he rides, the knight also utters the words *Laus Deo* ('Praise be to God'). Solomon was actually the head of a family of well-known Jewish painters, and sometimes painted Jewish and Old Testament pictures as well as genre subjects.

The Victorians as a whole embraced the notion of muscular Christianity, frequently linking the image of an all-powerful God with the strength and determination of an army. It is no coincidence that the quintessential Victorian hymn, written in 1865 by Sabine Baring-Gould, begins with the line, 'Onward Christian soldiers, marching as to war'. In the same way it is significant that when William Booth (1829–1912) founded his charitable organization in 1865 he called it the Salvation Army. Adopting the title of 'General' he ran the institution on semi-military lines and gave it a distinctly martial motto, 'Through Blood and Fire'.

PAINTED IN

London

MEDIUM

Oil on canvas

SIMILAR WORKS

Sir Isumbras at the Ford by Sir John Everett Millais, 1857

Solomon Joseph Solomon *Born* 1860 England

Died 1927

Wagrez, Jacques-Clément
Eros, 1876

© Sotheby's Picture Library

By the latter part of the nineteenth century, depictions of Cupid or Eros had often become cloyingly sentimental. This painting by Wagrez, however, captures the spirit of the ancient deity. Eros is portrayed as a mischievous youth taking pot shots at passers-by who come within his range. The relaxed pose emphasizes that as far as he is concerned, he is engaged in a game, rather than a serious piece of marksmanship. The victims are chosen at random and, like any irresponsible child, Eros takes no interest in the serious effects that his arrows may cause.

For the Greeks, this behaviour mirrored the cruel and unpredictable nature of lust itself. Accordingly the earliest depictions of the deity portrayed him as a Ker, a winged 'Spite'. In this guise he was bracketed alongside other banes of human existence such as sickness and old age. During the Renaissance he was often shown blindfolded. For some commentators this referred to the randomness of Cupid's targets, while also underlining the 'blind' or irrational behaviour that could ensue when someone fell in love. Others conversely saw it as an illustration of spiritual love. Hence Shakespeare's remark, 'Love looks not with the eyes, but with the mind;/And therefore is wing'd Cupid painted blind'.

PAINTED IN

Paris

MEDIUM

Oil on canvas

SIMILAR WORKS

The Poet by Alexandre Séon

Pan and Psyche by Sir Edward Coley Burne-Jones, *c.* 1872–74

Jacques-Clément Wagrez *Born* 1846 France

Died 1908

Seignac, Guillaume
The Wings of Desire

© Sotheby's Picture Library

Although known as the Roman god of love, Cupid is linked more specifically with desire (the Latin word *cupido* means 'desire'). Similarly, when humanist philosophers wrote about Cupid and Psyche, they described them as an allegory of the union between Desire (Cupid) and the Soul (Psyche), which produced Pleasure as its offspring. In artistic terms, the status of Cupid was often downgraded. Venus was seen as the presiding deity of love and he was cast in the role of her son or one of her attendants. This role is emphasized here by the red roses that adorn his hair. These blooms were sacred to Venus and were one of her chief attributes. This stems from the legend that the first red rose was created when she pricked her foot on a thorn and stained a white rose crimson with her blood.

In nineteenth-century art, painters often used the theme of Cupid simply as a pretext for portraying a pretty child. The celebration of childhood was a new development. Children featured prominently in the novels of Charles Dickens (1812–70) and Mark Twain (1835–1910), while artists illustrated scenes from their everyday lives. Sentimental images such as this were often copied as oleographs or tapestries and hung in the family home.

PAINTED IN

Paris

MEDIUM

Oil on canvas

SIMILAR WORKS

New Risen Hope by Annie Swynnerton

Love Locked Out by Anna Lea Merritt, 1889

Guillaume Seignac *Born* 1870 France

Died 1924

Medard, Eugène

L'Amour et Psyche ('Cupid and Psyche'), 1878

© Sotheby's Picture Library

This tangled tale revolved around Psyche, a young maiden whose beauty won her great renown. It even aroused the jealousy of Venus, who sent her son, Cupid, to unleash one of his arrows at the girl so that she would become infatuated with some hideous creature. This cruel plot backfired, however, and Cupid himself fell in love with her. He installed Psyche in his palace and came to her chamber every night under cover of darkness. He also forbade her to try and look upon his face. Psyche soon fell under the spell of this mysterious stranger, but was fearful of his insistence on secrecy. Eventually her curiosity got the better of her and she lit her lamp. Unfortunately a drop of hot oil fell on Cupid's skin, waking him instantly. He was furious at her disobedience and immediately flew off. Here Medard illustrates her vain attempt to hold him back.

Because of its ancient origins, most artists tended to depict this story in a Classical manner, laying particular emphasis on the study of the nude form. This version, however, is more akin to the Romantic fantasies about knights and damsels. Even the silhouette of Cupid's palace resembles a medieval castle.

PAINTED IN

Paris

MEDIUM

Oil on canvas

SIMILAR WORKS

Lamia by John William Waterhouse, 1909

Boreas and Oreithyia by Evelyn de Morgan, 1896

Eugène Medard *Born* 1847 France

Died 1887

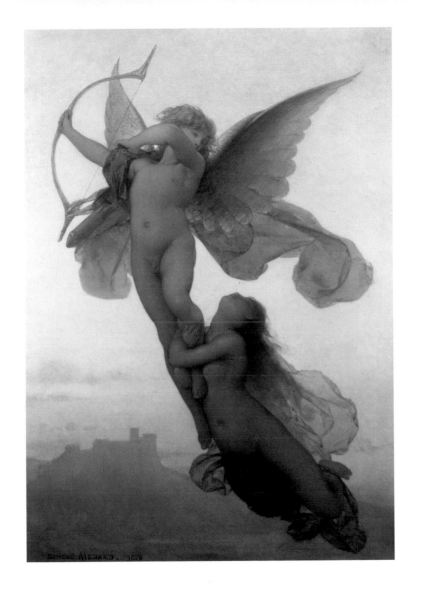

Stanhope, John Roddam Spencer
Love and the Maiden, 1877

Throughout his career, Stanhope was closely associated with the Pre-Raphaelite circle. He helped paint the murals in the Oxford Union, he had a studio next to Rossetti and he was a lifelong friend of Burne-Jones. He also shared their interests, most notably their devotion to early Italian art. This picture, for example, has affinities with Botticelli's (*c.* 1445–1510) *Primavera*. The dancers in the background are reminiscent of the Graces, while the profusion of flowers helps to conjure up a dreamlike atmosphere.

Stylistically Stanhope was chiefly influenced by Burne-Jones. His figures have the same pale, languid air. He also followed the latter's experiments with 'subjectless' paintings, paintings that evoked a mood rather than a specific storyline. In this instance, Stanhope appears to be depicting a scene from a Classical legend or a literary source, but neither of these is clearly identified. The title is deliberately vague. Instead the artist offers his public the suggestion of a romance: a young woman has apparently been struck by one of Cupid's arrows and gazes up adoringly at the love god, while he hurries off, seemingly oblivious to her. From these bare elements the spectator must use their imagination to create their own narrative.

PAINTED IN

London

MEDIUM

Tempera with gold paint and gold leaf on canvas

SIMILAR WORKS

The Bower Meadow by Dante Gabriel Rossetti, 1872

Love Among the Ruins by Sir Edward Coley Burne-Jones, 1870–73

John Roddam Spencer Stanhope *Born* 1829 Barnsley, England

Died 1908

Millais, Sir John Everett

Youth, c. 1847

Millais painted this charming scene at the start of his career, producing several versions of the subject. It was originally intended as part of a series on the *Four Ages of Man*. A young man is spending time with his lady love. While he caresses her, one of her pet dogs nudges his knee, anxious for attention. In a more complete version of the theme, now housed at Leeds City Art Gallery, two cherubs can also be seen hiding in bushes on the right-hand side of the picture looking on with amusement.

Millais was one of the founder members of the Pre-Raphaelite Brotherhood, an influential group which wished to recapture the directness and simplicity of early Italian art prior to the time of Raphael (1483–1520). In pursuing this aim they set many of their pictures in a romanticized, medieval environment just as Millais has done here. The use of cherubs in this fashion, however, was contrary to the spirit of the movement. It was far more typical of the Rococo era, when artists such as Jean-Honoré Fragonard (1732–1806) and Jean-Antoine Watteau (1684–1721) used them to help create a mood of love and pleasure. In many cases their cherubs appeared as living statues, eavesdropping on an amorous liaison.

PAINTED IN

London

MEDIUM

Oil on board

SIMILAR WORKS

Claudio and Isabella by William Holman Hunt, c. 1850

The Wedding of St. George and Princess Sabra by Dante Gabriel Rossetti, 1857

Sir John Everett Millais *Born* 1829 Southampton, England

Died 1896

Mowbray, Henry Siddons

The Marriage of Persephone, c. 1890

According to Greek mythology, Persephone was the daughter of Zeus and Demeter. One day she was out in the fields picking flowers with her friends when she caught the eye of Pluto, the god of the underworld. He had just been struck by one of Cupid's arrows and was immediately captivated by her beauty. Gathering her up in his chariot, he opened a chasm in the earth's surface and swept her off to Hades, his subterranean domain. Demeter, the corn goddess who ensured continual summer, was inconsolable at her daughter's disappearance. In her grief she let the fields become barren and no crops grew. Seeing this, Zeus gave orders for a compromise. Persephone was to be returned, provided she had eaten nothing during her captivity. Unfortunately for the unwilling bride she had consumed six pomegranate seeds and was thus only allowed to surface for six months of the year, which were to become spring and summer. For the remainder she was obliged to return to the underworld, during which autumn and winter would occur.

This picture illustrates Persephone leaving her friends to rejoin her husband. She is led to him by Hermes, shown with the winged helmet, who traditionally escorted the dead to Hades. In spite of the relationship's reluctant nature, Persephone was frequently depicted with symbols of love, such as Cupid and winged cherubic *amoretti*.

PAINTED IN

New York

MEDIUM

Oil on canvas

SIMILAR WORKS

Phryne at the Festival of Poseidon, God of the Seas by Henryk Siemiradzki, 1889

Henry Siddons Mowbray *Born* 1858 Alexandria, Egypt

Died 1928

Paton, Sir Joseph Noël

Fairies on a Shell

At the height of the fairy craze, many artists chose to portray a pair of fairy lovers floating downstream on a tiny vessel and it became one of the clichés of the genre. In most cases the couple were depicted on a leaf or an acorn cup. This had the dual advantage of emphasizing their diminutive stature and their rural habitat. In opting for a shell instead, Paton was betraying his Classical training. There was far less chance of coming across a scallop shell in a woodland glade, but it did underline the link with romance, as it was a traditional attribute of Venus. The goddess of love was wafted ashore on a giant shell after her birth at sea, and she was often portrayed riding in a shell-like carriage.

As a fairy artist, Paton is most closely associated with three great canvases: *The Quarrel of Oberon and Titania* (see page 166), *The Reconciliation of Oberon and Titania* (see page 28) and *The Fairy Rade*. However, he also had the distinction of producing the illustrations for the first edition of Charles Kingsley's (1819–75) *The Water Babies* (1863). These included a striking depiction of Mrs Doasyouwouldbedoneby on the frontispiece.

PAINTED IN

Dunfermline

MEDIUM

Watercolour

SIMILAR WORKS

Fairy on a Waterlily with Water Nymphs by Richard Dadd

Sir Joseph Noël Paton *Born* 1821 Dunfermline, Scotland

Died 1901

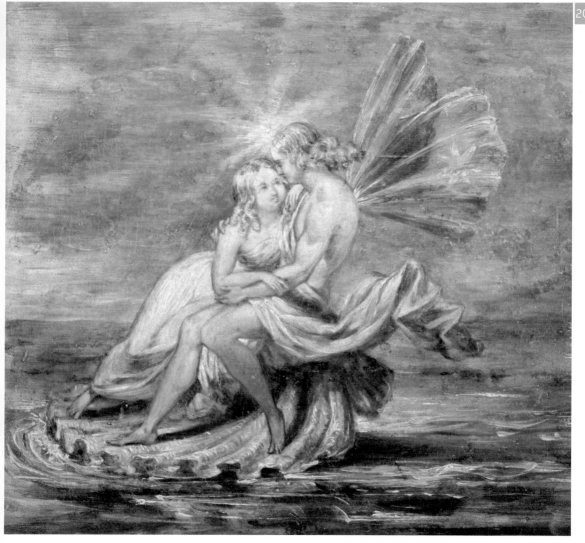

Ferrier, Gabriel-Joseph-Marie-Augustin
The Love Letter

The writing and receiving of love letters had long been a popular theme for artists. For the moneyed classes, marriage was still essentially a business arrangement with considerations of wealth and status taking priority over romance. Letters, even love letters, could come under parental scrutiny and during the Victorian era chaperones proved an added restriction. This system remained in force even after the advent of bicycles, which seemed to offer young people a new sense of liberty. In 1896 a Chaperone Cyclists' Association was founded.

Many nineteenth-century artists preferred to portray this type of subject as a contemporary issue, but Ferrier's picture has a deliberately archaic feel, typified by the old-fashioned quill pen and the cherub who peers over the woman's shoulder. This kind of image was frequently reproduced on prints and postcards. The latter were still a novelty, and many young girls made a hobby of collecting them. As one journalist noted: "Young ladies, who have escaped the philatelic intention or wearied of collecting Christmas cards, have been known to fill albums with missives of this kind". The popularity of romantic cards increased during the First World War, when women sent them to their sweethearts at the Front.

PAINTED IN

Paris

MEDIUM

Oil on canvas

SIMILAR WORKS

The Letter by James Tissot, 1876–78

Gabriel-Joseph-Marie-Augustin Ferrier *Born* 1847 France

Died 1914

after Bouguereau, William Adolphe
Cupid and Psyche, c, 1889

The image on this ceramic plaque was based on a painting by the French academic artist, William Bouguereau. In the original design the figures were shown full length. Significantly, there is a difference in the children's wings. Cupid has conventional angelic plumage, while his companion has butterfly wings. This illustrates the dual nature of her character.

According to the ancient tale, Psyche was human and in paintings that remained faithful to the narrative she was usually portrayed without wings. However, for Renaissance humanists her story also served as an allegory for the soul's journey through life (her name is the Greek word for 'soul'). As a result she acquired some of its visual attributes. On ancient sarcophagi (stone tombs) the soul had sometimes been represented as a butterfly emerging from a chrysalis. Later it was depicted as a tiny, winged human figure. These concepts are combined in Bouguereau's picture.

Given the sexual nature of the story, it is unusual to find Cupid and Psyche portrayed as children. However, Bouguereau was probably illustrating the end of their tale when, after many tribulations, they were finally reunited in the afterlife. In this context the infants may symbolize the innocence and purity of their heavenly existence.

PAINTED IN

Paris

MEDIUM

Ceramic plaque

SIMILAR WORKS

Dream of Love by Willem Martens

Outward Bound by Sir Edward Poynter, 1886

William Adolphe Bouguereau *Born* 1825 La Rochelle, France

Died 1905

Brickdale, Eleanor Fortescue

The Uninvited Guest, 1906

This sumptuous painting is a moral fable in medieval dress, precisely the type of subject that appealed to the Pre-Raphaelites and their followers. A wedding has just taken place and the bridal pair are now proceeding out of the church. As they do so, they pass the 'Uninvited Guest', the figure of Love who sits forlornly on the bare earth. The marriage is not a love match. This is emphasized by the arrow lying on the ground. Cupid has taken it out of his quiver, but has not used it. Instead, the fine clothes and the noble bearing of the guests suggest that the motives of the couple are governed by money or status. Love looks reprovingly at the newlyweds. He could still fire his arrow, of course, but there are hints that he will not. Already the bride's gown has become snagged on some brambles, suggesting that the course of her marriage may not run smoothly.

Brickdale's painting is notable for the immaculate depiction of the bride's satin gown. More remarkable still is the portrayal of Love. This figure bears all the traditional attributes of Cupid, but is far removed from the usual mischievous boy. He is older and more thoughtful, aware both of the consequences of love and of its absence.

PAINTED IN

London

MEDIUM

Oil on canvas

SIMILAR WORKS

Fair is My Love by Edwin Austin Abbey, *c.* 1900

Eleanor Fortescue Brickdale *Born* 1871 London, England

Died 1945

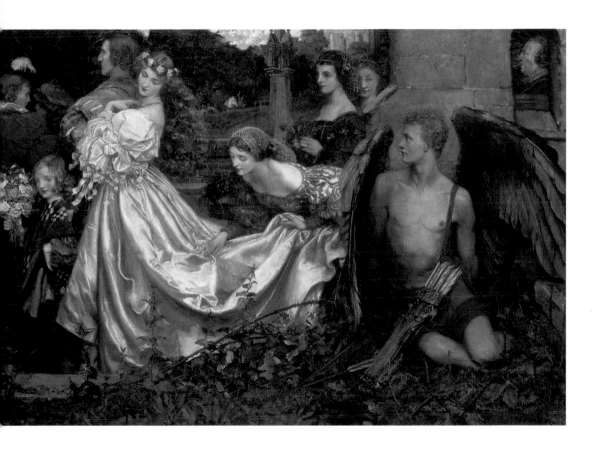

Boughton, George Henry
The Vision at the Martyr's Well

Many Victorians had an ambivalent attitude towards religion. Most were deeply pious even though they were capable of approaching sacred manifestations with a spirit of scientific enquiry, rather than through faith alone. In the 1880s, for example, there was considerable controversy after several people experienced a vision similar to this at Llanthony Priory in Wales. The witnesses saw "a most Majestic Heavenly Form, robed in flowing drapery", which they assumed was 'Our Ladye'. Some were prepared to take the miracle on trust, yet this was also the period when the Society for Psychical Research was founded (1882). This influential body, which was to include William Gladstone (1809–98), Alfred, Lord Tennyson (1809–92) and Lewis Carroll (1832–98) among its membership, made a particular study of spirit photography, where ghostly images similar to this vision were captured on film.

Boughton has a curious claim to fame, as a man who inspired Vincent Van Gogh (1853–90). At the start of his career the Dutchman lived for a time in London, where he worked as a teacher and also acted as a lay preacher in his spare time. In this capacity he preached a sermon at Richmond, which was inspired directly by one of Boughton's canvases, *God Speed!* (1874).

PAINTED IN

London

MEDIUM

Oil on canvas

SIMILAR WORKS

The Apparition by Gustave Moreau, 1874–76

George Henry Boughton *Born* 1833 Norwich, England

Died 1905

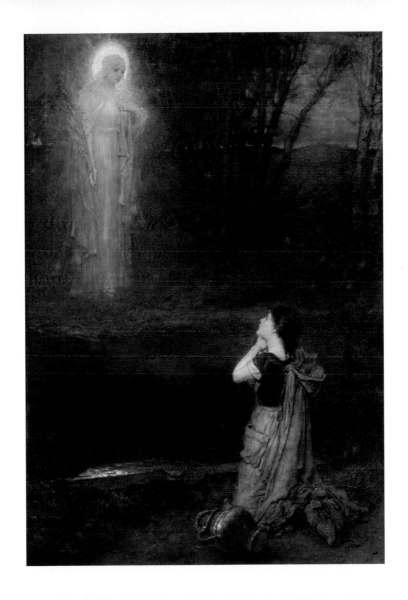

Stokes, Marianne (neé Preindlsberger)
Angels and the Holy Child, 1893

© Sotheby's Picture Library

Stokes once commented that the defining influences on her art came from an illustrated edition of Grimm's *Fairy Tales* given to her as a child, and her lifelong study of Catholic ritual. Her artistic education was equally diverse. Born in Austria, she trained in Munich and Paris, where she developed a naturalistic, academic style. She then painted in Brittany, where she met her husband, the British artist Adrian Stokes (1854–1935), and subsequently in the artistic colonies of Skagen and St Ives. A visit to Italy in 1891 inspired her to take up religious painting. For this she adopted a deliberately archaic style, mimicking the early Italians. She also experimented with early techniques, joining the newly formed Society of Painters in Tempera.

Many of these different influences can be detected in this unusual, pared-down version of the Nativity. There are no kings or shepherds and no ox or ass in this manger. The mood is one of contemplation rather than celebration, perhaps focusing on Christ's eventual sacrifice. The use of haloes and the medieval instruments recall early Italian altarpieces; the angelic children have a Pre-Raphaelite flavour; while the virgin's dreamy expression owes a debt to the contemporary Symbolist style.

PAINTED IN

St Ives

MEDIUM

Oil on canvas

SIMILAR WORKS

Tobias and the Angel by Jean-Charles Cazin

Marianne Stokes *Born* 1855 Austria

Died 1927

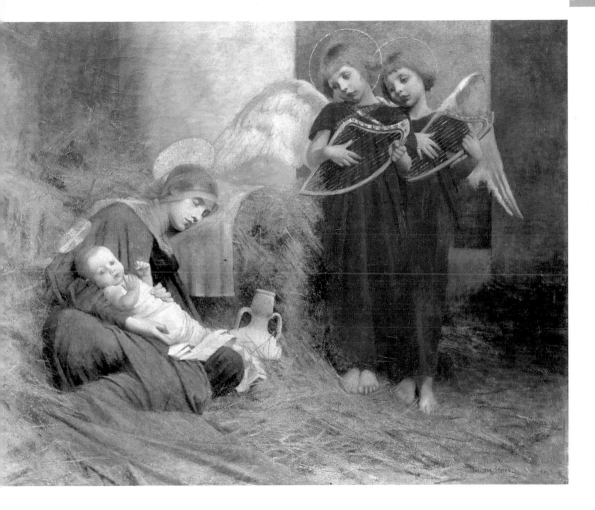

Fellowes-Prynne, Edward A.

Ecce Ancilla Domini

This sumptuously coloured version of the Annunciation follows a traditional format, employing a symbolic formula that had been in use since the Middle Ages. The archangel Gabriel arrives on a cloud, bringing Mary the news that she has been chosen by God to be the mother of Christ. His words are also shown on a strip of material, which hangs from his costume, '*Ave gratis plena Dominus tecum*' ('Greetings most favoured one! The Lord is with you', Luke 1:28). The virgin, meanwhile, holds her hand to her breast and utters the words "*Ecce ancilla domini*" ("Here I am. I am the Lord's servant", Luke 1:38) thereby accepting her destiny. At the top of the picture a ray of light beams down from the dove, which symbolizes the Holy Spirit. The light itself represents the Incarnation of Christ. When the beam touches her head, this is the moment of conception. Mary's purity is symbolized both by the lily and by the fence behind her. This indicates that she is standing in a *hortus conclusus* ('enclosed garden'), a traditional symbol of virginity. On the right-hand side, the apple on the wall refers to the temptation of Eve. Mary was described by theologians as the second Eve, because of her part in bringing about the redemption of humanity.

PAINTED IN

London

MEDIUM

Oil on canvas

SIMILAR WORKS

Vigilate et Orate by Sir Joseph Noël Paton

Edward A. Fellowes-Prynne *Born* 1854 England

Died 1921

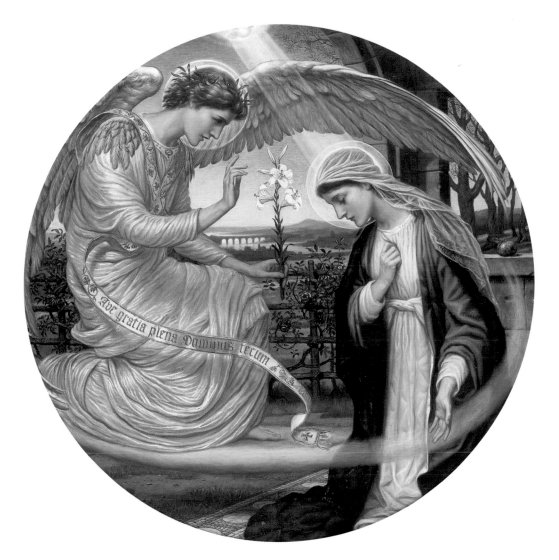

Frampton, Edward Reginald
Saint Catherine, 1902

© Sotheby's Picture Library

Frampton was a successful religious painter, who incorporated a wide variety of influences into his versatile style. His father was a stained-glass designer, which did much to influence his flat, decorative approach to composition. He also drew considerable inspiration from Burne-Jones and the Symbolists. He saw the former's retrospective exhibition at the New Gallery, following Burne-Jones's death in 1898, and his pale, slender angels owe much to the example of the Pre-Raphaelite artist. In addition, Frampton had close links with the art scene in France. He exhibited at the Salon and painted a series of pictures on Breton themes. In particular he tried to emulate the 'primitive' approach to religious painting, which Paul Gauguin (1848–1903) and other members of the artists' colony in Brittany had introduced in the late nineteenth century. Frampton was also heavily influenced by early Italian art. This may have persuaded him to try his hand at mural painting. In the event, murals were to form a substantial part of Frampton's output. He worked on a number of schemes in southern England, at places such as Hastings, Ranmore and Southampton. He also belonged to the Tempera Society and the Art Workers' Guild.

PAINTED IN

London

SIMILAR WORKS

St Elizabeth of Hungary Spinning for the Poor by Marianne Stokes, 1895

Edward Reginald Frampton *Born* 1872

Died 1923

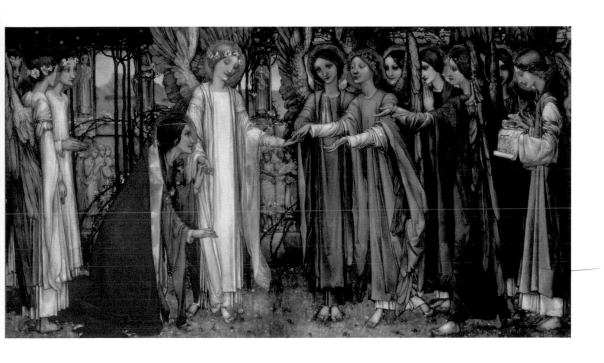

Waterhouse, John William

The Annunciation, 1914

The Pre-Raphaelites and their successors tried to instil a greater sense of realism into their religious pictures. In doing so they were following the advice of the critic, John Ruskin (1819–1900), who urged painters to portray the virgin as 'a simple Jewish girl', rather than 'a graceful princess crowned with gems'.

Waterhouse's remarkable version of the subject certainly breathed new life into the theme, avoiding many of the old clichés. He portrays the virgin as a young woman rather than a sacred icon. Her pose is very natural, reflecting her obvious surprise at seeing an angel appear out of nowhere. The setting is presented in an equally novel fashion, even though it manages to include several of the customary symbols. Traditionally the virgin is kneeling at a *prie-dieu* when Gabriel arrives. On it there is a text from the Old Testament prophesying the coming of the Saviour. According to St Bernard this came from Isaiah: 'Behold a virgin shall conceive, and bear a son' (Isaiah VII:14). Often, as here, there is a distaff (a stick for spinning thread) by the virgin's side. This alludes to the legend that Mary was raised at the Temple in Jerusalem, where she made vestments for the priests.

PAINTED IN

London

MEDIUM

London

SIMILAR WORKS

The Nativity by Dorothy Webster Hawksley

John William Waterhouse *Born* 1849 Rome, Italy

Died 1917

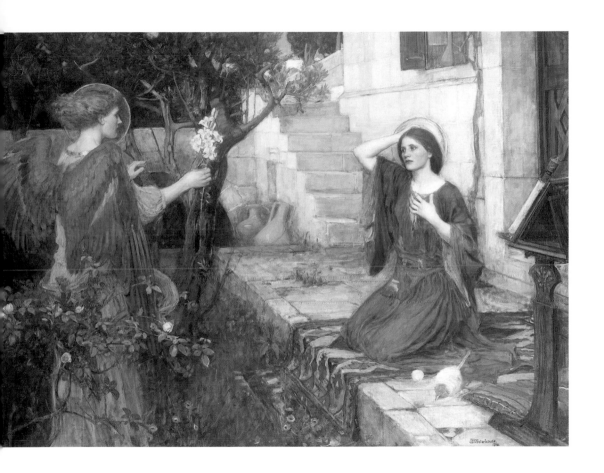

Marriott, F. Pickford

The Annunciation, 1901

© F. Pickford Marriott/Sotheby's Picture Library

This remarkable artwork is a triumph of style over content. The holy scene is imaginatively recast as a harmonious, symmetrical design. Gabriel, on the right, delivers his message, pointing upwards to indicate that it comes from God. He wears a crown, signifying that he is chief of the angelic host. Facing him Mary is surrounded by a swirl of infants' heads, emphasizing the theme of maternity. Some of these appear to have wings. Unusually, the focus of the picture is the lily. This symbolizes the virgin's purity and is also Gabriel's personal attribute. It is encircled by a shaft of golden light, emanating from the holy spirit. Traditionally this was directed at the virgin's head, but here it reaches her as she touches the flower.

Marriott was born in Stoke-on-Trent and at the age of 14 began work as a pottery painter. He worked in a wide variety of media including wood-carving, *repoussé* work and enamelling, although his most memorable works are probably his gesso panels. Marriott was a member of both the Art Workers' Guild and the Arts and Crafts Society, but also exhibited at the Royal Academy and the Salon. In later life he became a teacher.

PAINTED IN

London

MEDIUM

Panel in gesso with mother-of-pearl inlay

SIMILAR WORKS

Stations of the Cross (bas-relief) by Eric Gill, 1914–19

Owl Tapestry by Charles Francis Annesley Voysey

F. Pickford Marriott *Born* 1860 Stoke-on-Trent, England

Died 1941

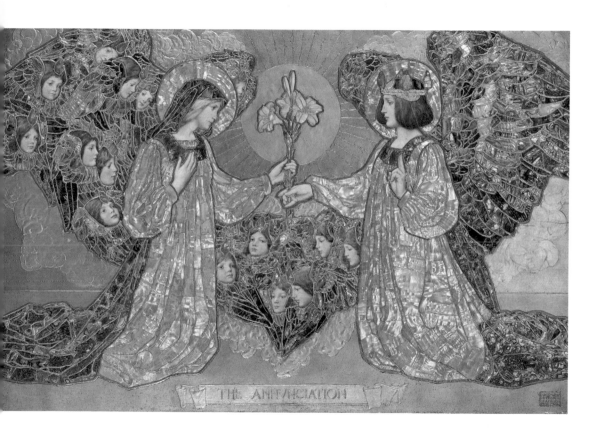

THE ANNVNCIATION

Burne-Jones, Sir Edward Coley
The Annunciation (The Flower of God), 1862

Over the course of his career, Burne-Jones tackled this subject many times and it is a tribute to his skill that he managed to bring something new to each version. On this occasion the most extraordinary feature is the setting, with the virgin kneeling in the upper floor of a modest, wooden building, while Gabriel perches on the branches of a tree. Christian artists often depicted Mary in a dark, crumbling edifice, indicating that she was raised in the old, Judaic order, while the new dispensation is represented by the shaft of light, which streams in through the window. The biblical text on the bed is a traditional feature, while the discarded shoes confirm that this is a sacred event. They refer to a passage in the Book of Exodus, 'Put off thy shoes from off thy feet, for the place whereon thou standest is holy ground'.

Much of Burne-Jones's religious output stemmed from his links with the firm of Morris and Co. Founded by William Morris (1834–96), this remarkable organization sought to revive traditional standards of craftsmanship by leading the drive against shoddy, mass-produced goods. Many of their commissions came from churches. Indeed Burne-Jones probably created more of his distinctive angels for stained-glass windows than for paintings.

PAINTED IN

London

MEDIUM

Watercolour and body colour

SIMILAR WORKS

Our Lady of Peace by Evelyn de Morgan, c. 1902

Sir Edward Coley Burne-Jones *Born* 1833 Birmingham, England

Died 1898

Rhead, George Wooliscroft

O Salutaris Hostia

Rhead's picture takes its name from a line in a Latin hymn: *O Salutaris Hostia* ('O Saving Victim') is the first line from the penultimate stanza of *Verbum Supernum Prodiens*, a hymn composed by St Thomas Aquinas (*c.* 1225-74).

> O saving victim opening wide / The gates of heaven to all below,

> Our foes press on from every side; / Thy help supply, thy strength bestow.

The hymn was originally used for the celebration of Mass at Lauds, during the Feast of Corpus Christi. Aquinas was asked to produce the verses by Pope Urban IV (1261–64), when he introduced the feast in 1264. Since then, the prayer has been used in other services, principally for the benediction of the blessed sacrament.

George Rhead was a versatile artist and teacher who produced etchings and ceramics, but was best known for his book illustrations. He often collaborated with his brother Louis (1858–1926), most notably on the illustrations for Tennyson's *Idylls of the King* (1859). In this painting his angelic orchestra is depicted in a Pre-Raphaelite manner, mimicking the style of early Italian art. Rhead deliberately attempted to create an archaic effect, depicting antique instruments, even though in his original Italian models these items would have been contemporary.

PAINTED IN

London

MEDIUM

Oil on canvas

SIMILAR WORKS

The Golden Stairs by Sir Edward Coley Burne-Jones, 1880

George Wooliscroft Rhead *Born* 1855 England

Died 1920

Cabanel, Alexandre

Expulsion from Paradise

Cabanel's depiction of the expulsion of Adam and Eve is set a little earlier than the painting on the following page. God has arrived in the Garden of Eden, ready to deliver his judgment on the sinful couple. He is accompanied by the cherubim, who will guard the entrance to Paradise, to prevent Adam and Eve from returning. In addition to their function as divine protectors, cherubims were sometimes shown bearing God on their wings. Several references to this can be found in the Bible, among them a passage in the Book of Samuel: 'And He rode upon a cherub, and did fly: and He was seen upon the wings of the wind' (II Samuel XXII, 11).

Cabanel was a successful Salon artist, who built his reputation on his skill at portraying the human figure. It is no surprise, therefore, that he chose the nude studies of Adam and Eve as the main focus of this painting. Eve, in particular, appears under the spotlight. Cabanel portrayed her in the same manner as his mythological characters so that she resembles a startled nymph or goddess. In spite of his immense popularity, the artist's fame faded swiftly following his death.

PAINTED IN

Paris

MEDIUM

Oil on canvas

SIMILAR WORKS

The First Communion at the Church of the Trinity by Henri Gervex

Alexandre Cabanel *Born* 1823 Montpelier, France

Died 1889

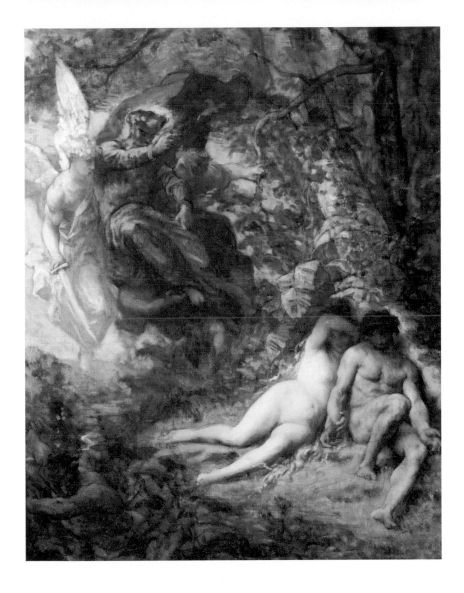

Stothard, Thomas
The Expulsion of Adam and Eve

Stothard's picture is a fairly literal depiction of the passage in the Book of Genesis when Adam and Eve were cast out of paradise: 'So he drove out the man; and he placed at the east of the garden of Eden Cherubims, and a flaming sword which turned every way, to keep the way of the tree of life' (Genesis III, 24). This term for 'angel' derives from the Hebrew word *k'rubim*. This originally referred to a lower order of Babylonian deities who mediated between humanity and the higher gods. In ancient sculpture they were represented by winged lions or bulls with human heads.

Thomas Stothard was a versatile painter and designer, but it was as a book illustrator that he really made his name. As he did not engrave his own plates, he managed to produce an enormous output during the course of his lengthy career. He excelled at depicting narrative scenes, conveying them with simplicity and a genteel refinement that won him many admirers, not to mention imitators. Most of his paintings were on a small scale, although he also executed imposing decorative schemes at Burghley House, near Peterborough, and at the Advocates' Library, Edinburgh.

PAINTED IN

London

MEDIUM

Oil on panel

SIMILAR WORKS

The Embarkation of the Pilgrim Fathers for New England by Charles West Cope, 1856

A Song for St. Cecilia's Day by John Tenniel

Thomas Stothard *Born* 1755 London, England

Died 1834

Cabanel, Alexandre

The Birth of Venus, 1863

© Sotheby's Picture Library

According to legend, the goddess of love rose fully formed out of the sea. In some versions of the myth she was wafted ashore on a giant scallop shell, while others reported that she sprang from the foam itself. This foam had gathered around the castrated genitals of Uranus (the personification of heaven), which had been flung in the sea. The Greek equivalent of Venus, the goddess Aphrodite, took her name from the word for 'foam' (*aphros*). Cabanel exploited the erotic potential of this theme to the full. His Venus reclines seductively, as if she were in the boudoir rather than the sea.

The fate of Cabanel's picture offers a telling lesson on the fickle nature of fame. In 1863 when it was exhibited at the Paris Salon it was the hit of the show. While paintings by Edouard Manet (1832–83), Paul Cézanne (1839–1906) and James McNeill Whistler (1834–1903) were rejected from the exhibition, it received a rapturous reception from both public and critics alike. It even found a distinguished buyer, Napoleon III himself. When he fell from power, however, it was passed to the Louvre. There, after a time, it fell out of fashion and was consigned to the storeroom.

PAINTED IN

Paris

MEDIUM

Oil on canvas

SIMILAR WORKS

Resting by Wojciech Gerson, 1862

The Cloud by Arthur Hacker, 1901

Alexandre Cabanel *Born* 1823 Montpelier, France

Died 1889

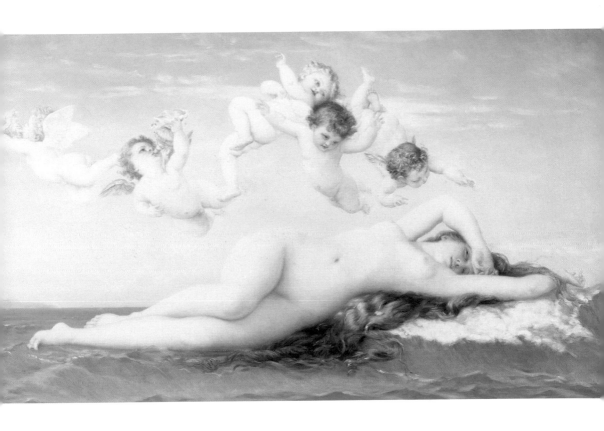

Zatzka, Hans

The Birth of Venus

© Hans Zatzka/Sotheby's Picture Library

In Zatzka's playful scene, Love is personified by the goddess Venus. She was traditionally associated with the scallop shell as a result of the legend that she was born out of the sea and carried ashore on a giant shell. Many artists portrayed this subject, most famously Botticelli (*c.* 1445–1510) in his *Birth of Venus* (*c.* 1485), and some also depicted the shell as a type of boat drawn by swans. Here Zatzka has turned it into a bed, transforming the surrounding riverside scene into a romantic, open-air boudoir. Venus is surrounded by some of her traditional attributes. Roses are scattered everywhere, referring to the myth that she helped create the first red rose. Similarly the profusion of other flowers relates to the legend that after she first set foot on dry land, flowers sprang up in her footsteps. The frolicking putti, who hover in the air, are also a predictable feature. Only the fairy strikes an incongruous note. Fairy painting was very much an English tradition, which had little impact on the other side of the Channel. When they were included in French pictures, fairies were often used rather indiscriminately as a general fantasy element in any mythical scene.

PAINTED IN

Vienna

MEDIUM

Oil on canvas

SIMILAR WORKS

The Pompeiian Girl by Federico Maldarelli, 1870

Hans Zatzka *Born* 1859 Vienna, Austria

Died 1945

Dearle, John Henry, after Burne-Jones
The Passing of Venus (copy of tapestry), 1923–26

This is a variant on the theme of the Triumph of Venus. On the left, the goddess of love sits enthroned in her winged chariot while Cupid carries out her bidding. As he draws his bow the women on the right shrink back in fear. The maiden lying prostrate beneath his feet, together with the three on the left, have already felt the force of the arrows of love.

Sir Edward Coley Burne-Jones produced the basic design for this tapestry, although it was still incomplete at the time of his death in 1898. He had been a crucial figure within William Morris's (1834–96) firm, Morris & Co, for many years. After his demise many of his duties were taken on by John Dearle, who had started out as an apprentice with the company and eventually became its managing director. He adapted Burne-Jones's design and supervised the first weaving of the tapestry at Merton Abbey, between 1901 and 1907. This version of the tapestry was destroyed by fire in 1910 at an exhibition in Brussels. Fortunately a colour photograph had been taken, and from this source Dearle was able to produce a copy when a reproduction was commissioned by George Booth, the publisher of the *Detroit News*. In 1927 Booth donated this to the Detroit Institute of Art.

PAINTED IN

London

MEDIUM

Tapestry

SIMILAR WORKS

The Orchard (tapestry) by William Morris, 1890

John Henry Dearle *Born* 1860 England

Died 1932

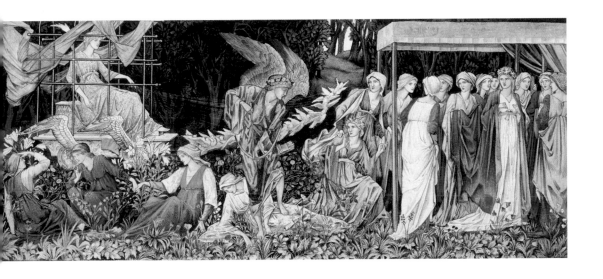

Bouguereau, William Adolphe

Putto Sur Un Monstre Marin ('Cupid on a Sea Monster'), *c.* 1857

Cherubs became associated with the sea through their links with Venus. The goddess of love was born out of the sea, and it became commonplace to use putti as decorative accessories in depictions of this event. After a time, the putti began to appear on their own in maritime subjects. Early cartographers, for example, would sometimes adorn their maps with them since this helped to fill out a space in their charts that might otherwise seem rather dull and empty. Normally, however, the cherub's mount was a dolphin since this also had associations with Venus.

In Bouguereau's picture, the goat-headed creature refers to a baser kind of love. Since antiquity the goat had been a traditional symbol of lust, linked with Pan and the lecherous, drunken antics of the satyrs. In Christian art, by contrast, it was associated with the damned. This particular creature also bears a resemblance to the astrological symbol for Capricorn, which consists of a goat's head and body, combined with a spiralling, serpent-like tail. In the nineteenth century this was occasionally used in allegories of the 12 months, where it represented December, or the four seasons, where it signified winter.

PAINTED IN

Paris

MEDIUM

Oil on canvas

SIMILAR WORKS

The Siren by Armand Point, 1897

William Adolphe Bouguereau *Born* 1825 La Rochelle, France

Died 1905

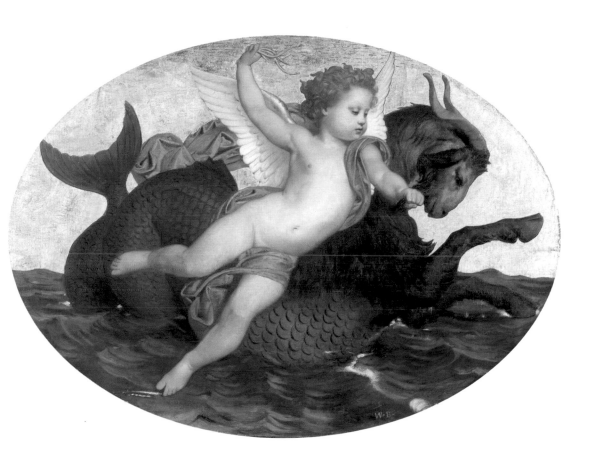

Ferrier, Gabriel-Joseph-Marie-Augustin
L'Ange Gardien ('The Guardian Angel')

The concept of the guardian angel was derived from a few biblical references. In the Gospel of St Matthew, Christ mentions how the 'little ones' have 'their angels (who) do always behold the face' of God (Matthew XVIII, 10). There is also a specific example in the Book of Tobit, in the Apocrypha, where Raphael acts as the guardian angel of Tobias. The idea was taken up by the Catholic Church: several popes introduced specific feast days for 'our guardian angels', and in a number of Baroque churches there are special chapels dedicated to them.

In artistic terms the subject evolved from early depictions of death scenes. These would often portray the soul as a naked infant being lifted out of the body and carried up to heaven by a small angel. These images strengthened the association between children and guardian angels, although in purely doctrinal terms the Church made it clear that adults also had their spiritual protectors. Nevertheless, nineteenth-century depictions of the subject were usually focused on infants, in part no doubt because of the health risks that they faced. Ferrier is mainly remembered now as a teacher rather than for his own work. His best-known pupil was the Cubist artist Fernand Léger (1881–1955).

PAINTED IN

Paris

MEDIUM

Oil on canvas

SIMILAR WORKS

The Nun by Eugen Napoleon Neureuther

Gabriel-Joseph-Marie-Augustin Ferrier *Born* 1847 France

Died 1914

Bouguereau, William Adolphe

L'Amour Mouillé, 1890

Like Peter Pan, Cupid never grew up. Even though some of the stories associated with him have a fairly adult theme – the legend of Cupid and Psyche is an obvious example – he was increasingly portrayed as a young child. By the nineteenth century there was also a growing tendency to use Classical accessories as nothing more than decorative trappings. Here, for example, there is no obvious story line. The artist simply wanted to produce an attractive picture of a youngster.

The idealization of children in art and literature went hand in hand with a growing interest in their welfare. The Industrial Revolution brought with it a dependency on child labour, particularly in the mines and the cotton mills. Attempts were made to redress this situation in the early Victorian period. One of the principal reformers was the 7th Earl of Shaftesbury (1801–85), who was instrumental in passing the Factory Acts (1833–50) and the Mines Act (1842), which restricted the use of children. Fittingly, when a monument was created in his honour, it took the form of a statue of Eros, the name for the Greek god that the Romans later referred to as Cupid. This famous landmark is situated next to Shaftesbury Avenue in London, the street that was named after him.

PAINTED IN

Paris

MEDIUM

Oil on canvas

SIMILAR WORKS

Eros (statue) by Sir Alfred Gilbert, 1891–93

Cupid and Psyche by Annie Swynnerton, 1891

William Adolphe Bouguereau *Born* 1825 La Rochelle, France

Died 1905

Gloag, Isobel Lilian

Four Corners to my Bed

Gloag's painting is a wonderfully literal depiction of an old nursery rhyme or prayer:

Matthew, Mark, Luke and John, / Bless the bed that I lie on!

Four corners to my bed, / Four angels round my head:

One to watch, one to pray, / And two to bear my soul away!

The verse dates back at least as far as the mid-seventeenth century, when it was included in a book called *A Candle in the Dark* (1656). It remained popular in the Victorian era, however, when the threat of infant mortality loomed over every parent. Gloag has conceived her angels as young girls wearing voluminous robes and playing medieval instruments. Three of them are virtually identical, while the fourth kneels by the cot and prays. Her hair and clothing set her apart from the musical trio. Perhaps she is a departed member of the family, praying for a younger sibling. Gloag's parents were Scottish, but she was trained in London and Paris and exhibited regularly at the Royal Academy. Her taste for rich, medieval settings harks back to the Pre-Raphaelites, while her sensuous depictions of *femmes fatales* link her with the Symbolist movement.

PAINTED IN

London

MEDIUM

Oil on canvas

SIMILAR WORKS

Three Women Plucking Mandrakes by Robert Bateman, 1870

Isobel Lilian Gloag *Born* 1868 London, England

Died 1917

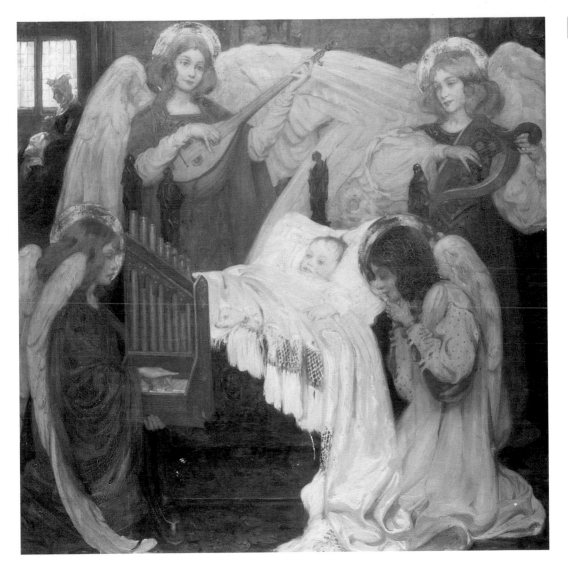

Bouguereau, William Adolphe
Wounded Eros, 1857

This painting combines two popular artistic themes. The subject of a boy removing a thorn from his foot was known from a much-copied antique statue that Bouguereau, as a classically trained artist, would certainly have known. Thorns also had a particular relevance for Venus and Cupid, both of whom were associated with roses. The second theme, which derived originally from one of the *Idylls* by Theocritus, showed the love god suffering after he had been stung by a bee. Most versions showed the boy standing tearfully beside his mother, holding the honeycomb that he had tried to steal. This anecdote was usually portrayed as a moral fable, as Venus pointed out to her child that the wounds he inflicted with his bow and arrows caused just as much distress to his victims.

No moral overtones are evident in this picture, however. In essence, Bouguereau is depicting a simple domestic scene that shows a mother looking after her child. He could have painted the figures in modern clothing, but by dressing up the subject as a Classical scene he gave the picture an added prestige. This would gain it greater praise at exhibition and fetch a higher price in the salerooms.

PAINTED IN

Paris

MEDIUM

Oil on canvas

SIMILAR WORKS

Venus Chiding Cupid and Removing his Wings (photograph) by Julia Margaret Cameron, 1872

Diana Wounded (sculpture) by Edgar Bertram Mackennal, 1905

William Adolphe Bouguereau *Born* 1825 La Rochelle, France

Died 1905

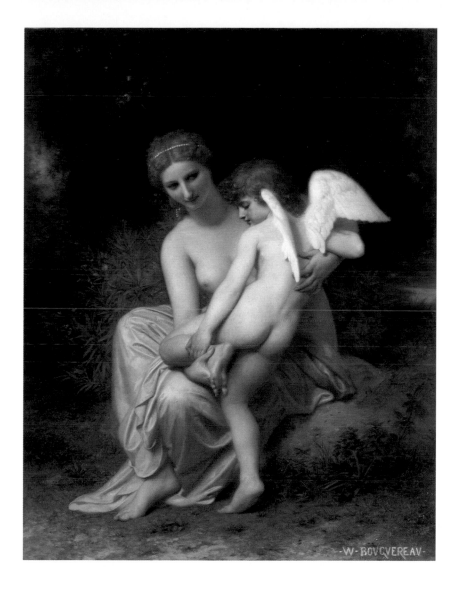

-W·BOVGVEREAV-

Strudwick, John Melhuish

Love and Time

Strudwick was one of a sizeable group of *fin de siècle* artists who became followers of Burne-Jones, sharing his taste for slender, languid figures and enigmatic subject matter. Those qualities are in evidence in this picture, which belongs to a series of allegories relating to Time. These were suffused with an air of gentle melancholy. In some of the pictures, Time was represented in the conventional manner, as an old man with a scythe, but Strudwick also made use of a female figure who represented the Passing Hour.

Strudwick was trained at South Kensington and the Royal Academy Schools, though the results were not encouraging. He did begin to make progress, however, after becoming a studio assistant. Initially he was an assistant to John Spencer Stanhope (1829–1908), before moving on to join Burne-Jones. Strudwick showed only one picture at the Royal Academy. Like his mentor, he preferred to exhibit at the Grosvenor Gallery and the New Gallery. When interviewed by George Bernard Shaw (1856–1950) he confessed that he "could not draw – never could". Even so this did not prevent him from developing an elegant and nostalgic manner, which contemporaries described as Italianate; a considerable irony, given that he never visited the country.

PAINTED IN

London

MEDIUM

Oil on canvas

SIMILAR WORKS

The Last Parting of Helga and Gunnlaug by Charles Fairfax Murray, c. 1887

John Melhuish Strudwick Born 1849 London, England

Died 1937

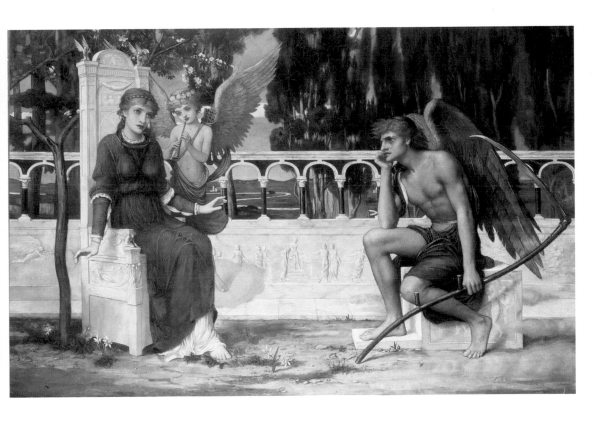

Zatzka, Hans

The Nymph's Garden

In Greek mythology nymphs were beautiful, young female spirits, who were given different names according to their location. Dryads and hamadryads inhabited trees and woodland groves; nereids and oceanids could be found in the sea; oreads made their home in the mountains; while rivers, lakes and streams were the haunts of the naiad. Most artists interpreted the term very loosely, portraying them simply as nubile young women, with no obvious supernatural overtones. They might be shown fending off the attentions of an unwanted suitor, acting as the attendants of a female deity or, as here, used in a picture that has no real subject other than to display the charms of an attractive, young woman.

The development of cheap colour-printing methods opened up new markets for artists such as Zatzka, who possessed technical gifts but lacked originality. Postcards were introduced in Austria in 1869, but the picture postcard did not really develop until the 1890s. Once it was established, however, it became hugely popular. Initially most of the pictures were of places, but soon images of every imaginable kind were in circulation. Zatzka rapidly built up a reputation as a designer of glamour postcards. Today he is remembered as a more significant figure in the history of postcards than in the history of art.

PAINTED IN

Vienna

MEDIUM

Oil on canvas

SIMILAR WORKS

The Eavesdropper by Karl Heinrich Hoff

Hans Zatzka Born 1859 Vienna, Austria

Died 1945

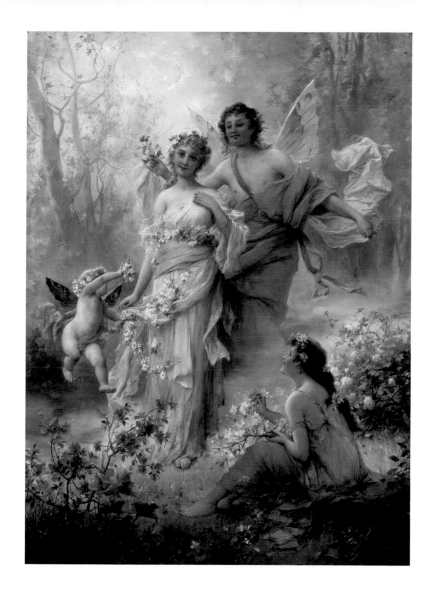

Shields, Frederic James

The Light of the World

Shields' devotional picture is about the salvation of humanity. The Christ Child walks along a narrow path, bringing light and hope into the darkness. The image of the lantern comes from the Bible ('Thy word is a lamp unto my feet, and a light unto my path', Psalm CXIX, 105), as is the metaphor about light ('I am the light of the world: he that followeth me shall not walk in darkness, but shall have the light of life, John VIII, 12). The child's face is steadfast and serious, aware of the sacrifice that is to come. Under his foot he crushes the snake, symbolizing the vanquishing of sin.

The artist drew his inspiration from Holman Hunt's picture of the same name. This featured the adult Christ alone, without the angel, but the basic message was the same. Hunt's painting had received a mixed reception when it was first exhibited in 1854, but by the end of the century it had become an institution. It was so famous that it was sent on a tour of the colonies from 1905–07. Shields was a follower of the Pre-Raphaelites and was personally acquainted with Hunt. He was also extremely devout. Every day he began his journal with the words: 'wash, prayer, Bible, breakfast'.

PAINTED IN

Manchester

SIMILAR WORKS

The Light of the World by William Holman Hunt, 1851–53

Frederic James Shields *Born* 1833 England

Died 1911

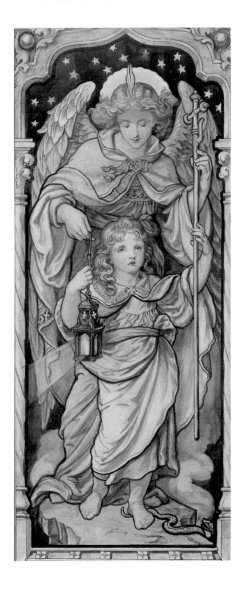

Zatzka, Hans

The Night Fairies

During the height of the Symbolist period there was a widespread vogue for poetic allegories of night-time and individual stars. Burne-Jones's *Evening Star* (1870) and Edward Hughes' *Night with her Train of Stars* were typical examples, both exuding an air of mysterious solemnity. Zatzka borrowed this subject matter, but imprinted it with his customary blend of frivolity and mawkish charm. His toothsome creations float serenely in the night sky, while a mischievous cherub scatters stars from the folds in their clothing.

Zatzka was born in Vienna and trained there at the Academy of Fine Arts. He produced decorative schemes for churches in Innsbruck, Mayerling, Olmutz and Vienna, as well as mythological and genre scenes. Above all he was known for his winsomely romantic pictures of young women and cherubs, which he marketed successfully as postcards.

PAINTED IN

Vienna

SIMILAR WORKS

The Spirit of the Summit by Frederic Leighton, 1891

Hans Zatzka *Born* 1859 Vienna, Austria

Died 1945

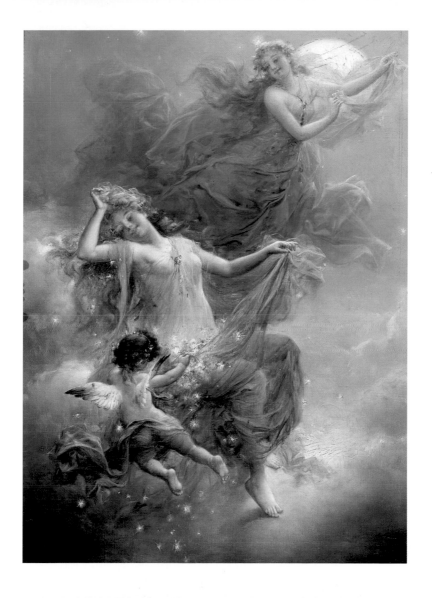

Babb, John Staines

Adolescentiae Somnia Celestiae...(detail)

Pictures of dreams and sleeping were very fashionable in the nineteenth century. Modern critics have questioned whether some of these pictures may have been influenced by the effect of drugs, and Fitzgerald's dream pictures, in particular, have come under scrutiny. The issue is complicated by the fact that opiates were both legal and readily available. Indeed, Britain had entered into two Opium Wars (1839–42 and 1856–60) with China in order to maintain this trade. In addition, Thomas De Quincey's (1785–1859) *Confessions of an English Opium Eater* was greeted with praise rather than recrimination when it was published in 1821–22. Nevertheless reservations were voiced later in the century, when the addictive properties of opium and laudanum became more evident. The Pharmacy Act of 1868 began the process of restricting their sale, and in the 1880s a series of cautionary books were published. Most notable of these was H. H. Kane's *Drugs that Enslave: the Opium, Morphine, Chloral and Hash Habits* (1881).

PAINTED IN

London

SIMILAR WORKS

Salome by Aubrey Beardsley, 1894

John Staines Babb *Flourished* 1870–1900

Margetson, William Henry

The Stranger

This type of study became popular in the late nineteenth century, when there was a taste for pictures that hinted at a story but did not offer a firm narrative. Here a woman sits in a reflective mood with Cupid at her feet. She is so wrapped up in her thoughts that she has lost interest in her book and does not appear to notice the god of love as he offers her a rose. By ignoring Cupid's gift there is a suggestion that she is the stranger in the title, a stranger to love.

Margetson studied at the South Kensington Schools and the Royal Academy, where he began exhibiting in 1885. He specialized in rather wistful studies of women on their own, usually cast in a vaguely allegorical or mythological setting. Some of these were adapted for use as advertising posters. He also produced a few religious pictures, most notably *St Mary at the Loom*.

PAINTED IN

Wallingford

MEDIUM

Oil on canvas

SIMILAR WORKS

The Ugly Princess by Eleanor Fortescue Brickdale, *c.* 1902

William Henry Margetson *Born* 1861 London, England

Died 1940

Knaus, Ludwig

Peace

Not all winged figures are fairies or angels. Sometimes they are allegorical characters representing abstract concepts, in which case the wings serve no real purpose other than to underline the point that the figure is not a human being. Traditionally, Peace was symbolized by a winged woman wearing an olive crown. She is often depicted, as here, with a *cornucopia* ('horn of plenty'). The idea of this was to emphasize the material benefits that would follow when peace was agreed. The addition of the putti, gathering up the flowers, is an unusual touch. Knaus probably included them for decorative reasons, although they are also associated with roses, which are among the blooms that Peace is scattering. Coincidentally, there is also a rose called 'Peace'. Winged female figures were used to represent a variety of other subjects; ironically, the closest parallel is probably the personification of Victory.

Born in Wiesbaden, Knaus was trained in Dusseldorf and Paris. He lived in Italy for a time, but returned to Germany to become a professor at the Berlin Academy. He was principally known as a genre painter and as one of the leading lights of the Dusseldorf school.

PAINTED IN

Berlin or Dusseldorf

MEDIUM

Oil on canvas

SIMILAR WORKS

The Gates of Dawn by Herbert Draper, 1900

Ludwig Knaus *Born* 1829 Wiesbaden, Germany

Died 1910

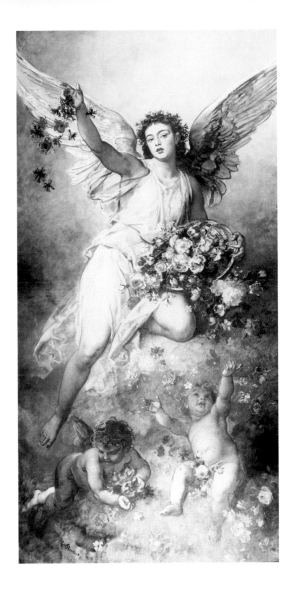

Crane, Walter

My Soul is an Enchanted Boat, c. 1875

© Sotheby's Picture Library

Crane painted this atmospheric picture near the start of his career, when he was closely involved with the Pre-Raphaelite circle. He admired the air of romantic mystery that they managed to achieve in their pictures. In particular, he was impressed by the poetic fantasies of Burne-Jones and described the effect of seeing his work for the first time: "The curtain had been lifted and we had a glimpse into... a twilight world of dark mysterious woodland, haunted streams, meads of dark green starred with burning flowers, veiled in a dim and mystic light... ".

A winged figure was a conventional symbol for the soul, but usually it was tiny; sometimes it was an infant. More importantly it was always shown with the human in question, often issuing from their mouth at the time of death. Crane's lyrical vision marks a new departure, in which the river provides a satisfying metaphor for the soul's journey through life. His inspiration probably came from two Arthurian themes, which were popular with the Pre-Raphaelites and their followers. One of these was the tragic tale of the *Lady of Shalott*, who was often depicted in a boat. The other concerned the death of Arthur, when the hero was conveyed to Avalon in a fairy vessel.

PAINTED IN

London

MEDIUM

Watercolour with body colour

SIMILAR WORKS

The Lady of Shalott by John William Waterhouse, 1888

The Mill by Sir Edward Coley Burne-Jones, 1870–82

Walter Crane *Born* 1845 Liverpool, England

Died 1915

Angels &
Fairies

Other Influences

Hughes, Edward Robert
Night

In the latter part of his career Hughes spent much of his time producing lyrical Symbolist pictures, often with a pronounced literary theme. Among these were several pictures on the theme of 'Night', which were ultimately inspired by the verses of W. E. Henley (1849–1903), published in his *Echoes:* 'Night with her train of stars/And her great gift of sleep'. In this picture the stars form a coronet around the head of the mysterious, angelic figure. The latter was illustrated more fully in the greatest of Hughes's 'Night' pictures, *Night with her Train of Stars* (1912). In this she was depicted as a highly poetic version of the angel of death, carrying away a dead infant in her arms while strewing red poppies in her path. This type of image was extremely popular in an age when the rate of infant mortality was frighteningly high.

Night was a highly fashionable subject during the Symbolist era. Odilon Redon (1840–1916), Lucien Lévy-Dhurmer (1865–1953) and Simeon Solomon (1840–1905) all produced memorable treatments of the theme, while Hughes' pictures are particularly close to the versions produced by Sir Edward Burne-Jones (1833–98). The attraction in each case was that the subject was highly evocative and yet could not be pinned down to a specific allegorical or mythological source.

PAINTED IN

London

MEDIUM

Watercolour with body colour

SIMILAR WORKS

Night by Sir Edward Burne-Jones, 1870

The Sleepers, and the One that Watcheth by Simeon Solomon, 1870

Edward Robert Hughes *Born* 1849 London, England

Died 1914

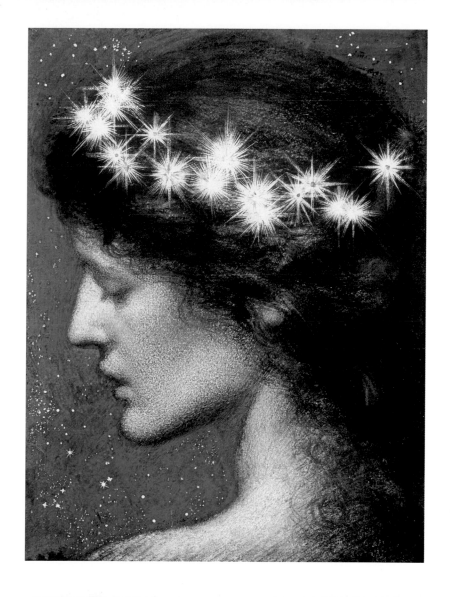

Grimshaw, John Atkinson

Iris, 1876

Grimshaw produced several variations of this theme. Most depict Iris, a messenger of the gods, who was turned into a rainbow after failing to wither the summer plants at the start of autumn. The painting is notable for the unusual pose of the figure as well as the eerie lighting. Iris's arms are folded across her chest and her eyes are closed as though she is asleep or dead. Prior to the nineteenth century artists had occasionally portrayed Iris in the kingdom of sleep. This occurred when Hera sent the goddess to rouse Morpheus, the god of dreams. In some variants of this picture, Grimshaw identified the figure as the spirit of the night. Here the link is that, according to Greek mythology, Sleep (Hypnos) was the son of Night (Nyx). The mysterious glow around the figure has led to suggestions that Grimshaw was influenced by the contemporary vogue for spiritualism and that the shimmering creature might actually be interpreted as a form of ectoplasm. The artist may have drawn some inspiration from this trend as the debate about spiritualism was certainly topical, but there is no evidence that he had any personal interest in the subject.

PAINTED IN

Knostrop Old Hall, near Leeds

MEDIUM

Oil on canvas

SIMILAR WORKS

Twilight Fantasies by Edward Robert Hughes, 1911

John Atkinson Grimshaw *Born* 1836 Leeds, England

Died 1893

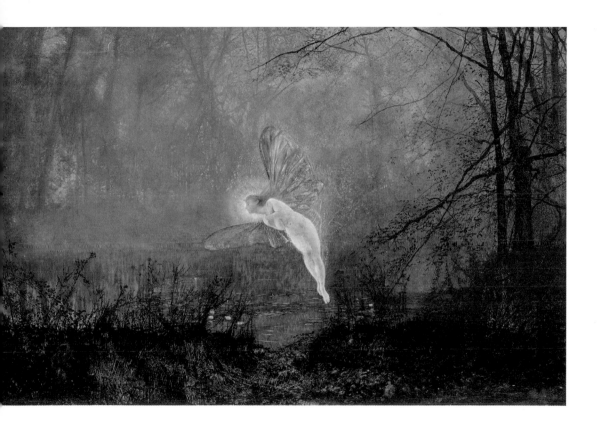

Hughes, Edward Robert
Midsummer Eve, 1908

During the later stages of the nineteenth century, a growing number of artists showed humans coming into contact with fairies. These encounters were usually friendly, unlike the earlier examples in folk tales or fairy literature where the humans were invariably punished for intruding on the privacy of the tiny creatures. This painting has some affinities with *The Introduction* (see page 318) by Eleanor Fortescue Brickdale (1871–1945), although Hughes's picture is far more atmospheric. This is largely due to the ambiguity, which arises from the uncertain link between the woman and the fairies. At first glance she appears to be human, but it is quite possible that she is meant to be some form of wood nymph. Her bare feet confirm that she is no casual passer-by, while the rapturous welcome she receives within the fairy ring is most uncharacteristic. Moreover, the flowers that adorn her dress and hair offer the suggestion that she may herself be a woodland creature. Most telling of all is the pipe that dangles from her side. From this it can be deduced that the girl has drawn the fairies to her by playing their magical music on her instrument. As such she is a forerunner of *The Piper of Dreams* (see page 106).

PAINTED IN

London

MEDIUM

Watercolour and body colour

SIMILAR WORKS

The White Knight by Walter Crane, 1870

The Lover's World by Eleanor Fortescue Brickdale, 1905

Edward Robert Hughes *Born* 1849 London, England

Died 1914

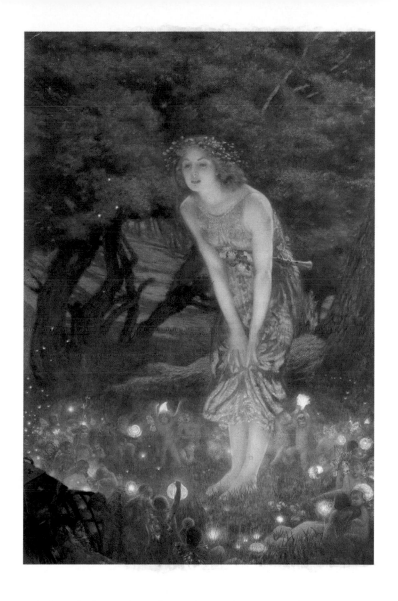

Grimshaw, John Atkinson

Spirit of the Night, 1879

Grimshaw painted a series of fairy pictures, all of which focus on a single, ethereal figure, hovering over an expanse of water. They fall outside the mainstream of fairy art for a number of reasons. Firstly they were created after the fashion for paintings of fairies had largely come to an end, although the tiny creatures were still popular as book illustrations. In addition his titles do not really relate to genuine fairies. Iris was a Classical deity, while Night could be interpreted as a mythological figure or an allegory. Here, though, she resembles a pantomime fairy, waving her wand. Grimshaw also painted another version of the scene, where the figure represented the goddess Artemis, gazing down at the sleeping figure of Endymion (see page 102). Clearly, the subjects of these various pictures were only meant as pretexts for the depiction of an otherworldly figure, bringing a sense of magic to a nocturnal scene. Grimshaw was a genuine specialist in this field, although he usually preferred to work in a modern context, creating moonlit studies of the quayside at Scarborough or Whitby, or of the damp, leaf-strewn streets of his native Leeds. Whistler himself acknowledged his talent exclaiming that "I considered myself the inventor of Nocturnes, until I saw Grimmy's moonlit pictures".

PAINTED IN

Knostrop Old Hall, near Leeds

MEDIUM

Oil on canvas

SIMILAR WORKS

Nocturne: Blue and Gold – Old Battersea Bridge by James McNeill Whistler, 1872–75

John Atkinson Grimshaw *Born* 1836 Leeds, England

Died 1893

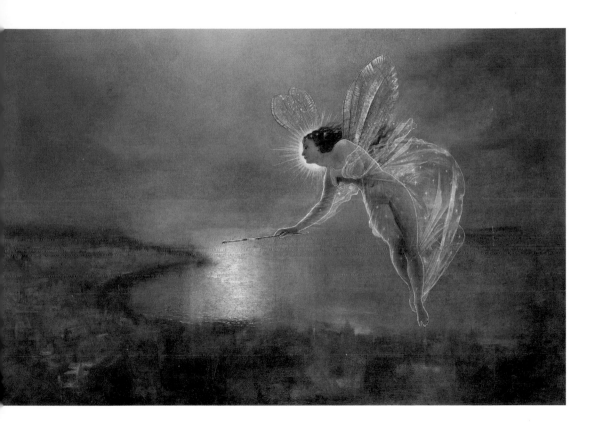

Allen, Daphne Constance

Flower Fairies: Spring

This belongs to a set of paintings depicting the four seasons, accompanied by the relevant fairies and flowers (see pages 80, 288 and 308). The immediate stimulus for the series probably came from the phenomenal success of Cicely Mary Barker's (1895–1973) books on flower fairies. The first of these, *Flower Fairies of the Spring*, was published in 1923 and proved such a hit that it was rapidly followed into print by similar books on the other seasons. After this Barker went on to produce a number of variations on the theme, among them *A Flower Fairy Alphabet*, *Flower Fairies of the Wayside* and *Flower Fairies of the Trees*. Each book had the same format: on every page there was a picture of a young child holding a single flower, accompanied by a brief, educational poem. The children were modelled on pupils from a nearby school, run by Cicely's sister. They made their own costumes for the project, dressing up in wings made out of gauze and twigs.

PAINTED IN

London

SIMILAR WORKS

The Cowslip Fairy by Cicely Mary Barker, 1930–50

Daphne Constance Allen *Born* 1899 London, England

Died unknown

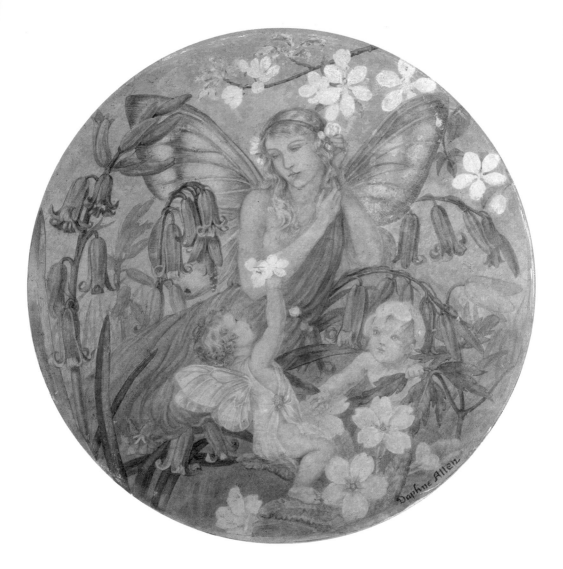

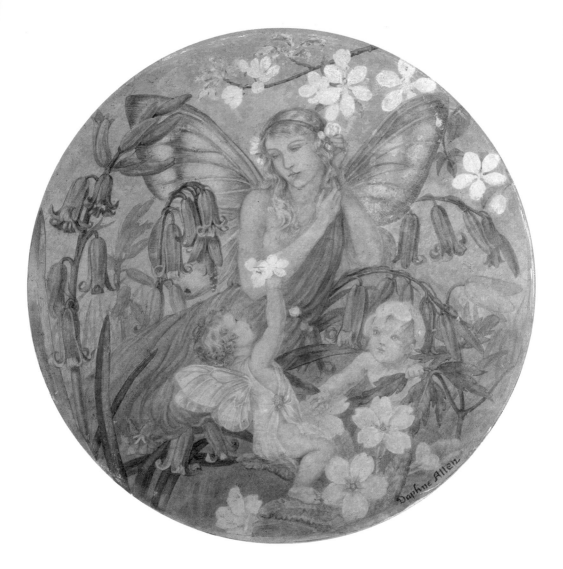

Fitzgerald, John Anster
The Enchanted Forest, c. 1860

© Sotheby's Picture Library

This scene is set on the margins of fairyland. The deer have come to the edge of the natural world, where they roam freely, to the start of the forest where the fairies hold sway. In making this distinction Fitzgerald was following an old tradition. By Tudor times many writers thought of woodlands as the natural habitat of fairies. In part this was due to a simple play on words. 'Wood' was a common term for 'mad'. At the same time it was widely believed that only people with heightened sensibilities, such as madmen, were capable of seeing the creatures of the spirit world. It did not take much imagination to make the connection between the two.

For the Victorians, the forest held an added significance. One of the driving forces behind the Romantic movement was a revolt against the growing mechanization of society during the Industrial Revolution. The genre of fairy painting was just one aspect of this movement. In its sphere the fairies were associated with the old, rural order that was slipping away. Their forests, wild and uncultivated, were indeed enchanted places. In contrast, other parts of the countryside were given over to railways and factories, the harbingers of the industrial age.

PAINTED IN

London

MEDIUM

Oil on canvas

SIMILAR WORKS

Moon Fairies II by John George Naish, 1853

John Anster Fitzgerald *Born* 1832 London, England

Died 1906

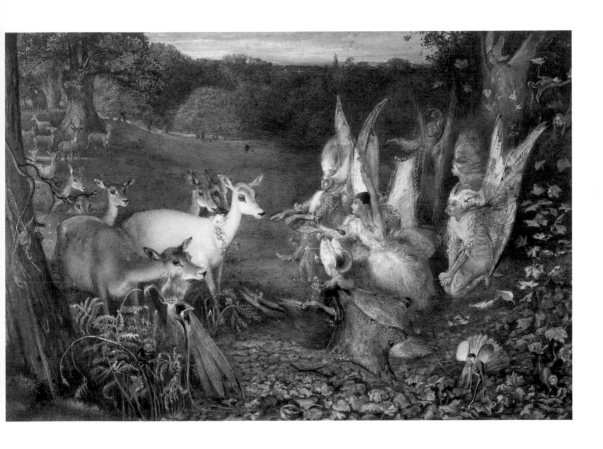

Doyle, Charles Altamont
A Band of Fairies

This is an unusually tranquil scene for Doyle – his paintings are normally crowded with humorous details. The treatment of a fairy dance was equally untypical. Fairies were seen as a secretive people; they preferred to seek their entertainments in sheltered places, forest glades, flowery dells and leafy river banks rather than the open countryside. The sweeping panorama betrays the influence of the Romantic movement. During this period, landscape artists often sought out rugged, spectacular scenery that created a strong impression on the senses. Doyle spent most of his career in Scotland and thus had ample opportunity to explore the Highlands. Even so, the need to portray the fairy figures on a visible scale created an obvious problem, lessening the impact of the distant peaks.

Charles Doyle came from an artistic family. He was the son of John Doyle (1797–1868), who enjoyed a successful career as a political caricaturist; his elder brother was Richard Doyle (1824–83), who was an illustrator as well as a purveyor of fairy subjects (see page 32); but his most famous relative was his son, Sir Arthur Conan Doyle (1859–1930), the creator of Sherlock Holmes. Conan Doyle led the defence of the Cottingley fairy photographs. This in turn begs the question whether Charles also believed in fairies.

PAINTED IN

Edinburgh

MEDIUM

Watercolour

SIMILAR WORKS

Where the Fairies Dance in a Place Apart by Laura Gwenllian James

Charles Altamont Doyle *Born* 1832 London, England

Died 1893

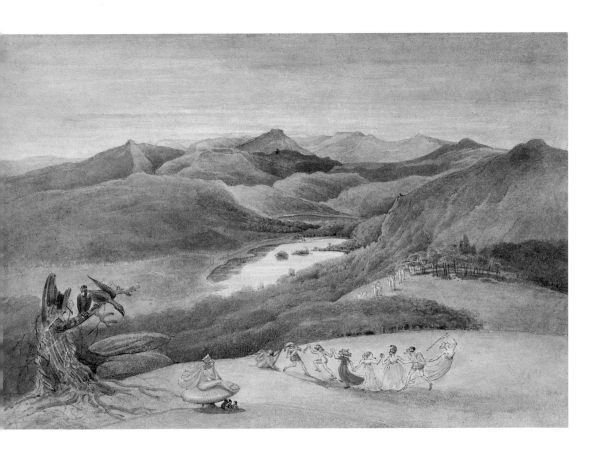

Burne-Jones, Sir Edward Coley

Angels, c. 1890

© Sotheby's Picture Library

This charming scene comes from the *Flower Book*, which Burne-Jones worked on intermittently in his later years. The series consisted of 38 small, circular paintings, which he intended to publish in book form. He died before this ambition could be realized, but a posthumous edition of the work did eventually appear in 1905. The pictures are reminiscent of the tiny illustrations in medieval manuscripts, which had stirred his imagination at an early age. In each case the initial stimulus for the picture came from a flower, although Burne-Jones took the opportunity to rework some of his favourite themes. *Angels*, for example, is clearly an Annunciation reduced to its simplest form. Gabriel fans his wings protectively over the stooping figure of Mary as she gathers lilies from the field. The predominant white colouring and the lilies both emphasize the virgin's purity and recall Dante Gabriel Rossetti's (1828–82) early versions of the theme (see page 26).

Burne-Jones' decision to use flowers as a symbolic theme belonged to a growing trend in the late nineteenth century. In its most popular form, this produced a range of books on the Language of Flowers. The artist himself preferred a more nostalgic approach, basing his pictures on quaint, old-fashioned flower names that had virtually fallen out of use.

PAINTED IN

Rottingdean or London

MEDIUM

Watercolour

SIMILAR WORKS

Ecce Ancilla Domini by Dante Gabriel Rossetti, 1850

Sir Edward Coley Burne-Jones *Born* 1833 Birmingham, England

Died 1898

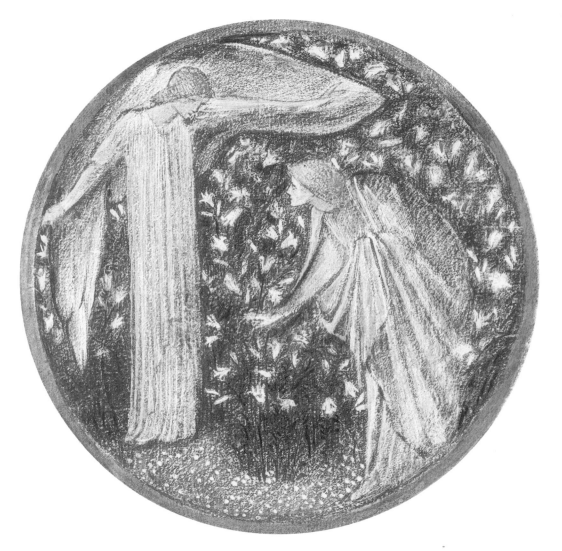

Fitzgerald, John Anster
Cat Amongst Fairies, c. 1860

© Sotheby's Picture Library

The treatment of fairy subjects changed dramatically in the 1860s. Earlier examples, by painters such as Robert Huskisson (1819–61), Richard Dadd (1817–86) and Daniel Maclise (1806–70), were often highly theatrical in their approach. In their work fairyland, as a setting, appeared utterly distinct from the real world. With the emergence of the Pre-Raphaelites, this approach began to change. When they were depicting outdoor subjects their pictures were notable for the meticulous detail of the landscape setting. This is immediately apparent in Sir John Everett Millais' (1829–96) canvas of *Ferdinand Lured by Ariel* (see page 176), where the artist spent weeks producing the background at Shotover Park, near Oxford. He wrote to a friend, 'The landscape I have painted in the *Ferdinand*... is ridiculously elaborate. I think you will find it very minute... I have done every blade of grass and leaf distinct'. Despite these efforts, *Ferdinand* was ultimately judged a failure, largely because the fairy subject matter sat uneasily with the human scale of the environment. As a result, the Pre-Raphaelites rarely tackled fairy themes again. Fitzgerald solved the problem by concentrating solely on the fairy elements, but portraying them with a fine attention to detail. When he attempted to depict his fairies in a normal setting, his efforts were far less successful.

PAINTED IN

London

MEDIUM

Watercolour

SIMILAR WORKS

The Fairy Queen by Sir Joseph Noël Paton

John Anster Fitzgerald *Born* 1832 London, England

Died 1906

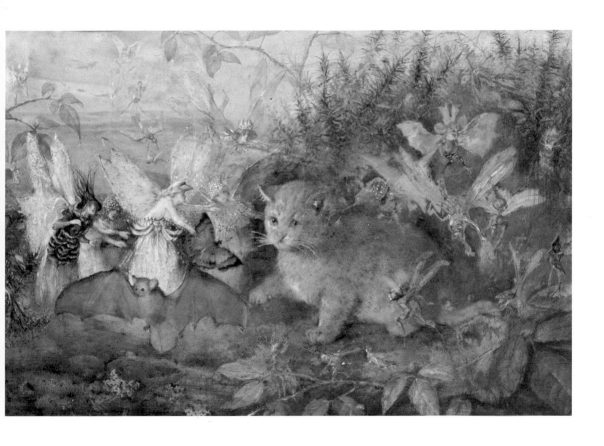

Doyle, Richard

The Fairy Tree

In his most effective fairy pictures, Doyle managed to blend his tiny creatures into the landscape so that they seemed an integral part of the countryside. Here they congregate under the spreading roots of an old tree, watched by two young children. This was a sensible place to look, since trees were one of the principal haunts of the tiny creatures. Oaks were a particular favourite, as is confirmed in a well-known saying: 'Fairy folks are in old oaks'. In northern England they were the habitat of the sinister oak men, who preyed on unwary travellers. This gave rise to an old superstition that it was wise to ask permission before passing through an oak copse. In part these traditions probably harked back to earlier times, when the tree was regarded as sacred and was used by the Druids in their rites. Fairies were thought to be equally devoted to ash and hawthorn trees: it was deemed unlucky to cut a branch from an ash tree, and even more imprudent to burn it in the hearth. Once again this was probably a folk memory of the time when the tree was used in the fire festival of Beltane (May Day).

PAINTED IN

London

MEDIUM

Watercolour on paper

SIMILAR WORKS

The Bird Woman and the Tree by Arthur Rackham

Richard Doyle *Born* 1824 London, England

Died 1883

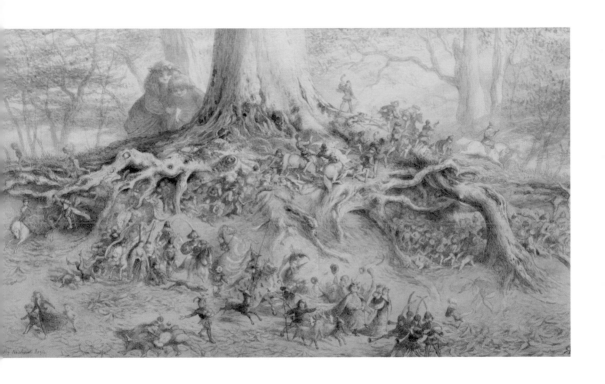

Allen, Daphne Constance

Flower Fairies: Summer

© Sotheby's Picture Library

This comes from a series of four paintings, showing flower fairies for each of the seasons (see pages 80, 276 and 308). It was painted at the end of a long-lasting trend, which extended back to the mid-Victorian period. The initial popularity of the theme owed much to a general growth of interest in gardening. This had long been the preserve of the rich, but the nineteenth century witnessed the arrival of a new phenomenon: the amateur gardener in the suburbs. They followed the lead of an extraordinary couple, John Loudon (1783–1843) and his wife Jane (1807–58). He founded several gardening magazines and published an enormous *Encyclopaedia of Gardening*, which became the fount of all knowledge for every amateur. Jane was possibly even more influential. After publishing a fantasy novel in her youth (*The Mummy*, 1827), she produced a marvellous range of gardening books aimed specifically at women. Among others they included *The Ladies' Companion to the Flower Garden* and *Gardening for Ladies*. These books were full of detailed illustrations, which certainly influenced some of the female fairy painters. For the following generation, Gertrude Jekyll was equally important. She was a regular contributor to *Country Life* and *The Garden* and did much to popularize the herbaceous border.

PAINTED IN

London

SIMILAR WORKS

Wild Clematis and Brambles by Christiana Jane Herringham

Daphne Constance Allen *Born* 1899 London, England

Died unknown

Vernon, Florence

The Fairy Haunt

This lively scene is full of incident, as fairies, birds and bats compete for space in the crowded undergrowth. The image of the fairy haunt altered considerably over the course of the nineteenth century. Just as the concept of fairies was re-assessed so, too, was the miniature world in which they lived. At the start of the century many people thought of nature as ordered and structured, because it had been created by God and must therefore form part of his divine plan. The findings of Charles Darwin (1809–82), however, cast doubts upon this theory. His emphasis on change and mutation encouraged fairy artists to think again, as did the notion of 'the survival of the fittest', a phrase coined by Herbert Spencer (1820–1903). Some of the strange, insect-like creatures that appear in later fairy paintings may well have been conceived as mutations. Similarly the idyllic settings that had been the natural habitat of some of the earlier spirits were often replaced with miniature battlegrounds, where the fairies had to compete with other species for survival.

MEDIUM

Oil on canvas

SIMILAR WORKS

An Intruder by Richard Doyle

Florence Vernon *Flourished* 1881–1904

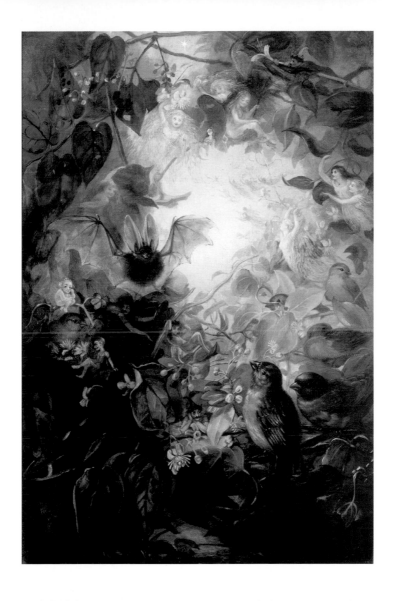

Murray, Amelia Jane (Lady Oswald)

A Fairy Resting Among Flowers

© Christie's Images Ltd

As her title suggests, Lady Oswald came from a privileged background. She was the daughter of Lord Henry Murray and spent her formative years on the family estate on the Isle of Man. Girls from this type of background were expected to demonstrate their artistic accomplishments, and usually received extensive private tuition in this field. They were not encouraged to tackle controversial themes, but flowers in particular would have been deemed eminently suitable. Fairies, too, would have seemed a natural choice, particularly as the two themes were increasingly linked together. This is emphasized by a passage in *Jane Eyre* (1847), where Charlotte Bronte (1816–55) described how her heroine 'busied herself in sketching fancy vignettes'. These included a scene of 'an elf sitting in a hedge-sparrow's nest, under a wreath of hawthorn bloom'.

Murray's fairies are pretty, delicate and innocuous, a template that would eventually be adopted by the illustrators of many children's books. This tiny creature holds a spear, in contrast to the thorns preferred by Fitzgerald's warrior fairies, but in her hands it appears to be a decorative accessory, rather than a weapon.

PAINTED IN

Isle of Man

MEDIUM

Watercolour and pencil

SIMILAR WORKS

Fairy Gossip by Daphne Constance Allen

Amelia Jane Murray, Lady Oswald *Born* 1800 Port-e-Chee, Isle of Man

Died 1896

Dell, Etheline E.

Fairies and a Fieldmouse

Dell painted several watercolours on the subject of fairies, most of them loosely based on Shakespearean themes. Here, a group of female fairies pamper a mouse by offering it food and stroking its fur. The bloated mouse is unconvincing and may well have been based on a stuffed specimen. The craft of taxidermy entered a new phase after the 1830s, when improved preservation techniques involving the use of arsenic enabled practitioners of the art to achieve more lifelike results.

The fairies are exclusively female and are reminiscent to a degree of the erotic creations of John Simmons (1823–76). As always with Dell, however, it is the flowers that catch the eye. The gigantic blooms cluster together and press inwards on the scene. On their petals there are dewdrops that dwarf the distant stars. The sheer size of the flowers makes them seem slightly threatening. In this regard Dell probably drew inspiration from botanical illustrations, where there was often a disparity of scale between the flower and its setting. The most celebrated example of this phenomenon dates from the start of the Romantic era when Dr Robert Thornton (1768–1837) produced his *Temple of Flora* (1799–1807). His enormous blooms were set against atmospheric backgrounds so that even the most unpretentious flower could appear distinctly menacing.

PAINTED IN

London

MEDIUM

Watercolour and body colour

SIMILAR WORKS

The Sacred Egyptian Bean (from *The Temple of Flora*) by Peter Henderson

Etheline E. Dell *Flourished* 1885–1891

Fitzgerald, John Anster
The Wounded Fawn

Fitzgerald was a prolific painter of fairy subjects, although the quality of his work varied considerably. When he was working in watercolour, as here, his fairies often had a wispy, ethereal quality that emphasized their otherworldly status. Posterity has preferred his edgier pictures where the fairies are at war with their fellow creatures, but in Victorian times there was a huge market for sentimental scenes such as this.

Animals often feature prominently in Fitzgerald's paintings. This has given rise to the suggestion that he was influenced by the contemporary taste for taxidermy. The Victorians had a morbid fascination with the subject and examples of stuffed animals were a common sight. They were used in scientific study, and could be found both in museums and in the home. In this respect it may be significant that many of Fitzgerald's pictures are an unusual shape, domed at the top. This may reflect the influence of the bell-shaped glass cases, which were often used for display purposes in the Victorian home. Ultimately these derived from the Wardian case, a sealed glass case invented in 1842 by Dr Nathaniel Ward as a means of preserving delicate botanical specimens during transportation.

PAINTED IN

London

MEDIUM

Watercolour on paper

SIMILAR WORKS

The Rabbits' Schoolroom (taxidermy group) by Walter Potter

John Anster Fitzgerald *Born* 1832 London, England

Died 1906

Naish, John George

Elves and Fairies: A Midsummer Night's Dream, 1856

Naish trained at the Royal Academy and exhibited there throughout his career. His choice of subject matter varied considerably, but in the 1850s he produced a number of fairy pictures. The most notable examples were *Titania* (1850) and this, his masterpiece, which was shown at the British Institution in 1856.

This does not depict a precise moment in the play, although the fairies and elves (by this stage, the two words were virtually synonymous) do carry out some of the activities mentioned by Shakespeare. On the right, for instance, some fairies attack a caterpillar with tiny spears, recalling Titania's exhortation to her followers to 'kill cankers (i.e. canker-worms or caterpillars) in the musk-rose buds' (Act II, Scene II). On the whole, though, Naish seems more interested in the flowers than the fairies. These are painted with a meticulous attention to detail, very much in the manner of the Pre-Raphaelites. Interestingly they are not Shakespearean flowers, but rather the types of bloom that became popular with Victorian gardeners. The most prominent ones are a fuchsia, a nasturtium and a scarlet geranium. In the 1860s Naish moved to Ilfracombe in Devon, which offered better opportunities to develop his love of nature. For the remainder of his career he worked exclusively on landscapes.

PAINTED IN

London

MEDIUM

Oil on panel

SIMILAR WORKS

Ophelia by Sir John Everett Millais, 1851–52

John George Naish *Born* 1824 London, England

Died 1905

Dell, Etheline E.

Midsummer Fairies

Dell painted a series of fairy pictures in the 1880s mostly following a set pattern. Her subjects were diminutive fairies, usually female, disporting themselves in a silvan retreat. Their tiny size is emphasized by the enormous blooms and insects that surround them. The fairies appear to give off their own light, with the centre of the composition resembling the warm glow of a spotlight. Here, for example, the huge yellow rose is clearly lit from below, rather than above. At first glance the ambiguity of the lighting may disguise the fact that the background is a starry night sky, which is just visible through the fretwork of leaves and flowers.

Midsummer Fairies is set within a proscenium arch. This, together with the dramatic lighting, lends the picture a theatrical air, which is shared by so many other fairy paintings. The link with the stage is further strengthened by the picture's title. Dell produced a number of scenes, such as *Titania's Bower*, that refer to *A Midsummer Night's Dream* without actually depicting a specific episode from it. In this instance it is possible that the sleeping figure in the foreground, who is isolated from the rest of the group, is meant to represent Titania.

PAINTED IN

London

MEDIUM

Watercolour and body colour

SIMILAR WORKS

Titania by John George Naish, 1866

Etheline E. Dell *Flourished* 1885-1891

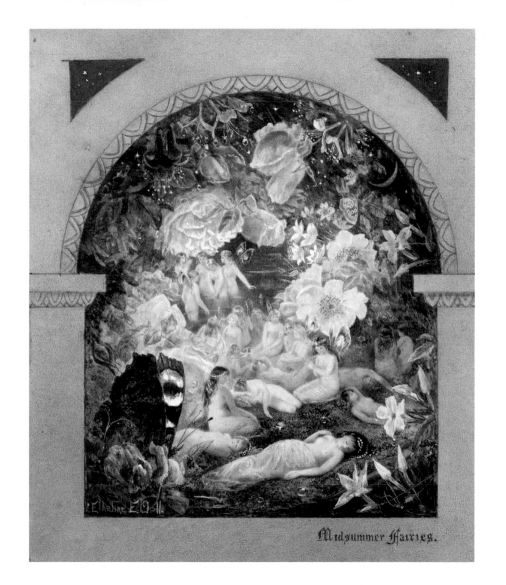

Midsummer Fairies.

Murray, Amelia Jane (Lady Oswald)

A Fairy Sitting on a Snail

This whimsical scene resembles a parody of a royal progress. The fairy assumes the regal air of a queen even if her mount is only a snail, and she waves a leaf instead of a fan. For all this, the most remarkable aspect of the painting is Murray's skill at handling the natural-history elements. In this respect her work has obvious affinities with the illustrated books of the period.

The scientific displays at the Great Exhibition of 1851 sparked off a wave of interest in the population at large. There was a positive craze for 'botanizing', learning the names of every plant by heart and for collecting interesting natural specimens. These included flowers, which were often pressed into books, as well as different types of fern, lichen, seaweed and shell. Collecting butterflies, moths and birds' eggs also became popular hobbies. Some people even brought live specimens into the home, keeping them in glass vivaria where their natural living conditions could be replicated for study purposes. Publishers were not slow to capitalize on these fads. Scores of books and magazines on natural history were launched on the market, many of them containing colourful prints. Both the snail and the rose in Murray's painting may well have been copied from publications of this kind.

PAINTED IN

Isle of Man

MEDIUM

Watercolour and pencil

SIMILAR WORKS

The Butterfly by Luis Ricardo Falero, 1893

Amelia Jane Murray, Lady Oswald *Born* 1800 Port-e-Chee, Isle of Man

Died 1896

Fitzgerald, John Anster
The Bird's Nest

The combination of birds and fairies was a perennial favourite with Fitzgerald. However, the relationship between these creatures varied considerably. Fairies were often shown attacking a bird, but here they appear friendlier. The central figure offers a bird a drink from an acorn cup, while another takes food from his mouth. In a similar scene, though, the fairies attempt to poison some birds so that they can steal their nest.

Fitzgerald's interest in birds' nests was not unusual in the mid-Victorian period. Collecting birds' eggs was a popular pastime for children and the subject was covered in illustrated books. Fitzgerald must also have been influenced by the success of William Henry Hunt (1790–1864). The latter was a still-life artist who specialized in meticulously detailed paintings of birds' nests, so much so that he gained the nickname of 'Birds' Nest Hunt'. He gave lessons to John Ruskin (1819–1900), the champion of the Pre-Raphaelites, exerting an important influence on the movement. Hunt achieved his lifelike results by using a fine brush over a ground of Chinese white, a technique that Fitzgerald also sometimes employed. The fairy painter also framed some of his pictures in a mesh of gilded twigs so that they resembled a nest. These were so fragile that few have survived, but *Fairies in a Bird's Nest* (see page 314) is one of these.

PAINTED IN

London

MEDIUM

Watercolour

SIMILAR WORKS

Bird Nests with Primroses by William Henry Hunt

John Anster Fitzgerald *Born* 1832 London, England

Died 1906

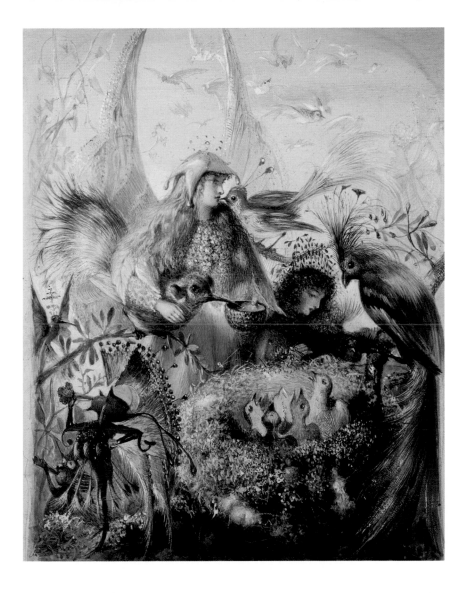

Murray, Amelia Jane (Lady Oswald)

Fairies Floating Downstream in a Peapod

© Christie's Images Ltd

Throughout her long career, Lady Oswald specialized in depicting tiny fairies dwarfed by the everyday flowers that surrounded them. In each case the flower is depicted with the same loving care as its miniature inhabitants. There is rarely a specific subject in her pictures and, perhaps for this reason, Murray was never ranked alongside the best of the fairy painters. Today she is probably chiefly remembered for a posthumous collection of her work, *A Regency Lady's Faery Bower*, which was first published in 1985.

Murray was undoubtedly influenced by many of the lavishly illustrated flower books that appeared during her lifetime. The authors of these books did not restrict themselves to botanical or horticultural matters, but also sought to link flowers with ancient folklore, charming rhymes or spurious symbolism. Within this context it is hardly surprising that books about flowers and fairies began to flourish. Certainly there was no shortage of books offering sources of information. In *The Sentiment of Flowers* (1837) a clergyman called Robert Tyas produced a series of uplifting remarks to accompany each of the flower engravings by James Edwards. Six years earlier Rebecca Hey had trodden a similar path in *The Moral of Flowers* (1835), and she also went on to illustrate *The Spirit of the Woods* (1837).

PAINTED IN

Isle of Man

MEDIUM

Watercolour and pencil

SIMILAR WORKS

But He Was Only Sunk in a Dream of Delight by Eleanor Vere Boyle

Amelia Jane Murray, Lady Oswald *Born* 1800 Port-e-Chee, Isle of Man

Died 1896

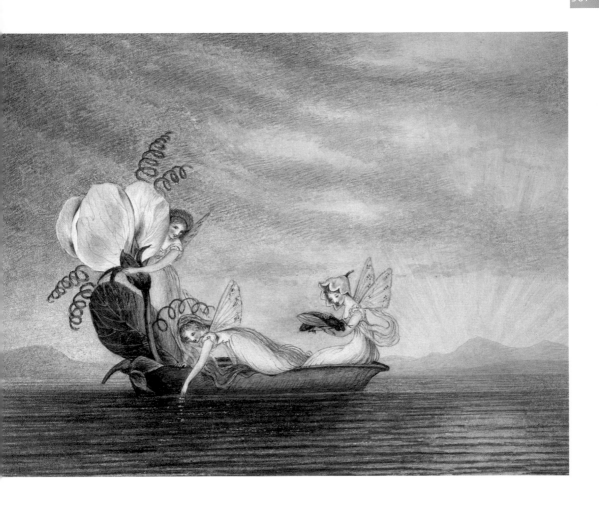

Allen, Daphne Constance

Flower Fairies: Winter

© Sotheby's Picture Library

This is one of a series of paintings showing flower fairies at various times of the year. For obvious reasons, winter presented the artist with the greatest difficulties. In the absence of flowers, she decided to focus on the friendship between fairies and birds, presenting a far more harmonious view of their relationship than most of the earlier fairy painters.

Daphne Allen was born in London and taught to paint by her father, who was also an artist. She displayed a precocious talent, exhibiting her paintings from the age of 13. While still a teenager she also contributed to two books, *A Child's Visions* and *The Birth of the Opal*. These early efforts gained considerable attention in the press, where Allen was described as a prodigy. Her adult career never quite lived up to this early promise, but she became a prolific illustrator, producing work for the *Illustrated London News*, *The Tatler* and *The Sketch*. As a painter she was probably best known for her religious works. The most notable of these were commissioned for the reredos at Christ Church Cathedral in Newcastle, Australia.

PAINTED IN

London

SIMILAR WORKS

The Court of Faerie by Thomas Maybank, 1906

Daphne Constance Allen *Born* 1899 London, England

Died unknown

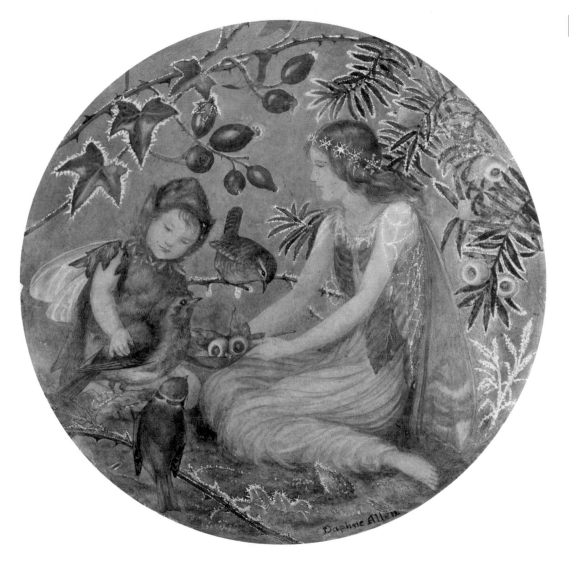

Fitzgerald, John Anster

Fairies in the Snow

In many of Fitzgerald's pictures the fairies seem at war with their surroundings, doing battle with birds and insects. Occasionally, however, he painted a more optimistic scene where the attitude of the tiny creatures seemed more harmonious. This tallied with a view put forward by some writers, that the fairies belonged to a happier, bygone age, before the world became sullied by progress and materialism. No one expressed this viewpoint more forcefully than John Ruskin. In a lecture entitled 'Fairyland' he painted his own picture of this nostalgic wonderland: "There are no railroads in it, to carry the children away... no tunnel or pit mouths to swallow them up, no league-long viaducts... And more wonderful still — there are no gasworks! No waterworks, no mowing machines, no sewing machines, no telegraph poles, no vestiges, in fact, of science, civilization, economical arrangements, or commercial enterprise!".

PAINTED IN

London

MEDIUM

Pencil, watercolour and body colour

SIMILAR WORKS

The Deserted Garden by John Everett Millais

John Anster Fitzgerald *Born* 1832 London, England

Died 1906

Cruikshank, George

Fairyland Scenes

There are many pictures showing fairies at war with their neighbours. In Cruikshank's piece of knockabout fun, however, the roles are reversed. Normally the fairies have the upper hand, but here the insects take their revenge, pinching and stinging their diminutive foes. The colourful gnomes or dwarfs are fine comic creations, but they clearly stem from the world of children's literature rather than the darker realms of traditional folklore.

Fairies played a relatively minor role in Cruikshank's career. He started out as a political caricaturist, lampooning the follies of Napoleon and the Prince Regent. Later on he became better known as a social commentator. In particular he was known for his campaigning cartoons on behalf of the Temperance movement, which became a near obsession after the 1840s. Cruikshank was also a prolific book illustrator. He produced his most celebrated work for Charles Dickens (1812–70) while, in terms of fairy material, he is chiefly associated with the first English edition of *German Popular Stories* (1823–26) by the Brothers Grimm.

PAINTED IN

London

SIMILAR WORKS

The Magic Mirror by Helen Jacobs

George Cruikshank *Born* 1792 London, England

Died 1878

Fitzgerald, John Anster
Fairies in a Bird's Nest, c. 1860

Fitzgerald produced a series of paintings showing armed fairies attacking a bird. In most cases their real interest lay in capturing the nest; here, the onslaught has been successful. The bird has either fled or been killed and the victors are enjoying their spoils. Three female fairies are sleeping inside the nest, while all around them a grotesque array of creatures make sport with the bird's eggs. The presence of the sleeping figures links this painting with Fitzgerald's so-called 'dream pictures' (see pages 104 and 108). Once again, the dividing line between dream and reality is uncertain. Have the grotesque figures been dreamt up by the sleepers?

The inhabitants of Fitzgerald's fairyland come from two distinct sources. The miniature humans are not radically different from the fairies of Huskisson, Paton or Simmons. They may sometimes appear more callous, however, in their animosity towards some animals. The more outlandish creatures belong to a fantasy tradition that stretches back to the Middle Ages, when they featured in the margins of illuminated manuscripts or as gargoyles on churches. There are particularly close links with the work of Hieronymus Bosch (c. 1450–1516) and Pieter Bruegel (c. 1525-69), both of whom used the image of a deformed creature crawling inside a hollow eggshell.

PAINTED IN

London

MEDIUM

Oil on canvas

SIMILAR WORKS

Primroses and Bird Nests by William Henry Hunt

John Anster Fitzgerald *Born* 1832 London, England

Died 1906

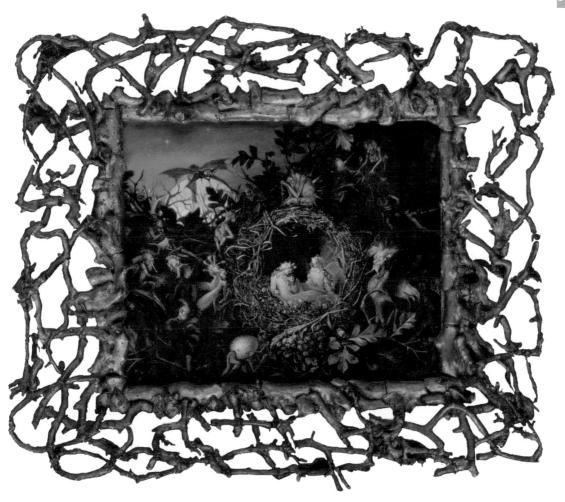

Doyle, Richard

Gnomes

Strictly speaking, gnomes are not fairies – they are elementals. This term describes the groups of creatures that, according to Renaissance philosophers, were deemed to represent the four elements. Thus earth, air, fire and water were linked respectively with gnomes, sylphs, salamanders and nereids. This classification was first mentioned by Paracelsus (1493–1541), a Swiss alchemist who may have devised the system himself. Gnomes (literally 'earth-dwellers') were said to live underground, where they protected mines and other subterranean treasures. Because they were accustomed to living in darkness, they hated the sunlight, which had the power to turn them to stone.

It is quite feasible that Doyle knew of the ornamental garden gnomes that started to become popular in the Victorian era. These were first developed in Thuringia, Germany, in the early 1800s. In Britain the first recorded examples were installed at Lamport Hall, on the estate of Sir Charles Isham, around 1860. They were marketed as good-luck charms for the garden.

PAINTED IN

London

MEDIUM

Watercolour

SIMILAR WORKS

The Fairy Falconer by John Anster Fitzgerald

Richard Doyle *Born* 1824 London, England

Died 1883

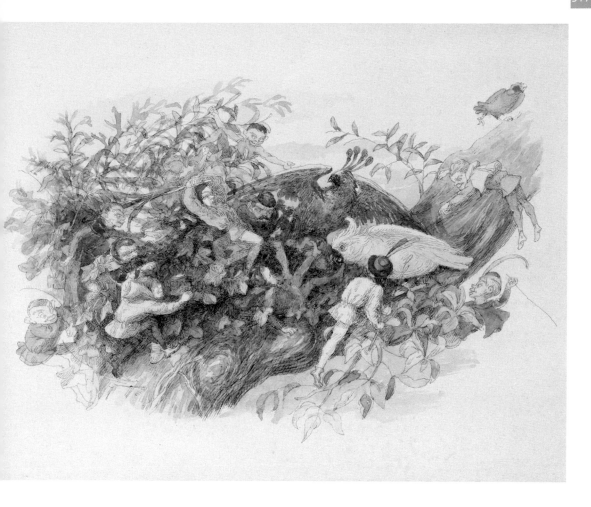

Brickdale, Eleanor Fortescue
The Introduction

Encounters with the fairy people were rarely depicted as cordially as this picture implies. However, in her rare fairy pictures Brickdale usually presented the creatures in a favourable light. The polite old fellows are either gnomes or dwarfs. There was often considerable confusion between the two: both, for example, were closely associated with mines. Both also received a mixed press. *In Snow White and the Seven Dwarfs*, the latter are portrayed as kind and hospitable. The success of the tale, which was collected by the brothers Grimm and became popular in Britain from the 1820s, did much to fix this opinion in the public's mind. Yet there were also a number of stories that portrayed dwarfs as evil, most notably *Yellow Dwarf* and *Snow White and Rose Red*.

Brickdale was born in London and trained at the Royal Academy. She is probably best remembered for her paintings, which were executed in a florid, Pre-Raphaelite manner, but she also enjoyed a successful career as an illustrator and a designer of stained-glass windows. In addition she taught at the Byam Shaw School of Art after it opened in 1911, and became the first female member of the Institute of Painters in Oils.

PAINTED IN

London

MEDIUM

Watercolour and pencil

SIMILAR WORKS

The Wounded Dove by Rebecca Solomon, 1866

Eleanor Fortescue Brickdale *Born* 1871 London, England

Died 1945

Fitzgerald, John Anster
The Wounded Squirrel

Fitzgerald's fairies are often malevolent but here they demonstrate their helpful side, tending to a sick animal. Woodland creatures were a common feature in his pictures, but they often appeared very static, as though they were stuffed. It is certainly possible that Fitzgerald used stuffed animals as his models, or at least was inspired by them, as the practice was extremely common in Victorian England. In addition, during the 1850s and 1860s, when the artist produced most of his fairy paintings, there was a widespread craze for an eccentric type of tableau in which dead animals were arranged into anthropomorphic settings.

This craze was sparked off at the Great Exhibition of 1851, where a display from Germany caught the eye. In the 'Miscellaneous Manufactures and Small Wares' section, Hermann Ploucquet showed a *Frog Carrying an Umbrella*, *The Kittens at Tea*, and *Long-tail Teaching the Rabbits Arithmetic*. Queen Victoria described the exhibits as "really marvellous", and within a year, some of them were featured in a book entitled *The Comical Creatures from Wurtemberg* (1851). Ploucquet's success seems to have inspired Walter Potter (1835–1918, see page 126), who began exhibiting works in a similar vein at his parents' inn at Bramber, in Sussex.

PAINTED IN

London

MEDIUM

Pencil, watercolour and body colour, with gum arabic

SIMILAR WORKS

The Kittens at Tea – Miss Paulina Singing (taxidermy group) by Hermann Ploucquet

John Anster Fitzgerald *Born* 1832 London, England

Died 1906

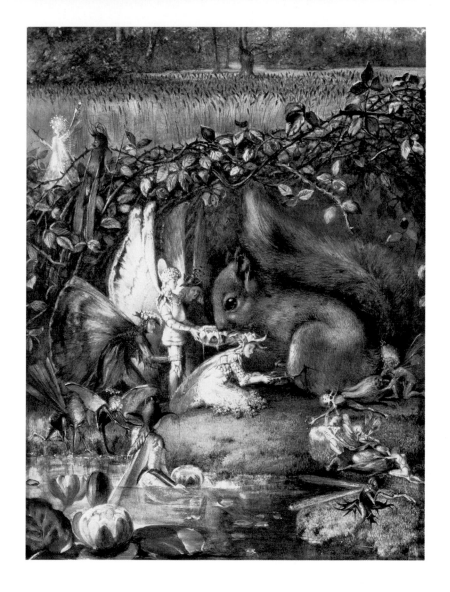

Doyle, Richard
The Fairy Tree, c. 1840–44

Although he is usually included in the mainstream of fairy artists, Doyle also liked to poke fun at the genre. Before all else, he was a keen observer of human foibles and a highly inventive humorist. It is no surprise therefore that this elaborate watercolour, produced at the height of the fairy craze, is actually a gentle satire on the phenomenon. In the centre, for example, the fairy king with his ridiculously long moustache is a jocular parody of noble Oberon. Elsewhere, fairies topple out of birds' nests and flower buds, while a fairy procession turns into a shambolic conga line. Most of the creatures are not really fairies, but misshapen humans. In this respect it is worth recalling that the artist's father (John Doyle, 1797–1868) was a celebrated caricaturist. Some of the characters are comical versions of figures from everyday life: jockeys, lawyers, barbers, even a painter at his easel. Others are dressed up in costumes from pantomimes or plays. Amongst all the chaos there is a humorous performance of the balcony scene from *Romeo and Juliet*, and a grotesque version of Starveling from *A Midsummer Night's Dream*.

PAINTED IN

London

MEDIUM

Watercolour with sepia ink and gouache on tinted paper

SIMILAR WORKS

The Proper Mode of Riding in Rotten Row by John Leech

Richard Doyle *Born* 1824 London, England

Died 1883

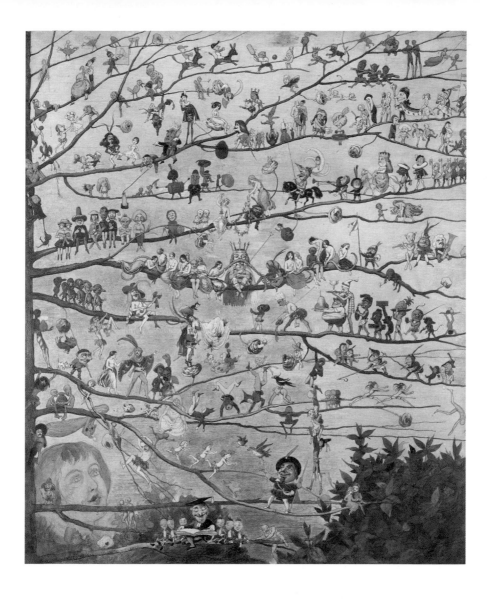

Rackham, Arthur

The Guest of Honour: A Baby Attended by Sprites and Fairies, 1905

© Arthur Rackham/Christie's Images Ltd

In some of his pictures, Rackham blurred the dividing line between good and bad fairies. Here a group of woodland creatures celebrate the arrival of a new baby, presumably a changeling. Some garland it with flowers, while others form a procession bringing food and drink. In certain circumstances fairies were thought to signify good luck when they visited a newborn infant.

One of Rackham's greatest assets was his ability to produce a never-ending range of fairy people. His elves and goblins, with their pointy ears and noses and their churlish expressions, managed to appear humorous, whilst also remaining grotesque enough to frighten small children. The scariest components of his pictures, however, were his trees. These often seemed to come alive, with branches like clawing arms and snarling faces appearing in the bark. In this painting, Rackham's inspiration came from the engravings of his favourite draughtsman, Albrecht Dürer (1471–1528).

PAINTED IN

London

MEDIUM

Watercolour

SIMILAR WORKS

The Butterfly by Annie French

Arthur Rackham *Born* 1867 London, England

Died 1939

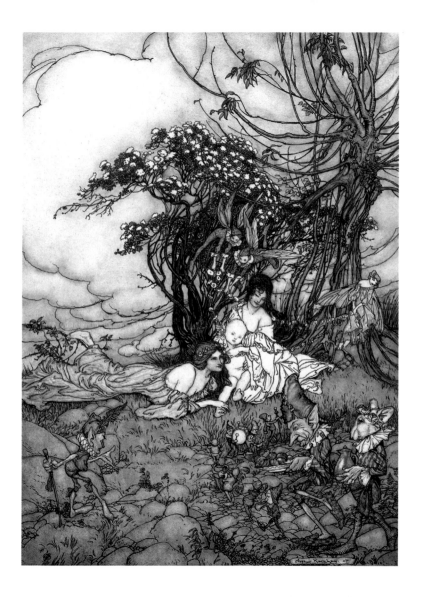

Fitzgerald, John Anster

The Storm

This is an example of the one of the most popular fairy themes, where tiny creatures float downstream on a leaf or a flower. As usual, the chief attraction of the scene lies in Fitzgerald's inventive mix of creatures. His fairyland is truly a place of wonder, where pretty, doll-like humans cohabit peacefully with strange, mutated insects. More than any other fairy artist, however, Fitzgerald gives the impression that appearances may be deceptive. Here the viewer may feel empathy for the humanoids as they cling together in the aftermath of the storm, but elsewhere their behaviour is more questionable. At times they can be vicious, while their lack of emotion can make them appear sinister. It is often unclear whether the more grotesque fairies are meant to be regarded as evil or simply ugly. Fitzgerald was evidently familiar with the work of Hieronymus Bosch and Pieter Brueghel. In their work, however, the context usually offers some clues to the interpretation of the figures, but in Fitzgerald's pictures the situation is frequently more ambiguous. Even in the so-called 'dream' pictures, where the grinning spirits are usually described as tormentors, their real motives remain uncertain.

PAINTED IN

London

MEDIUM

Watercolour on paper

SIMILAR WORKS

The Elves' Market by Arthur Rackham

John Anster Fitzgerald *Born* 1832 London, England

Died 1906

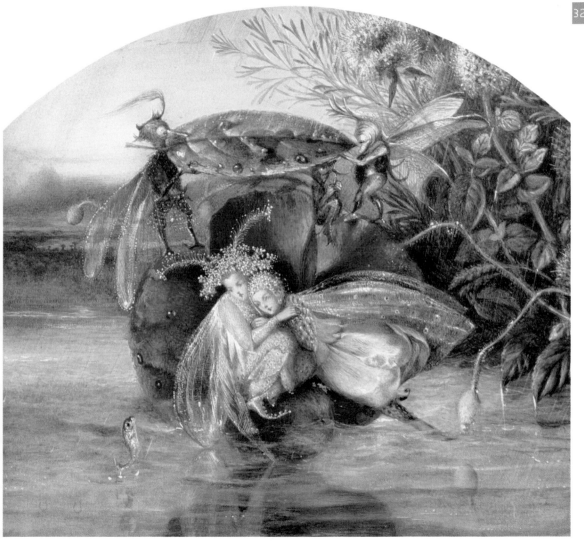

Rackham, Arthur

The Pert Fairies and the Dapper Elves

Rackham's picture illustrates a few lines from John Milton's (1608–74) *Comus*, a masque that was first performed at Ludlow Castle in 1634. Masques were lavish spectacles in which music and dance featured prominently, but *Comus* was also a dark tale of a struggle between good and evil, featuring a moral lesson about the dangers of eating fairy food. Milton's roots were in Oxfordshire, where he steeped himself in the local fairy traditions.

Elves appear in many different guises in fairy painting. The creatures originated in Scandinavian mythology, where from an early stage a distinction was made between light elves and dark elves. The former were generally harmless, while the latter could be far more sinister. In Britain the meaning of the word was equally varied. For Shakespeare the term was virtually synonymous with diminutive fairies, but in Scotland it was usually reserved for larger ones. Their behaviour was equally varied. Some elves could be evil: kidnapping humans, stealing cattle and ruthlessly taking revenge for any perceived slights against them.

PAINTED IN

London

MEDIUM

Pen, ink and watercolour

SIMILAR WORKS

'E was an exquisite Elf by Edmund Dulac

Arthur Rackham *Born* 1867 London, England

Died 1939

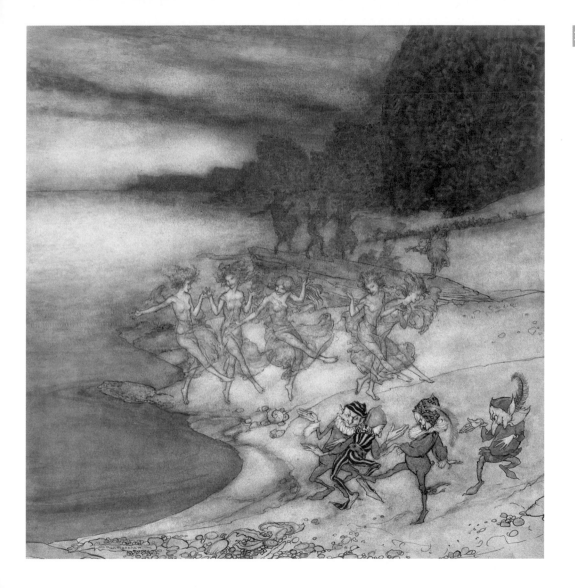

Morgan, Walter Jenks

'Where rural fays and fairies dwell'

Morgan took the title of his painting from a poem by William Shenstone (1714–63):

Here, in cool grot and mossy cell, / Where rural fays and fairies dwell; / Though rarely seen by mortal eye...

Shenstone was a landscape gardener as well as a poet, and he combined these vocations in a collection of verses entitled *Inscriptions* (1865). These lines were conceived as poems that might be found scattered around his estate at Leasowes, near Halesowen, inscribed on such items as urns, obelisks and seats. Shenstone's description of the fairy revels is very conventional, even down to the warning contained in the final lines:

And tread with awe these favour'd bowers, / Nor wound the shrubs, nor bruise the flowers;

So may your path with sweets abound; / So may your couch with rest be crown'd!

But harm betide the wayward swain, / Who dares our hallow'd haunts profane!

Walter Morgan was trained at the Birmingham School of Art. After serving an apprenticeship with a lithographer, he made his name as an illustrator, contributing regularly to *The Graphic* and the *Illustrated London News*. He became president of the Midlands Art Club and the Birmingham Art Circle.

PAINTED IN

Birmingham

MEDIUM

Watercolour on paper

SIMILAR WORKS

Where the Fairies Dance in a Place Apart by Laura Gwenllian James

Walter Jenks Morgan *Born* 1847 Bilston, England

Died 1924

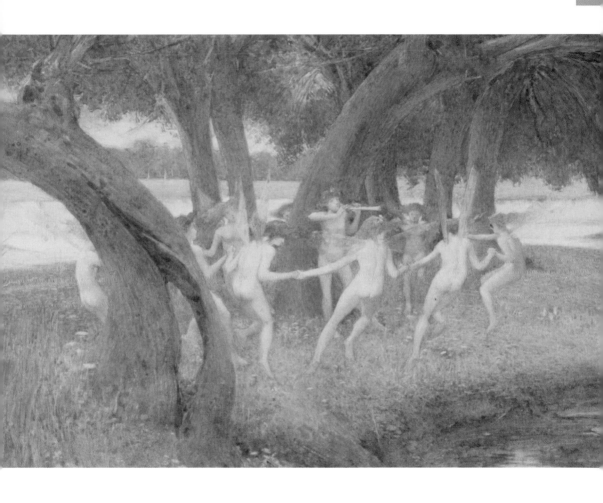

Doyle, Richard

A Procession of Fairies and Birds (detail), 1880

© Christie's Images Ltd

This is a fairy 'rade' or cavalcade. There were many reports of processions such as this, particularly in Scotland and Ireland. It is no surprise, therefore, that the most striking depiction of this type of event came from Joseph Noël Paton, a Scottish artist who was well versed in local folklore. In his *Fairy Rade* he showed a changeling being carried off in triumph to the fairies' home in an ancient stone circle. Most of the sightings of fairy processions took place on mystical dates, usually Midsummer Eve or Hallowe'en, when fairies became visible to humans. In many of the old folktales, the rades provided mortals with an opportunity of rescuing loved ones who had been carried off to fairyland. In the ballad of Tam Lin, for example, a young woman called Janet manages to snatch back her sweetheart when a procession passes by on Hallowe'en. The fairies do their best to prevent this by turning Tam Lin into a snake, a bear and a red-hot iron bar, but Janet refuses to loosen her grip and so wins the day.

PAINTED IN

London

MEDIUM

Watercolour and pencil

SIMILAR WORKS

The Fairy Rade by Sir Joseph Noël Paton

Richard Doyle *Born* 1824 London, England

Died 1883

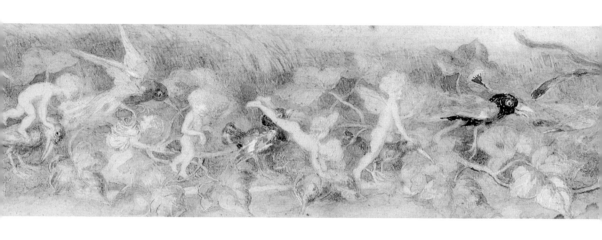

Fitzgerald, John Anster
In the Fairy Bower

Unusually for Fitzgerald, this painting displays some theatrical qualities that hark back to the fairy pictures of the previous decade. A spotlight focuses on the embrace of the fairy couple, while leaving their companions in the shade. Even so, this is a comforting and harmonious scene. Although the couple are surrounded by mice and some very strange attendants, nothing threatens to disturb their sleep.

Fitzgerald's pictures were produced at a time when there was considerable concern about the future of the countryside. Political economists seemed determined to pursue the goal of progress at any cost, as the following passage illustrates: 'When we have ascertained, by means of science, the methods of Nature's operation, we shall be able to take her place to perform them for ourselves... men will master the forces of Nature; they will become themselves architects of systems, manufacturers of worlds.' Set against this remorseless desire for change and control, the certainties of the fairies existence began to seem like a fading dream.

PAINTED IN

London

MEDIUM

Oil on canvas

SIMILAR WORKS

Asleep in the Moonlight by Richard Doyle, 1870

John Anster Fitzgerald *Born* 1832 London, England

Died 1906

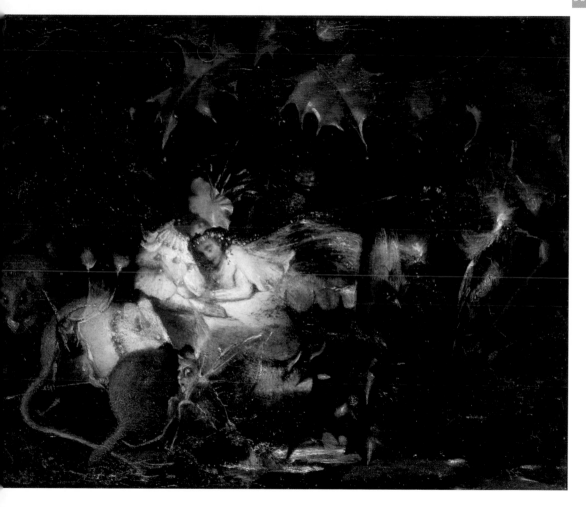

Cruikshank, George

A Fairy Gathering

In this entertaining scene, Cruikshank's impish fairies produce a highly comical dance for their distinguished guests. Even so the picture has a sinister edge. Bats were the natural enemies of fairies, while the broken eggshell on the right has presumably been violated by the dancers. This may explain the curious, bird-like creature on the left, who peers down angrily at the proceedings.

There have been many reported sightings of fairy dances, one of the earliest coming from the antiquarian John Aubrey (1626–97), who related the experience of his local curate: "he sawe an innumerable quantitie of very small people, dancing rounde and rounde... making all maner of small odd noyses". The curate tried to run away, but found that he could not move, "being, as he supposes, kept there in a kind of enchantment". At length when the fairies spotted him, "they surrounded him on all sides... and pinched him all over, and made a sorte of quick humming noyse... ". Perhaps he escaped lightly, for W. B. Yeats (1865–1939) told an alarming tale of a woman who was stolen away in her youth. When she returned seven years later, she had no toes, having danced them off in fairyland.

PAINTED IN

London

MEDIUM

Pen, ink and watercolour

SIMILAR WORKS

Wood Elves playing Leapfrog over Toadstools by Richard Doyle, *c.* 1870–80

George Cruikshank *Born* 1792 London, England

Died 1878

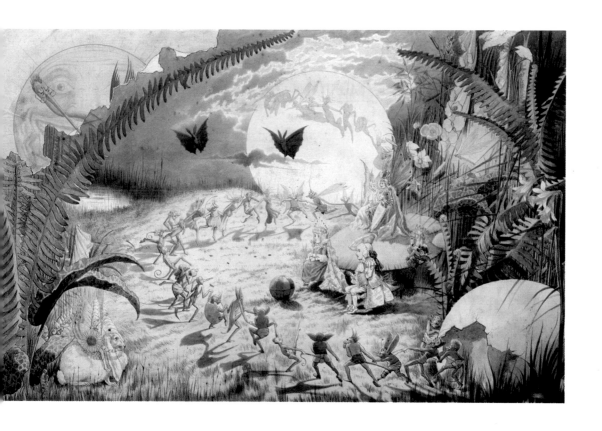

Fitzgerald, John Anster
The Fairies' Banquet, 1859

Using a mushroom as a table, a colourful array of fairies sit down to eat. The glistening fruit looks tempting, but all may not be as it seems. At the top, a purple convolvulus is prominently displayed; a flower that normally signifies sleep or death. The company looks equally mixed. Some of the fairies are undeniably sweet, but others appear demonic. The creature in the lower left-hand corner, for example, is squatting in the traditional pose of an incubus.

Although their food always looked delicious to mortals, fairies often created this impression by using 'glamour', a form of enchantment that distorted the viewer's perceptions. Underneath this magic sheen the food might be far less enticing. Robert Herrick (1591–1674), for example, wrote that they ate 'Beards of mice, a Newt's stewed thigh/A bloated earwig, and a Flie'. When humans did try fairy food, they usually found the taste exquisite, hence why the idea of 'fairy cakes' caught on. At the same time it could be dangerous. In Christina Rossetti's (1830–94) *Goblin Market*, Laura begins to pine away after eating some of their fruit, but she is desperate to taste it again.

PAINTED IN

London

MEDIUM

Oil on canvas

SIMILAR WORKS

The Fairy Picnic by Charles Altamont Doyle, 1882

John Anster Fitzgerald *Born* 1832 London, England

Died 1906

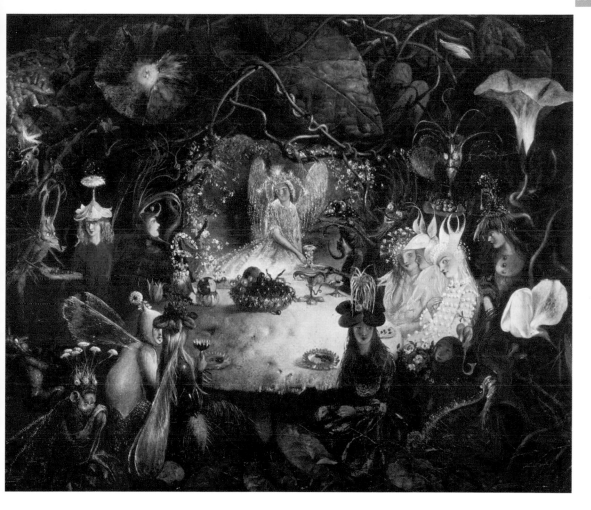

Pinta, Henri Ludovic Marius

L'Ange Musicien ('Musician Angel'), 1892

Since the Middle Ages, celestial choirs and orchestras have been an ever-present feature of Christian art. Their popularity stems from the exhortation in the Book of Psalms that the faithful should make use of music in paying homage to God:

Praise ye the Lord... / Praise him with trumpet's sound; / His praise with psaltery advance;

With timbrel, harp, string'd instruments, / and organs, in the dance.

Praise him on cymbals loud: Him praise / on cymbals sounding high.

Let each breathing thing praise the Lord... (Psalm CL)

Many nineteenth-century artists took these words literally and deliberately portrayed their angelic musicians with a range of archaic instruments.

Henri Pinta was a French history painter and muralist, who produced much of his best work in the Marseille area. His most celebrated pictures are probably the murals, which he produced for the church of Notre Dame du Mont in Marseille.

PAINTED IN

Marseille

SIMILAR WORKS

The First Communion at the Church of the Trinity by Henri Gervex

Henri Ludovic Marius Pinta *Born* 1856 France

Died unknown

H. PINTA
92

Fitzgerald, John Anster
The Concert

In all the early reports of fairy activities, one of the most consistent elements was the emphasis on music. It played an important part both in their revels and in their solemn processions. The music itself varied considerably to suit these different occasions. Sometimes it was wild and frenetic, ideal for dancing. At other times it resembled a low chanting, echoing the fairies' ambiguous association with the spiritual world. Every commentator agreed, however, that the sound of fairy music was otherworldly and enchanting. Mortals felt drawn to it, although like the song of the sirens it was dangerous to listen to it for too long. This did not deter musicians from trying to learn its secrets. Many bagpipe and fiddle tunes are said to be based on the plaintive melodies heard by rural folk, when eavesdropping at fairy gatherings.

The vogue for fairy subjects also left its mark on contemporary music. Some pieces originated from the ballets on fairy themes, the most celebrated example being Pyotr Ilyich Tchaikovsky's (1840–93) *Dance of the Sugar-Plum Fairy* (1891–92). On a more general level, though, the trend also spawned a wide variety of other material including *The Fairy Garden* (1911) by Maurice Ravel (1875–1937) and Igor Stravinsky's (1882–1971) *The Fairy Kiss – Land of Eternal Dwelling* (1928).

PAINTED IN

London

MEDIUM

Watercolour

SIMILAR WORKS

Moore's Irish Melodies by Daniel Maclise, 1846

John Anster Fitzgerald *Born* 1832 London, England

Died 1906

Cowper, Frank Cadogan

Francis of Assisi and the Heavenly Melody, 1902

St Francis of Assisi (1182–1226) was famed during his lifetime as the founder of the Franciscan order of mendicant friars. He is shown wearing their brown habit in this picture, together with the traditional girdle. This has three knots representing the friar's triple vow of poverty, chastity and obedience. The colourful details of Francis's life were portrayed by many artists, most notably Giotto (*c*. 1270–1327), and they often chose to focus on the saint's affinity with birds and animals. These were said to become tame in his presence. He is also said to have preached sermons to the birds, likening their song to the music of heavenly choirs. In one of his addresses he urged them to praise God for his blessings, at which point the birds took off, flying into the formation of a cross.

Cowper is sometimes described as the last of the Pre-Raphaelites. He studied at the St John's Wood Art School and the Royal Academy before travelling to Italy. From the outset, Cowper's approach was remarkable for its meticulous attention to detail. Before embarking on this painting, for example, he was determined to visit Assisi to ensure that the picture's setting looked authentic.

PAINTED IN

London

MEDIUM

Oil on canvas

SIMILAR WORKS

The Boer War by John Byam Shaw, 1900

Frank Cadogan Cowper *Born* 1877 Wicken, England

Died 1958

Doyle, Richard

Rehearsal in Elfland: Musical Elf Teaching the Young Birds to Sing, 1870

This is another of Doyle's charming illustrations for *In Fairyland*. The fairies were known for the sweetness of their music, although more for the playing of their instruments than for their songs. There are stories about them giving some mortals the gift of music, but not birds. Instead, this is a playful reworking of the theme of the Fairy School, which was invented at the height of the fairy craze. Doyle had already parodied this in his *Fairy Tree* (see page 322), where he replaced the usual group of dainty, female pupils with a row of ungainly elves.

Doyle's picture coincided with a period of growing concern about bird welfare. By 1860 the great-crested grebe had become virtually extinct in Britain, largely because its exploitation by the fashion industry. The bird's pelt was used as a fur substitute by some couturiers, while its exotic plumage was in great demand from milliners. The Society for the Protection of Birds was founded in 1891. This received the royal seal of approval in 1899, when Queen Victoria barred certain regiments from wearing osprey plumes in their uniforms, and in 1904, when its royal charter was granted.

PAINTED IN

London

MEDIUM

Colour-printed wood-engravings

SIMILAR WORKS

The Fairy School by Daphne Constance Allen, 1918

Richard Doyle *Born* 1824 London, England

Died 1883

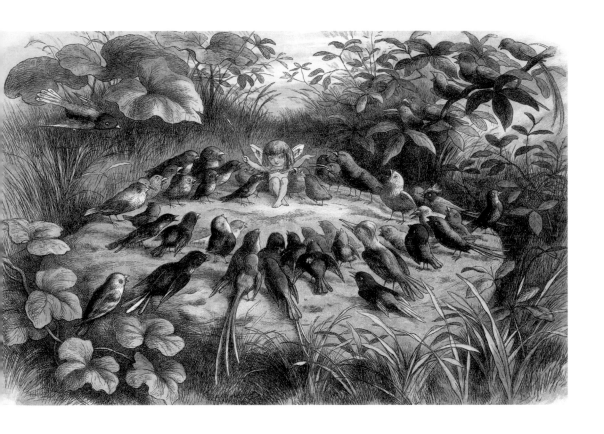

Doyle, Richard

The Fairy Dance, 1875

© Sotheby's Picture Library

This type of scene became extremely popular during the heyday of fairy painting. It represents the most conventional idea of fairy revels, as they dance together happily in a circle. The fairy king surveys the entertainment from his vantage point on top of a mushroom, while his queen is resting in the foreground fanned by an attentive infant. On the right two frogs have come to join in the fun, but are soon chased away.

When fairies danced they left a pattern on the ground. In the days before crop circles became fashionable, any unexplained circular markings on the ground were often described as fairy rings. This stemmed from the tradition that fairy dances could neither be seen nor heard by humans, unless they actually stepped inside the ring. Once there, mortals were likely to be swept up in the action, dancing until they were exhausted.

PAINTED IN

London

MEDIUM

Watercolour

SIMILAR WORKS

The Golden Age by Thomas Heatherley, *c.* 1862

Richard Doyle *Born* 1824 London, England

Died 1883

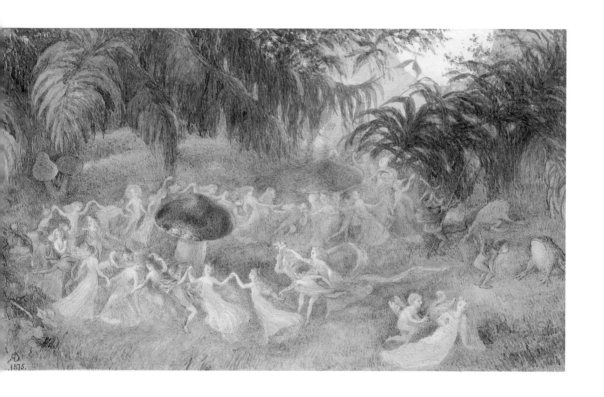

Jones, Grace

The Fairy Dance, c. 1920

By the early years of the twentieth century, many of the old superstitions about fairies had all but died away. Few Victorian artists would have envisaged a child enjoying such a happy scene as is depicted. Instead they would have feared for her safety, given the fairies' reputation for stealing pretty, young children. They would have been equally horrified at the way the girl is sitting inside the ring. This, too, was fraught with danger. Any mortal who stepped inside a fairy ring was liable to come under their power. They might force their victim to join the dance, refusing to release them for months on end. Worse still, they might carry them away to fairyland. Some people never returned from that magical place, while others only came back after many years had passed. In addition they were unlikely to survive such a journey and some crumbled to dust the moment they returned to the real world, while others just slowly pined away.

MEDIUM

Watercolour

SIMILAR WORKS

The Nutcracker by Ida Rentoul Outhwaite

Grace Jones *Born* unknown

Died unknown

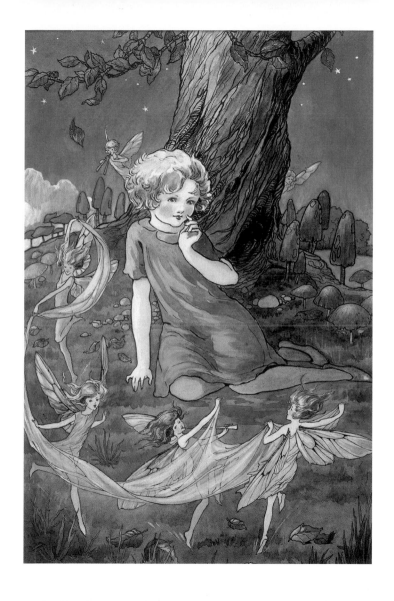

Doyle, Richard
Fairy Dance in a Clearing

In this spirited depiction of a fairy dance, Doyle presents the action from the viewpoint of a secret observer, peering through the grass. The witness has been spotted, however, for a tiny fairy in the foreground is gazing directly at us. Secrecy was often a sensible precaution at the fairy revels, as the dances could prove fatal for unwary mortals. While they were cavorting with the fairies they also lost all track of time. *In Llewelyn and Rhys*, an old Welsh folk tale on this theme, two farm labourers were returning home when Rhys inadvertently stepped into a fairy ring, where he promptly vanished and became caught up in their dance. Months passed and there were whisperings that Llewelyn had murdered his friend. Tiring of this, he returned with witnesses to the spot where Rhys had disappeared. No one could see or hear anything until they placed a foot inside the fairy ring, at which point they heard the sweetest music and saw the fairies dancing. Swiftly Rhys was pulled out of the circle and, when questioned on the matter, was adamant that he had been dancing for only five minutes.

PAINTED IN

London

MEDIUM

Watercolour

SIMILAR WORKS

The Chase of the White Mice by John Anster Fitzgerald, *c.* 1864

Richard Doyle *Born* 1824 London, England

Died 1883

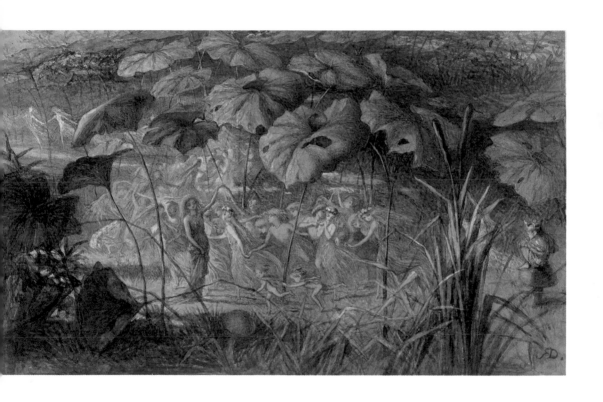

Doyle, Charles Altamont

A Dance Around the Moon

Doyle had a whimsical approach to fairy painting. His tiny characters are usually humorous, hiding in sugar-bowls, performing balancing acts with flowers and cheating at cards, although they occasionally have a flavour of something more sinister. So it is in this painting. The scene resembles a mad scramble, rather than a dance. Parts of it would not look out of place in a Keystone Cops routine. Jockeys, huntsmen, lawyers and police are caught up in a chase, alongside characters from fairy tales and mischievous sprites. In the centre there is a quirky depiction of a nightmare, complete with an impish incubus. A woman's hair has been transformed into the mare's tail, however, and she is dragged along painfully in its wake.

Doyle's fragile health may have given an edge to his work. In the 1880s he was committed to the Montrose Royal Lunatic Asylum suffering from a combination of epilepsy and alcoholism. With typical gallows humour, he immediately dubbed the place 'Sunnyside'. Doyle continued to paint in these later years, giving rise to obvious comparisons with Richard Dadd (page 34). In common with the latter, Doyle managed to convey an irrational concoction of images with dream-like clarity.

PAINTED IN

Montrose

MEDIUM

Pen, ink and watercolour

SIMILAR WORKS

The Triumphal March of the Elf King by Richard Doyle, 1870

Charles Altamont Doyle *Born* 1832 London, England

Died 1893

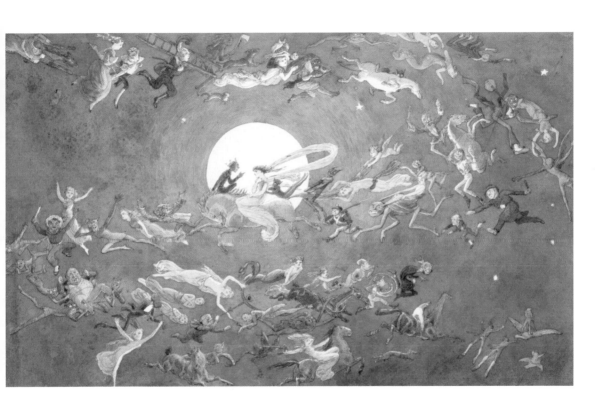

Doyle, Richard

The Triumphal March of the Elf King, 1870

This is one of the most elaborate plates from *In Fairyland*, Doyle's best-known venture in this field. It depicts a fairy procession or rade (see page 330). The elf king resembles the ruler, who featured so prominently in *The Fairy Tree* (see page 322). His beard and moustache are so long that they require special attendants. Elsewhere there are instances of the spite that characterized Fitzgerald's pictures. One fairy whips a snail, while another kicks a spider and a third tugs the tail of a bird.

In Fairyland was typical of the lavish, illustrated books that were aimed at the children's market but proved equally attractive to adults. All the contributors were experienced in this field. Doyle had previously worked on James Planché's (1796–1880) *An Old Fairy Tale told Anew* (a reworking of *Sleeping Beauty*) and *The King of the Golden River*, a fairy tale by John Ruskin (1819–1900). The author, William Allingham (1824–89), was equally well known, having produced one of the most famous Victorian poems on fairies:

Up the airy mountain / Down the rushy glen

We daren't go a-hunting / For fear of little men.

The printer, Edmund Evans (1826–1905), was also highly regarded for his use of advanced colour-printing techniques.

PAINTED IN

London

MEDIUM

Colour-printed wood-engraving

SIMILAR WORKS

The Fairy Queen, A Procession by Charles Altamont Doyle, 1882

Richard Doyle *Born* 1824 London, England

Died 1883

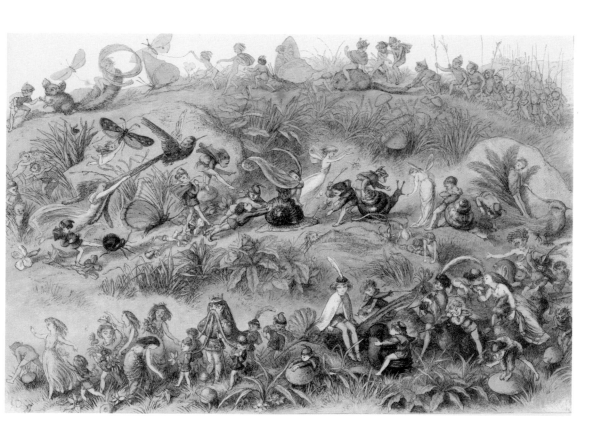

Rackham, Arthur

The Fairies Have Their Tiff With the Birds, 1906

Rackham made a practice of exhibiting the original drawings for his illustrations at the Leicester Galleries, timing the show to coincide with the publication of the book. Apart from the sale of the drawings themselves, these occasions also gave him the opportunity to meet new clients. In 1905, for example, the Leicester Galleries arranged a meeting with J. M. Barrie (1860–1937), who promptly commissioned the artist to produce the illustrations for his *Peter Pan in Kensington Gardens* (1906). This delightful scene is drawn from that series, which was published in the following year. As usual the critics were full of enthusiasm for the artist's efforts. As one commented, "Mr Rackham seems to have dropped out of some cloud in Barrie's fairyland, sent by providence to make pictures in tune to his whimsical genius". It was unusual for Rackham to be able to talk directly to one of his authors and the two men certainly enjoyed a cordial, working relationship. Even so, Rackham was disappointed that in the final version of his tale Barrie chose to transfer so much of the action to Never-Never land. "I think Never-Never lands are poor prosy substitutes for Kaatskills (Catskills: Rackham had just been working on *Rip Van Winkle*) and Kensingtons, with their stupendous powers of imagination. What power localising a myth has." As a result, Kensington Gardens featured prominently in his illustrations.

PAINTED IN

London

MEDIUM

Pen, ink and watercolour

SIMILAR WORKS

The Princess Carried Off by the Bees by Henry Justice Ford

Arthur Rackham *Born* 1867 London, England

Died 1939

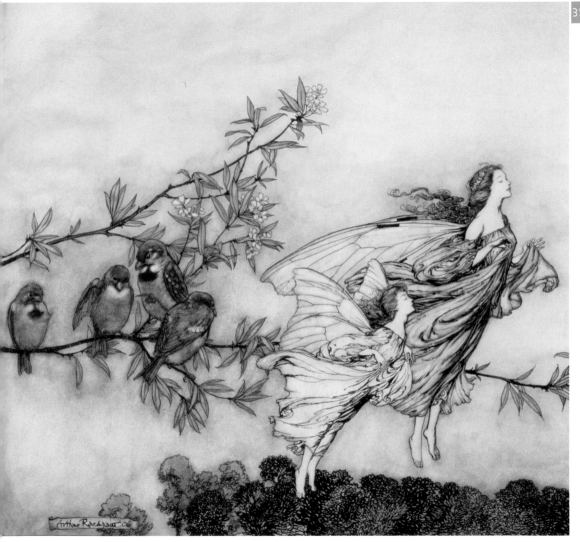

Goble, Warwick

'The fairies came flying in at the window...', 1909

© Warwick Goble/Mary Evans Picture Library

This is one of Goble's illustrations for the 1909 edition of Charles Kingsley's (1819–75) masterpiece, *The Water Babies, A Fairy Tale for a Land-Baby*. It shows the fairies fitting a new pair of wings to a young girl. Kingsley's story demonstrates the way that children's literature altered fairy traditions. Tom, the orphaned chimney sweep, can only find happiness after he has died and been transformed into a water baby. This was a reversal of the older folk tales, where fairies were feared for their practice of stealing children away from their rightful family. Mrs Doasyouwouldbedoneby, however, can be seen as an idealized form of a parent.

Kingsley's book also had a campaigning edge to it: significantly, the law on the use of children as chimney sweeps was changed within a year of its original date of publication (1863). Indeed, the author had been inspired to write *The Water Babies* after reading a damning government report about the increased use of 'climbing-boys' in the trade. By profession Kingsley was a clergyman, but he was probably better known to his contemporaries as a social reformer. He helped run a periodical called *Politics for the People*, and courted controversy by announcing, "What is the use of preaching about Heaven to hungry paupers?".

PAINTED IN

London

MEDIUM

Watercolour

SIMILAR WORKS

Peter Pan in the Fairies' Orchestra by Arthur Rackham

Warwick Goble *Born* 1862 London, England

Died 1943

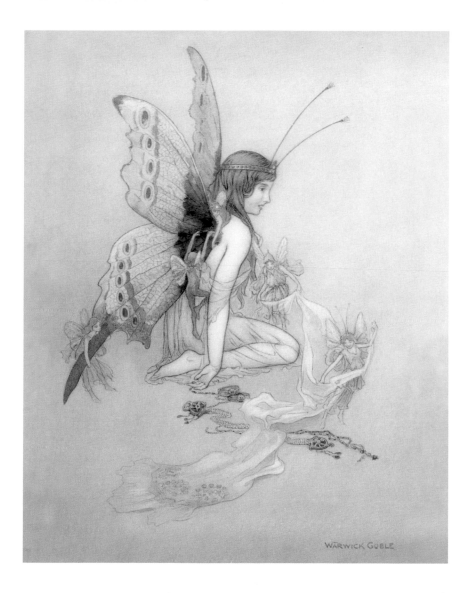

WĀRWICK GŌBLE

Goble, Warwick
Fairies Around a Baby's Cot, 1920

© Warwick Goble/Mary Evans Picture Library

This illustration is one of the 16 plates that Goble designed for *The Book of Fairy Poetry* (1920), an anthology edited by Dora Owen. The artist was a late developer in the realm of children's fiction. After training at the Westminster School of Art, Goble worked for a firm of printers specializing in chromolithography and contributed illustrations to a number of periodicals, among them the *Pall Mall Gazette* and the *Westminster Gazette*. He also began exhibiting his watercolours at the Royal Academy from 1893.

Goble illustrated a number of books in the 1890s, most notably *The War of the Worlds* (1898) by H. G. Wells (1866–1946), but he did not make his mark in children's literature until the following decade. In the early Edwardian period the success of Arthur Rackham and Edmund Dulac (1882–1953) created a vogue for lavishly illustrated children's classics, prompting publishers to seek out similar artists. Goble's work on *The Water Babies* helped to establish him in this field. He never reached the dizzying heights of Rackham or Dulac, but his interest in Japanese art brought him a lucrative series of commissions on Asian projects. Indeed, he probably produced his best work for *Green Willow and Other Japanese Fairy Tales* (1910).

PAINTED IN

London

MEDIUM

Watercolour

SIMILAR WORKS

Nightcaps for the Babies by William Henry Romaine Walker

Warwick Goble *Born* 1862 London, England

Died 1943

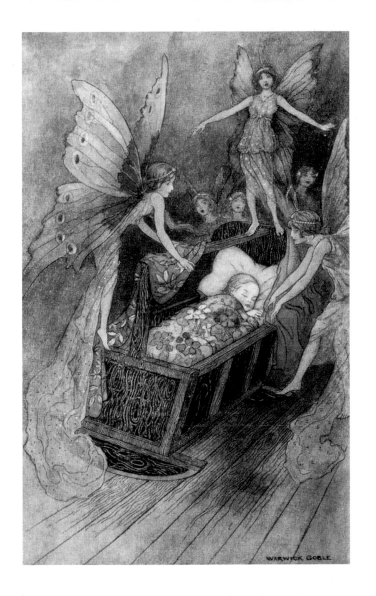

WARWICK GOBLE

Dulac, Edmund

'She found herself face to face with a stately and beautiful lady...' 1910

This is Dulac's illustration for the story of *Beauty and the Beast* which appeared in the 1910 edition of *The Sleeping Beauty and other Fairy Tales* by Sir Arthur Quiller-Couch (1863–1944). In the story the fairy appears to Beauty, urging her to go and stay at the Beast's palace so that her father can be freed. She also appears at the close of the tale, when Beauty's unselfish virtue is rewarded. Dulac was a stage designer, among other things, and there is little doubt that his experience in that field was relevant here. *Beauty and the Beast* evolved from a folk tale, but in the nineteenth century it was also performed as a pantomime. With her rich apparel and her wand, this figure is based on a traditional fairy godmother, a role that might be described as the secular equivalent of a guardian angel. Dulac was Rackham's only serious rival during the Edwardian period. Both men excelled at producing illustrations for the lavish, gift editions of classic stories. Ostensibly these books were designed for children, although they doubtless appealed even more to adults. As is evident from this picture, Dulac was strongly influenced by Oriental art, most notably Persian miniatures.

PAINTED IN

London

MEDIUM

Watercolour with pen and ink

SIMILAR WORKS

This Good Fairy by Kay Nielsen

Edmund Dulac *Born* 1882 Toulouse, France

Died 1953

Cotman, Frederick George
Spellbound, 1912

Few people will have difficulty in recognizing this scene as a key episode from the story of *Sleeping Beauty*. A wicked fairy has decreed that the princess will fall into a deep sleep, if she pricks her finger on a spindle. In a bid to prevent this, the king has prohibited the use of these machines, but his daughter eventually comes across one hidden away in a dusty old attic. As she pricks her finger the spell comes into force. The story dates back to the fourteenth century, although the best-known version was by Charles Perrault (1628–1703) and was translated into English in 1729. Cotman took the unusual step of portraying the subject in modern dress, rather than in the customary medieval setting.

Frederick Cotman belonged to a distinguished East Anglian family of artists. He was the nephew of John Sell Cotman (1782–1842), a famous landscape painter who became one of the leading lights of the Norwich School. Frederick entered the Royal Academy in 1868 and began showing his work there in 1871. He won his first award for a history painting, *The Death of Eucles* (1873), but soon followed a similar path to his uncle by specializing in landscapes. *Spellbound* was a very rare excursion into the realms of fantasy.

PAINTED IN

Ipswich

MEDIUM

Watercolour

SIMILAR WORKS

Sleeping Beauty by Walter Crane, 1895

Frederick George Cotman *Born* 1850 England

Died 1920

Buckland, Arthur Herbert
The Fairy and the Beetle, 1922

In many ways, this is the fairy equivalent of Emile Munier's (1840–95) *The Rescue*. In both cases the wings provided a suitable pretext for producing a sentimental picture of a child. In Buckland's case, however, there was far more emphasis on the *plein-air* setting. There was a vogue for paintings of outdoor nudes at the turn of the century. In part this was due to the development of English Impressionism, and in part to public health issues. There was growing recognition of the value of fresh air and exercise, which helps to explain the popularity of swimming and bathing pictures. In addition, the foundation of the Fellowship of the Naked Trust in 1891 signalled the start of the naturist movement.

Buckland was born in Taunton, but trained in Paris at the Académie Julian. He showed his work at both the Royal Academy and the Paris Salon. Buckland was a highly versatile artist. He was known primarily for his Romantic landscapes, but also produced portraits, genre scenes and book illustrations.

PAINTED IN

London

MEDIUM

Watercolour on paper

SIMILAR WORKS

August Blue by Henry Scott Tuke, 1893

Arthur Herbert Buckland *Born* 1870 Taunton, England

Died 1927

Dennys, Joyce

Oh Grown-Ups Cannot Understand

This is an illustration of a well-known verse by the poet and lecturer, Alfred Noyes (1880–1958):

Oh grown-ups cannot understand / and grown-ups never will

How short the way to fairyland / Across the purple hill.

Noyes' sentiments underline the gradual shift in relationships between fairies and children. In their early appearances in literature, fairies were more likely to communicate with adults than children. If anything the child tended to be a victim, like the stolen Indian boy in *A Midsummer Night's Dream*. During the late Victorian and Edwardian period, however, when fairies were increasingly relegated to the nursery, this trend was reversed. Children became the confidants of fairies, while adults were ruthlessly excluded. This was most famously the case in *Peter Pan*, where Wendy's mother mused nostalgically on her own childhood adventures with the boy, which could never be repeated after she had grown up. In a similar fashion the myth about stolen babies was significantly altered: the fairies now became rescuers, only taking children that were unwanted or unloved. This was the theme of Rudyard Kipling's (1865–1936) tale, *Cold Iron*. Dennys was a prolific illustrator and author, best remembered perhaps for *Henrietta's War: News from the Home Front, 1939–1942*, a humorous account of life in wartime Devon.

MEDIUM

Litho plate

SIMILAR WORKS

Fairy Watching a Girl Reading by Helen Jacobs

Joyce Dennys *Born* 1893 England

Died 1991

Folkard, Charles James

Fairy with Wings

© Charles James Folkard/Chris Beetles, London, UK/www.bridgeman.co.uk

Fairies were never the same after *Peter Pan*. Once the bond between children and fairies was firmly established, the darker elements of fairyland were gradually excluded. Even in the drawings of Arthur Rackham, who had a definite taste for the grotesque, the fairies were generally the least threatening elements. On top of this, artists were well aware of the growing commercial opportunities. Their illustrations did not just appear in books; they were also available on posters, cards, prints and calendars, and this was a further incentive for steering clear of any controversy.

The glorious colouring of this fairy may owe a debt to the exotic style of Edmund Dulac. Folkard himself was a prolific illustrator and cartoonist. He worked for a time on the *Daily Mail* where he invented a comical mouse called Teddy Tail, which featured in the paper for more than four decades. He also illustrated many of the classic children's books, among them *Mother Goose Nursery Rhymes*, *Songs from Alice*, *Old Mother Hubbard*, *The Swiss Family Robinson*, *The Arabian Nights* and many more.

PAINTED IN

London

MEDIUM

Watercolour on paper

SIMILAR WORKS

The Princess Badoura by Edmund Dulac, 1913

Charles James Folkard *Born* 1878 England

Died 1963

Henry, Ron and Jean
Bottom of the Garden, 1988

This charming, modern slant on the fairy world takes its name from 'The Fairies' by Rose Fyleman (1877–1957):

There are fairies at the bottom of our garden! / It's not so very, very far away;

You pass the gardener's shed and you just keep straight ahead - / I do so hope they've really come to stay.

There's a little wood, with moss in it and beetles, / And a little stream that quietly runs through;

You wouldn't think they'd dare to come merry- / making there - Well they do.

Fyleman's poem was published in *Punch* in 1917 at the height of the First World War. It proved an instant hit with the public and she became a regular contributor to the magazine. In the following year her first collection of verse, *Fairies and Chimneys*, went into print. The poem may well have inspired Elsie Wright and Frances Griffiths to produce their fairy photographs in Cottingley Glen. Their chosen location corresponds quite closely to Fyleman's description and Elsie admitted that she knew the poem.

PAINTED IN

England

MEDIUM

Gouache

SIMILAR WORKS

Fairy Watching a Girl Reading by Helen Jacobs

Ron Henry *Born* 1936 London England

Jean Henry *Born* 1943 London England

Author Biographies

Iain Zaczek (author)

Iain Zaczek was born in Dundee, Scotland, and educated at Wadham College, Oxford, and the Courtauld Institute of Art. He has since gone on to forge an impressive career as a freelance writer on art- and Celtic-related subjects, and is interested in particular in Pre-Raphelite art and International Gothic. Recent publications include *Essential Art Deco* (Paragon, 2000), *The Essential William* Morris (Paragon, 1999), *The Art of the Icon* (Studio Editions, 1994), *Lovers in Art* (Studio Editions, 1994) and *Impressionist Interiors* (Studio Editions, 1993).

George P. Landow (Foreword)

George P. Landow has taught at several universities, including Brasenose College, Oxford, and Brown University, Rhode Island> Amongst many associations with other universities, he was founding dean of the University Scholars Programme, National University of Singapore (1999–2001). His fields of interest include nineteenth-century literature, art and religion as well as literary, media and hypertext theory. Landow helped organize several international loan exhibitions including Fantastic Art and Design in Britain, 1850 to 1930 (1979), and his books include *Victorian Types, Victorian Shadows: Biblical Typology and Victorian Literature, Art, and Thought* (Routledge & Kegan Paul, 1980), *Images of Crisis: Literary Iconology, 1750 to the Present* (Routledge & Kegan Paul, 1982) and *Ruskin* (Oxford UP, 1985). He also founded and created victorianweb.org, an educational site on Victorian art, literature, history, religion, economics and science.

Picture Credits: Prelims and Introductory Matter

Pages 1 & 3: Léon Jean Basile Perrault, *Cupid's Arrows*, (detail) 1882 © Sotheby's Picture Library

Page 4: Fitzgerald John Anster, *Fairy Twilight*, © Christie's Images Ltd

Page 5 (l to r top): Constantin Makowsky, *The Toilet of Venus* (detail)© Christie's Images Ltd, John Atkinson Grimshaw, *Iris* 1876 © Sotheby's Picture Library, Richard Doyle, *The Fairy Queen's Carriage* 1870 © The Stapleton Collection/www.bridgeman.co.uk

Page 5 (l to r bottom): John Duncan McKirdy, *Yorinda and Yoringel in the Witch's Wood*, (detail) 1909 © Christie's Images Ltd, Robert Huskisson, *Titania's Elves Robbing the Squirrel's Nest c.* 1854 © Christie's Images Ltd, A.C. Lalli, after Dante Gabriel Rossetti, *Dante's Dream at the Time of the Death of Beatrice c.* 1900 © Christie's Images Ltd

Page 6 (l to r top): Arthur Rackham, *The Meeting of Oberon and Titania* (detail) 1905 © Arthur Rackham/Sotheby's Picture Library, Gustave Doré, *The Fairies: A Scene Drawn from Shakespeare* 1873 © Sotheby's Picture Library, Henry Meynell Rheam, *The Fairy Wood* 1903 © Roy Miles Fine Paintings/www.bridgeman.co.uk

Page 6 (l to r bottom): John George Naish, *Elves and Fairies, A Midsummer Night's Dream* 1856 © Christopher Wood Gallery, London, UK/www.bridgeman.co.uk, Amelia Jane Murray, (Lady Oswald), *A Fairy Resting Among Flowers* © Christie's Images Ltd, George Cruikshank, *A Fairy Gathering* © The Maas Gallery, London, UK/www.bridgeman.co.uk

Page 7: John Henry Dearle, *The Passing of Venus* 1923–26 © Sotheby's Picture Library

Further Reading

Bown, N., *Fairies in Nineteenth-Century Art and Literature*, Cambridge University Press, 2001

Briggs, A., *Victorian Things*, Batsford, 1988

Briggs, K., *A Dictionary of Fairies*, Allen Lane, 1976

Briggs, K., *The Vanishing People*, Batsford, 1978

Carpenter, H. & Prichard, M., *The Oxford Companion to Children's Literature*, Oxford University Press, 1984

Celebonovic, A., *The Heyday of Salon Painting*, Thames & Hudson, 1974

Davis, J., *Fairies*, Pitkin Guide, 2004

Fairies, Brighton Museum exhibition catalogue, 1980

Froud, B., *Good Faeries, Bad Faeries*, Pavilion Books Ltd., 1998

Girouard, M., *The Return to Camelot*, Yale, 1981

Hamilton, J., *Arthur Rackham*, Pavilion Books Ltd., 1990

Harrison, J. F. C., *Late Victorian Britain*, Fontana Press, 1990

Henry Fuseli, Tate Gallery exhibition catalogue, 1975

Lambourne, L., *Victorian Painting*, Phaidon, 1999

Langmuir, E., *Angels*, National Gallery Publications, 1999

Marsh, J. & N. & Gerrish, P., *Pre-Raphaelite Women Artists*, Thames & Hudson, 1997

Richard Dadd, Tate Gallery exhibition catalogue, 1974

Shakespeare, W., *A Midsummer Night's Dream*, New Cambridge Edition, 2003

Sherborne, M., *A Midsummer Night's Dream: York Notes*, 2000

Silver, C. G., *Strange and Secret Peoples, Fairies and Victorian Consciousness*, Oxford University Press, 1999

The Age of Rossetti, Burne-Jones & Watts, Symbolism in Britain, 1860-1910, Tate Gallery exhibition catalogue, 1997

The Last Romantics, Barbican Art Gallery exhibition catalogue, 1989

The Pre-Raphaelites, Tate Gallery exhibition catalogue, 1984

Victorian Fairy Painting, Royal Academy of Arts exhibition catalogue, 1997

Wilson, A. N., *The Victorians*, Hutchinson, 2002

Wood, C., *Fairies in Victorian Art*, Antique Collectors Club Ltd., 2000

Etheline E. Dell, *Fairies and a Fieldmouse*

Index by Work